THE SACRAL TREASURE OF THE GUELPHS

Front Cover. *"Paten of St. Bernward."* Gilt-silver and niello, Diam. 5-5/16 inches (13.4 cm.).
St. Oswald Reliquary Workshop, Germany, Lower Saxony, Hildesheim(?), ca. 1185.
Purchase from the J. H. Wade Fund with additional gift from Mrs. R. Henry Norweb. CMA 30.505 (See also Color Plate XIII.)

Back Cover. *Book-Shaped Reliquary.* Ivory plaque (for which see Figure 17), set within a frame of silver,
gilt-silver, gems, and pearls on a core of wood, frame: 12-3/8 x 9-1/2 x 2-11/16 inches (31.4 x 24.2 x 6.8 cm.).
Germany, Lower Saxony, Brunswick, ca. 1340. Gift of the John Huntington Art and Polytechnic Trust. CMA 30.741

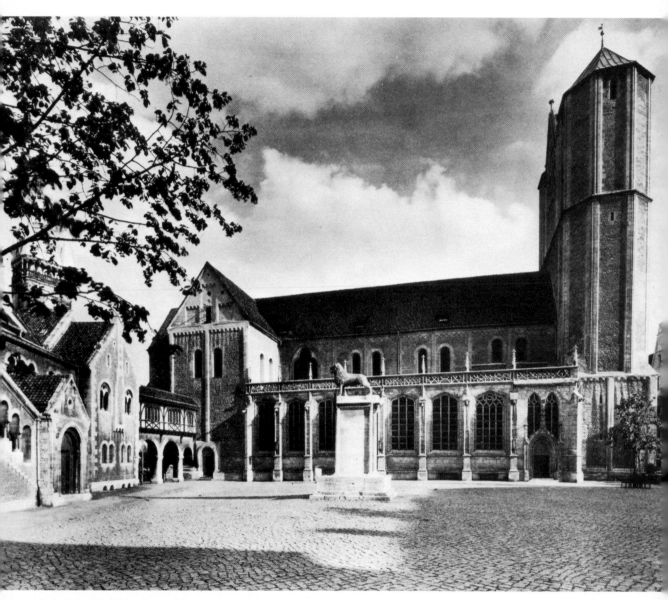

Cathedral of St. Blaise, Bronze Lion, and Burg Dankwarderode, Brunswick.

THE SACRAL TREASURE OF THE GUELPHS

Patrick M. de Winter

The Cleveland Museum of Art
In cooperation with Indiana University Press

Duchy of Saxony and Outlying Territories

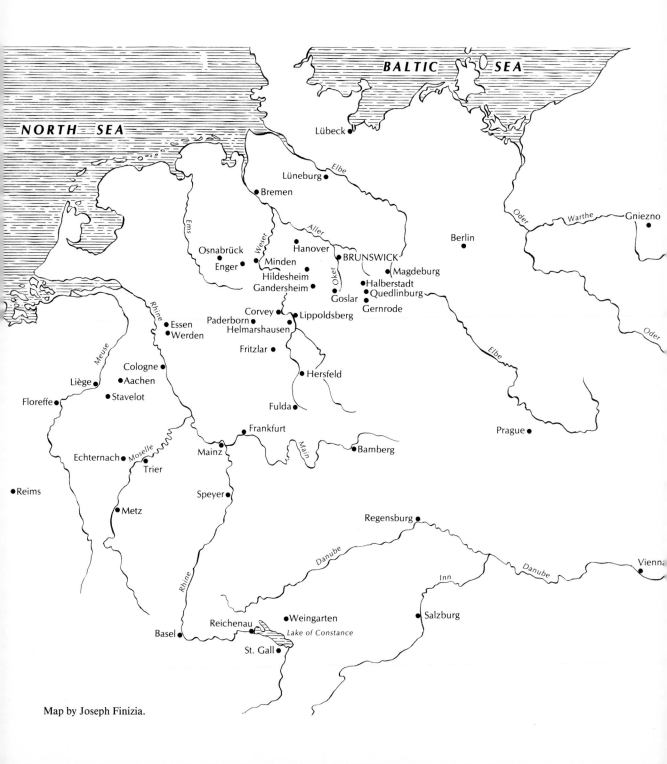

Map by Joseph Finizia.

Contents

Color Plates

7 Introduction

13 Chapter I
Dawn of German Art:
Images of Salvation and Power

29 Chapter II
Commissions and Acquisitions of the Brunons
in Eleventh-Century Brunswick

55 Chapter III
Henry the Lion and the Arts of
Twelfth-Century Lower Saxony

115 Chapter IV
A Time of Steady Growth:
Thirteenth-Fifteenth Centuries

128 Chapter V
Vicissitudes and Dispersal of the Treasure

139 Appendix I
Contents of the Guelph Treasure
as Known in the Twentieth Century

143 Appendix II
Present Whereabouts of the Guelph Treasure

144 Frequently Cited Literature

145 Notes to the Text

156 Acknowledgments

156 Photograph Credits

157 Index

9 I. *Ceremonial Cross of Count Liudolf Brunon*
(obverse).

10 II. *Ceremonial Cross of Countess Gertrude*
(obverse).

11 III A. *Ceremonial Cross of Count Liudolf Brunon*
(reverse).

11 III B. *Ceremonial Cross of Countess Gertrude*
(reverse).

12 IV. *Cumberland Medallion.*

12 V. *Portable Altar of Countess Gertrude* (mensa).

18 VI. *Christ, Peter, and Five Other Apostles*
(front of *Portable Altar of Countess Gertrude*).

18 VII. *Virgin and Six Apostles*
(back of *Portable Altar of Countess Gertrude*).

19 VIII. *The Holy Cross Adored by Constantine,
St. Helena, Sigismund, and St. Adelaid* (right)
end of *Portable Altar of Countess Gertrude*).

19 IX. *St. Michael and Four Angels*
(left end of *Portable Altar of Countess Gertrude*).

61 X. *Horn of St. Blaise.*

61 XI. *Reliquary Casket with Champlevé Enamels
of Sharp Colors.*

64 XII A-D. *Four Plaques with Seated Prophets:
Isaiah, Elisha, Obadiah, and Hosea.*

64 XII E. *Judgment and Martyrdom of St. Lawrence.*

64 XII F. *Pyx.*

89 XIII. *Monstrance with the "Paten of St. Bernward."*

90 XIV-XV. *Arm Reliquary of the Apostles.*

91 XVI-XVIII. Details of *Arm Reliquary
of the Apostles.*

92 XIX. *Altar Cross.*

97 XX. *Perfume* or *Incense Burner.*

97 XXI. *Lion Aquamanile.*

100 XXII. *Architectural Monstrance with
a Relic of St. Sebastian.*

105 XXIII. *Solomon(?), Sponsa, Justice, and Truth;
Nativity.*

108 XXIV. *St. Matthew.*

©Copyright 1985 by The Cleveland Museum of Art.
Museum photography by Nicholas Hlobeczy.
Designed by Merald E. Wrolstad.
Manuscript edited by Jo Zuppan.

Typesetting by Northern Ohio LIVE, Cleveland.
Printing by Great Lakes Lithograph, Cleveland.
Distributed by Indiana University Press,
 Bloomington, Indiana 47405

Library of Congress Cataloging in Publication Data
appears on page 160.

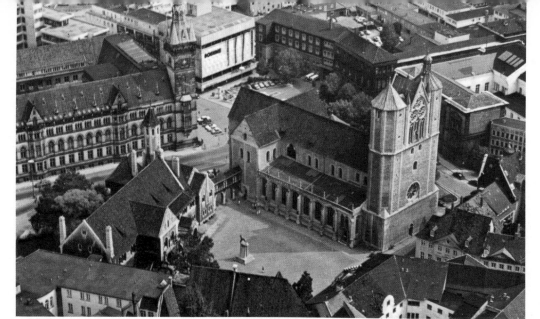

Figure 1.
Brunswick's Burgplatz.
At right is the Cathedral of
St. Blaise; flanking it on the
right is the Castle of
Dankwarderode; at center,
is the bronze lion erected in
1166.

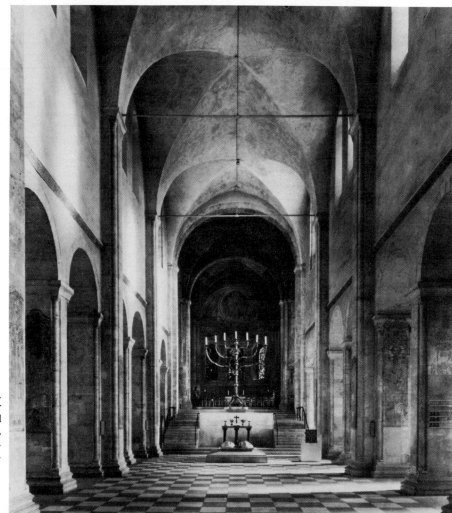

Figure 2.
Nave and choir
of Cathedral
of St. Blaise,
1173 and later.
Brunswick.

Introduction

After crossing a fertile undulating plain bathed by the gentle meanders of the Oker, one comes to Brunswick, a thriving middle-sized German city of Lower Saxony (see Map). Although today essentially defined by functional modern architecture, Brunswick's center still focuses on the old Medieval Burgplatz (Figure 1), dominated by the Cathedral of St. Blaise. This venerable edifice, with its steep walls flanked by massive octagonal towers, was for the greater part erected in the twenty years spanning 1173-1194. After crossing its threshold and proceeding towards the stage-like raised apse (Figure 2), one is awed first by the loftiness of the nave and then by the chromatically harmonious late Romanesque mural paintings depicting scenes from the Testaments, the Finding of the True Cross, and events from the lives of SS. John the Baptist, Blaise, and Thomas of Canterbury, who have stood as protectors of the church since the early thirteenth century. At the chancel and visible from all main vantage points are the tombs of the founder, Henry the Lion, duke of Saxony, and his consort, Matilda Plantagenet, marked by noteworthy limestone effigies (Figure 3). The duke is not represented either with his hands crossed or lying at his side — traditional gestures of eternal repose — but rather holding a model of the church, evidence of his largess, and grasping a sword, symbol of his rank and implication of his knightly valor. Duke Henry, an eminent figure in German Medieval times, was bestowed the epithet of "Lion" as much on account of his aloof and ambitious politics as for the bravery he displayed on the field. In addition to being a striking embodiment of the Medieval German prince, Duke Henry was also a major patron of the arts. He made Brunswick his capital and in 1166 erected there in front of his castle of Dankwarderode, flanked by the Burgkirche of St. Blaise, a mighty, over life-size bronze lion (Figure 4), the heraldic symbol of his family and a fitting image of his relentless rule.

The name Guelph (of Welf in German) — that of the family of which Henry the Lion is the most illustrious figure — is often cited by students of Medieval history, as it has also come to stand for the political faction siding with the papacy in the age-long conflict between church and state, and opposing the Ghibellines, backers of the Holy Roman emperors. The House of Guelph, along with its predecessor the Brunon and followed by its heir, the House of Brunswick-Lüneburg, made a long series of gifts to the Treasury of the Cathedral of St. Blaise which came to be known in Germany as the *Welfenschatz*, or Guelph Treasure. This remarkable hoard was to comprise liturgical and devotional implements, nearly all dating from the Ottonian, Romanesque, and Gothic periods. In 1482, the year of its first known inven-

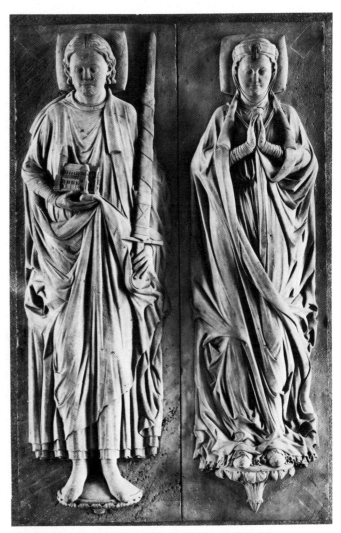

Figure 3. *Recumbent Effigies of Henry the Lion and Matilda Plantagenet.* Limestone, maximum length 93-1/2 inches (237 cm.). Germany, Lower Saxony, early thirteenth century. Brunswick, Cathedral of St. Blaise.

7

tory, the Treasure numbered 140 items. Most of the 85 pieces still extant in the twentieth century were dispersed in the 1930s between a number of public and private collections in Europe and in the United States, while a few were lost.[1]

The Guelph Treasure, as we know it today, includes truly remarkable objects of sacral arts: crosses, portable altars, reliquaries, pyxes, and manuscripts, often dazzling for the shimmer of their gold and silver surfaces and the magic glow of their variegated gems and enamels. Culturally, it is an outstanding expression of spiritual values and has paramount importance for the German art of the Middle Ages. This collection — equalled only by the ecclesiastical treasures of Aachen, Hildesheim, and Trier — is also unique for the number of its objects whose production can be specifically localized in Saxony. Apart from a catalogue published in 1930 and long out of print, no study devoted to the Guelph Treasure has yet been available in English.[2] The present publication, therefore, has a twofold purpose: to examine the formation of the Treasure and to reappraise its artistic significance by highlighting some of its most important pieces, particularly those in The Cleveland Museum of Art.

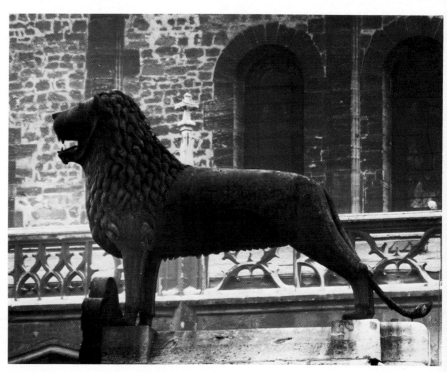

Figure 4. *Defiant Lion.* Bronze (perhaps cast in Goslar) with traces of gilding, ca. 1166. Germany, Lower Saxony, Brunswick. Due to corrosion caused by pollution, the original cast was removed from the Burgplatz in 1984 and is to be exhibited in Dankwarderode, which has been transformed into a museum. A copy of the lion now crowns the original monument.

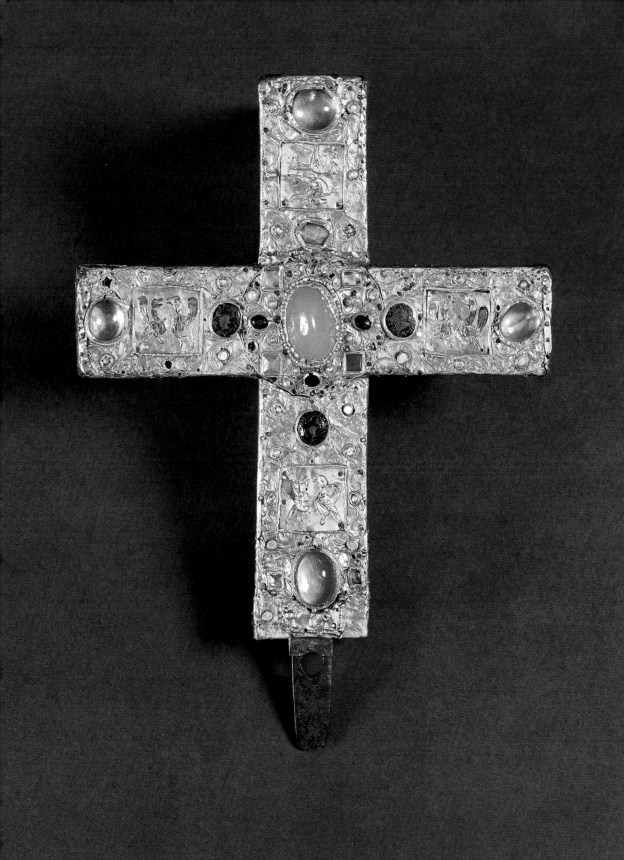

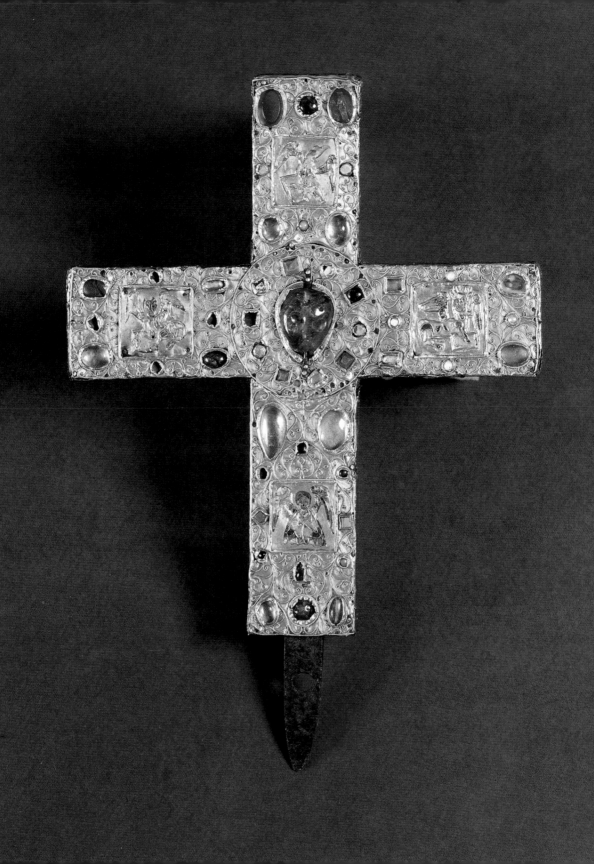

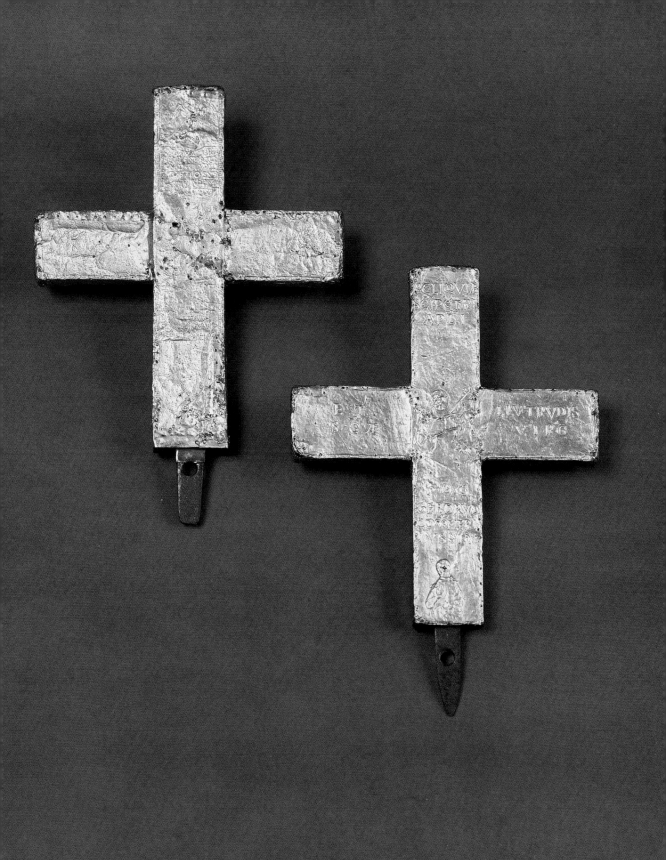

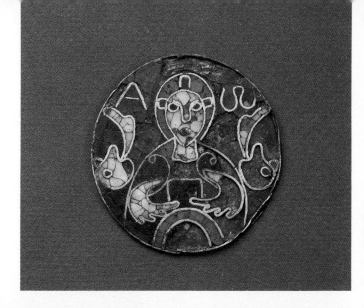

Color Plate IV. *Cumberland Medallion* (with Bust of Christ). Cloisonné enamel and gold on copper, Diam. 1-15/16 inches (5 cm.), thickness 3/16 inch (.5 cm.). Germany, Weserraum, late eighth century. Purchase from the J. H. Wade Fund. CMA 30.504

Color Plate V. *Portable Altar of Countess Gertrude* (mensa). Red porphyry set into a casket of oak and framed in gold, with the following inscription in niello: GERDRVDIS XPO FELIX VT / VIVAT IN IPSO / OBTVLIT HVNC LAPIDEM GEMMIS / AVROQ NITENTEM, 10-1/2 x 8 inches (26.7 x 20.3 cm.). Germany, Lower Saxony, Hildesheim, ca. 1045. Gift of the John Huntington Art and Polytechnic Trust. CMA 31.462

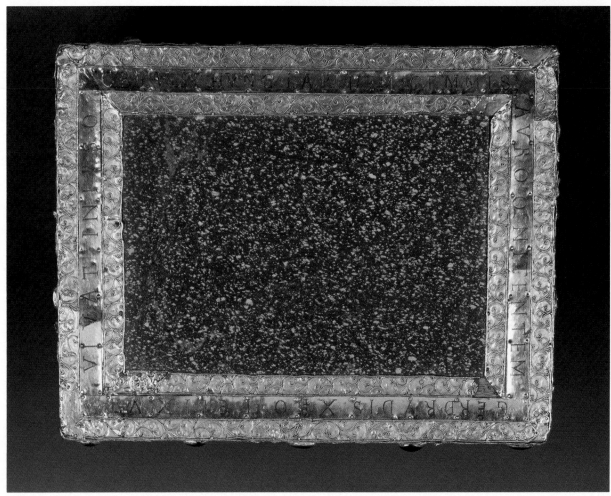

Dawn of German Art: Images of Salvation and Power

The early Medieval period is an unequivocal milestone in the history of German art. The vast expanse of the Holy Roman Empire could boast of many artistic centers, each often with its own distinctive speciality ranging from goldsmith work and enameling to monumental bronze sculpture, and from book illumination to mural painting. Among all other arts, that of the metalsmith had a particularly well-rooted tradition. Even before the advent of Charlemagne, these craftsmen excelled in making buckles and brooches, weapons and horse trappings with rich abstract designs. Enameling had been successfully practiced for centuries by the tribes north of the Rhine. As early as the second century the Greek philosopher Philostratus described the glass designs, as hard as stone, produced by the Barbarians on heated bronze.[3]

Earliest in date among extant objects in the Guelph Treasure is a late eighth-century enamel (Color Plate IV) known as the *Cumberland Medallion*, now in Cleveland.[4] Originally perhaps a sacerdotal brooch, it is one of the finest as well as the largest German objects of its kind known from this period. In ornamental forms suited to the technique of cloisonné enamel—in which colored glass particles are fused by firing into separate cells formed by strips of metal (here a gold alloy) usually welded to a copper base—its represents a human figure in bust length identifiable as Christ. In a nearly cubistic abstraction, the Redeemer is shown outlined against a cruciform halo behind the rainbow of the Covenant, his two large claw-like hands holding the sacred book of his teachings. Looming above the figure are the first and last letters of the Greek alphabet clearly associated with Christ, who in St. John's words said, "I am Alpha and Omega, the beginning and the end" (Apocalypse 1:8). The immemorial implication conjured up by these letters is emphasized by the two roaring lions with their flame-like tongues, symbols of the Resurrection since according to ancient lore newborn cubs lie dead for three days until their father brings them to life by breathing in their faces. Although the enamel of the medallion is damaged, it nonetheless still imparts a vivid coloristic effect with opaque white flesh tones, turquoise and wine red for the mantle, and sapphire blue for the binding of the book. This extraordinary representation suggests the power of magic. Its highly conceptual style is based on the earlier striking decorative abstractions developed at the great monasteries of Monkwearsmouth, Jarrow, and Lindisfarne within the Hiberno-Saxon culture of the Kingdom of Northumbria, today's northern England. These ornamental forms were carried in books and liturgical implements by missionaries such as St. Willibrord, who left a famous volume of gospels (Figure 5) to

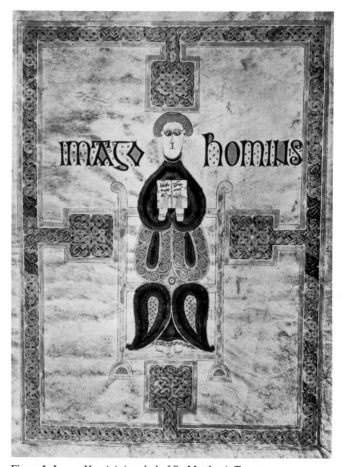

Figure 5. *Imago Hominis* (symbol of St. Matthew). Tempera on parchment, 13-3/16 x 10-7/16 inches (33.5 x 26.5 cm.). England, Northumbria, end seventh century. *Echternach Gospels.* Paris, Bibliothèque nationale, lat. 9389, folio 18v.

the abbey he founded in the early eighth century at Echternach, near Luxemburg.

Although the geographical origin of the *Cumberland Medallion* cannot be pinpointed readily, its bold technique and general style with rhythmic contours and broad areas of enameling can be associated with a series of roundels with christological figures in Darmstadt (Figure 6) and with a rare representation of the Virgin (Figure 7) incorporated in the tenth-century binding of the *Gospels of St. Gozelin*, which are traditionally asso-

Figure 6. *Half-Length Figure.* Cloisonné enamel on copper, Diam. 1-3/16 inches (2.9 cm.). Germany, Weserraum, eighth century. Darmstadt, Hessisches Landesmuseum, Inv. II B13.

ciated with the Weserraum, that region of today's West Germany which extends from the Rhine at the point where the Moselle becomes its tributary, north to the Baltic Sea. The metalsmiths of this area had evidently seen some late antique or early Byzantine models which would have been particularly accessible in such city-settlements as Trier and Mainz which traced their origin to the Romans and which were subsequently drawn to the culture of the Eastern Empire.

If, in the German realm, this abstract and often zoomorphic style had its first impact in the Weserraum, it soon traveled, with unabated impetus, south and east along the Rhine to the Lake of Constance, and followed the course of the Danube in Austria. The silver *Altheus Reliquary* with its paired enamel saints (Figure 8) exemplifies the Alemannic, or South German, adaptation of this style, while the *Tassilo Chalice* (Figure 9), perhaps from Salzburg, with its more naturalistically rendered medallion of Christ, represents a significant example from Austria.[5]

The charming, bellowing lions of the *Cumberland Medallion* (Color Plate IV) seem to be distinctly echoed in the playful German cloisonné enamel symbol of St. Mark inset in the right arm of a late tenth-century Anglo-Saxon cross (Figure 10). This suggests that goldsmiths from the Weserraum, who had taken the inspiration for their forms from insular art, in turn, were highly admired for their works on English soil.[6] Such objects therefore are clues, not to large historical swells, but to the constant undertow influencing tides of art in the early Medieval period.

In the wake of Charlemagne and his sons, who strove to recreate Roman culture north of the Alps, the Ottonian emperors, far less oriented to a cultural *renovatio*, embarked on the construction of often vast religious edifices. The Speyer, Mainz,

Figure 7. *Medallion of the Virgin.* Cloisonné enamel, gold, and copper. Germany, Weserraum, late eighth or early ninth century. Detail of binding of *Gospels of St. Gozelin.* Nancy, Cathedral, Treasury.

Figure 9. *Tassilo Chalice.* Silvered and gilt-bronze, H. 10-5/8 inches (27 cm.). Austria, Salzburg(?), 777-788. Kremsmünster, Abbey.

Figure 8.
Altheus Reliquary.
Silver and cloisonné enamel,
H. 6-3/16 inches (15.8 cm.).
South Germany, 780-799. Sion
(Sitten), Cathedral, Treasury.

Figure 10. *Reliquary Cross.*
Gold, cloisonné enamel, and
walrus ivory on a core of wood,
7-5/16 x 5-5/16 inches (18.5 x
13.4 cm.). Anglo-Saxon, late
tenth century. The symbols of
the evangelists in cloisonné
enamel are probably German
of the late eighth-ninth century.
London, Victoria and Albert
Museum, 7943-1862.

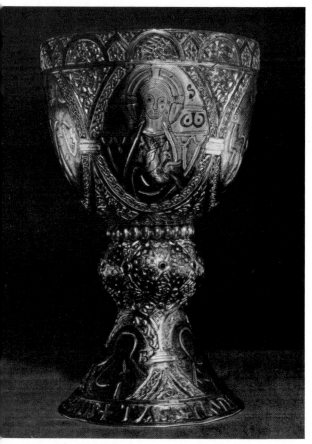

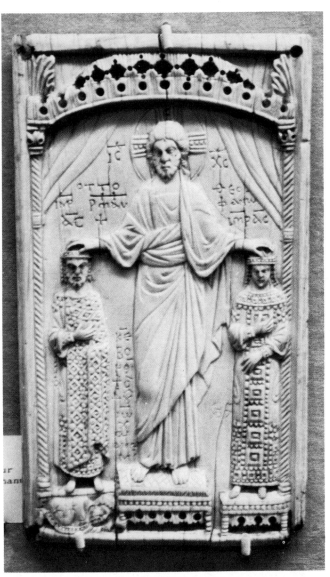

Figure 11. *Christ Crowning Otto II and Theophanu.* Ivory plaque, 7-1/16 x 4-1/16 inches (18 x 10.3 cm.). Byzantine artist working in Germany, 982-83. Paris, Musée de Cluny, Inv. CL392.

and Bamberg cathedrals are striking examples of their enterprise. Furnishing these new structures with rich and often ostentatious cult implements for the *ministerium* (liturgy) was but another part of their endowments. The imperial title was now elective rather than hereditary, and it was the wish of each new ruler, in order to distance himself from his peers as *primus inter pares*, to see a priest-king role, substantiated by divine will, as part of his exalted position (Figure 11). Even if the prince should govern reprehensibly, Christ's words as they are spoken in the gospels had for him, more than in the case of common mortals, a manifest promise of redemption. The rich evangelistary which many a ruler commissioned as a very personalized object, adorned with miniatures in which his dignity was clearly upheld, were bound in glistening covers evoking godly visions. On the sumptuous exterior of the *Codex Aureus of St. Emmeram* (Figure 12), the goldsmith evoked, through the calculated layout of the fine raised settings of the many gems, no less wonderous a vision of the celestial Jerusalem than that conjured up by St. John: "the city itself pure gold like to clear glass . . . adorned with all manner of precious stones" (Apocalypse 22: 18-19). For their continual munificence towards foundations, these rulers, like new Davids, could proclaim "Lord I have loved the beauty of thy house" (Psalms 26:8). The ever increasing number of ecclesiastical buildings which sprung up in Ottonian times is in turn partly connected with this fundamental evolution of the ceremonial in the liturgy and partly with an increased veneration of martyrs and saints to whom the new churches were dedicated.

Ritual requirements resulted in a proliferation of furnishings as *ornamentum* (in contrast to the *ministerium*) in the interiors of Ottonian churches: altars, tombs, screens, ambos, candelabras and lamps, textile hangings, and shrines, as well as precious reliquaries for those sacred mementi of the saints that were the focus of steady devotions and brought an ever-increasing wealth to churches through the offerings of pilgrims.[7] Reliquaries which at times vividly took on the shape of their content — consider the shrine of 977-993 made for St. Andrew's sandal (Figure 13) — were fashioned in a variety of techniques readily combining casting, chasing, embossing, engraving, niello, filigree, and enameling. These dazzling visions of semi-Oriental splendor mirrored the hieratic values of the Byzantine court style, while their bold forms appealed to the spirit of the old German tribes.

Constantinople was indeed looked upon as a criterion both for its court ceremonies revolving around the role of the emperor, supreme head of both church and state, and for the ar-

Figure 13. *Portable Altar and Reliquary of St. Andrew's Sandal.* Gold, gilt-bronze, gems, pearls, and cloisonné enamel on a core of oak, 12-3/16 x 17-5/8 x 8-11/16 inches (31 x 44.7 x 22 cm.). Germany, Trier, 977-993. Trier, Cathedral, Treasury.

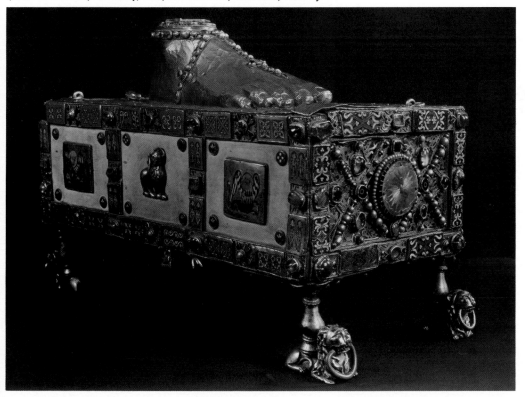

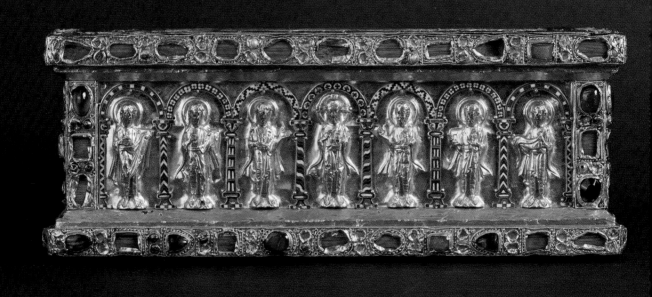

Color Plates VI-VII. *Christ, Peter, and Five Other Apostles* (front); *Virgin and Six Apostles* (back).
Gold, cloisonné enamel, gems, and pearls on a core of oak, 4 x 10-1/2 inches (10.2 x 26.7 cm.). CMA 31.462

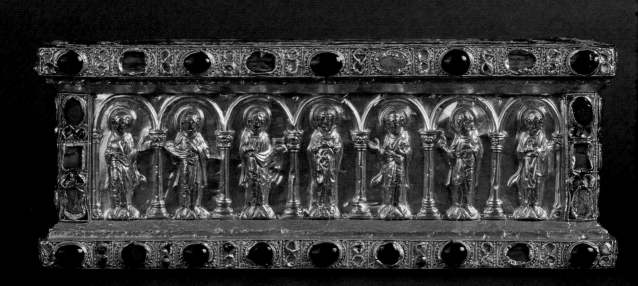

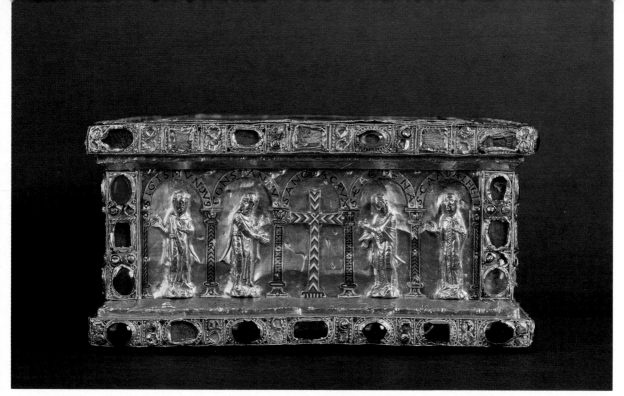

Color Plates VIII-IX. *The Holy Cross Adored by Constantine, St. Helena, Sigismund, and St. Adelaide* (right end);
St. Michael and Four Angels (left end), 4 x 8 inches (10.2 x 20.3 cm.). CMA 31.462

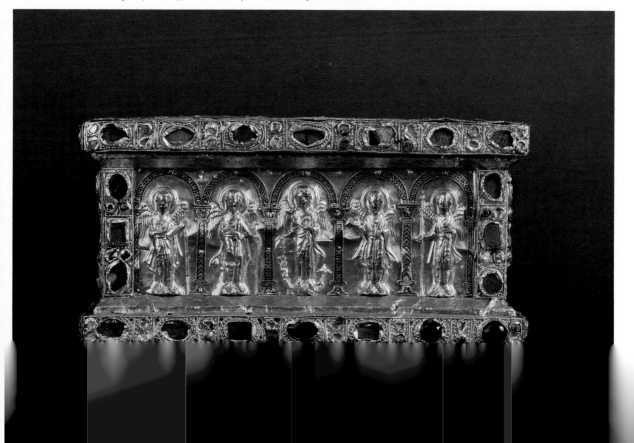

Figure 14. Pendant: *Virgin and Child*. Steatite relief: 2-1/16 x 1-9/16 inches (5.2 x 4 cm.). Byzantium, tenth century. Added frame: gilt-silver with pearls, 2-5/8 x 2-1/16 inches (6.7 x 5.2 cm.). Aachen, mid-fourteenth century. Purchase from the J. H. Wade Fund. CMA 51.445

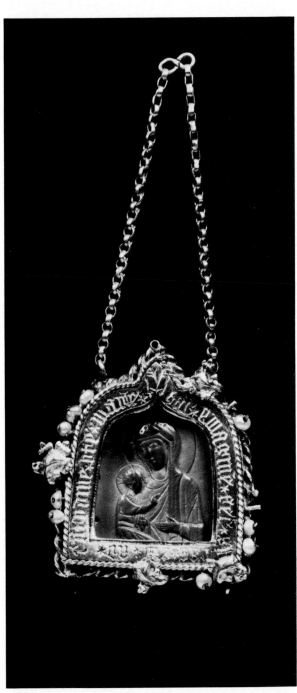

tistic standards it had developed and codified. The West consciously modeled some of its buildings on the finest examples of Byzantine architecture. The central plan church built by Charlemagne at Aachen, for example, is clearly inspired by San Vitale at Ravenna, a city which had been under the rule of the Eastern Empire between the sixth and eighth centuries. The West also eagerly turned to the art of Constantinople for iconographic models and the fine craftsmanship of goldsmith work, bronze casting, and sumptuous fabrics. In Germany, Byzantine objects were in fact shrouded with an aura inseparable from their source. Such is the case, for example, of a small Byzantine pendant of greenish steatite with a relief of the *Virgin and Child* (Figure 14), formerly in the Treasury of Aachen and now in Cleveland. Though stylistically it cannot be dated earlier than the tenth century, it nonetheless was held to have been worn by Charlemagne and found on the emperor when, according to tradition, Otto III in the year 1000 opened the tomb and discovered the body of his great predecessor sitting upright on a throne, wearing the crown, and holding the scepter. Such a vital insignia as the coronation mantle in the Holy Roman Empire was traditionally made out of Byzantine brocades. When Otto II married Theophanu (Figure 11), daughter of the Eastern emperor, Romanus II, on 14 April 972, the bride arrived in Germany bearing costly Byzantine gifts which then served as models in such places as Trier, Echternach, and Regensburg especially during the decades preceding the beginning of the second millennium.[8]

In the Imperial West the rulers were not alone in promoting artistic activity. Bishops, who not infrequently were the younger sons of princes and other lords, often commanded substantial wealth in addition to spiritual authority. In turn, they plainly realized that building new churches and commissioning illuminated codices and liturgical objects in bronze and precious metals could reap spiritual and material advantages for them personally as well as glory for their see. The high clergy did in fact exercise a clearly felt normative influence on artistic developments of this period. Archbishop Egbert of Trier (Figure 16), Bishop Bernward of Hildesheim (Figure 80), and abbesses such as Matilda (Figure 37), granddaughter of Otto I, and Theophanu at Essen (Figure 47), were among the many prominent ecclesiastic German patrons of this time.

Abbots and bishops of the period also frequently aspired to present to their contemporaries the image of great learning and of divine inspiration. Indicative of the high esteem in which metalsmithing, as well as painting on manuscripts, was held are the claims by many an ecclesiastic of practicing these arts

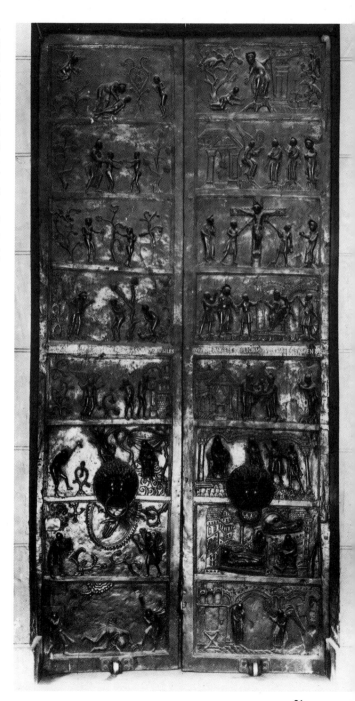

Figure 15. *Bronze Doors from St. Michael's of Hildesheim.* H. 188-1/2 inches (472 cm.), W. (of each door) 44-1/16 inches (112 cm.). Germany, Lower Saxony, Hildesheim, 1015. Hildesheim, Cathedral.

and the laudatory comments of followers seeking the attribution of these abilities to their mentors. Skill was held as a gift of God, a vestige of those qualities which man possessed in full measure before the Fall and which he could now use to reflect something of his essential purpose -- the praise of God. Art was not merely seen as making a work of beauty but also as an act of piety capable of strengthening the faith of the beholder. The archetypical model bishop-goldsmith was St. Eligius, who in the seventh century not only produced saddles and similar works in gold with gems for the Frankish kings Lothar and Dagobert, but expended much of his abilities as well at fashioning many precious reliquaries to glorify the church and its saints. Among examples of putative artistic prelates of Ottonian times is St. Bernward of Hildesheim, who is credited with making large bronze objects (Figure 15), goldsmith works, and miniatures (Figure 80) in books. The zeal of ecclesiastics for smithery is clearly expressed in the writings of about 1100 by a monk of the Benedictine Abbey of Helmarshausen:

> Henceforth be fired with greater ingenuity: with all the striving of your mind hasten to complete whatever is still lacking in the house of the Lord and without which the divine mysteries and the administering of the offices cannot continue. These are chalices, candlesticks, censers, cruets, ewers, caskets for holy relics, crosses, missal covers, and all the other things that practical necessity requires for use in ecclesiastical ceremony.[9]

Gerbert of Reims, the greatest scholar of his time who was crowned pope in 999 as Sylvester II, writing to Archbishop Egbert to request from the famed Trier workshop goldsmith works for his archbishop — from "the brother to the brother" — stated that these would "delight the eyes and the mind by the beauty of [their] form." "Your great and famous *ingenium* [genius]," Gerbert continued, after some digressions, "may ennoble our poor material by the addition of *vitrium* [glass] as well as pleasing artistic compositions," referring to the enameling for which Trier, among all other German centers, was so famed in the late tenth century.[10] Whether or not Egbert did design goldsmith works is a moot point. That he was a great art patron, though, is clearly evident and is emphasized, for example, in a miniature (Figure 16) from his own book of pericopes — selected passages from the scriptures.

An eleventh-century Guelph Treasure piece of particular relevance here, since it was both an implement of the *sacerdotum* — that is, the liturgy — and an article of the *ornamentum*, is a large ivory plaque (see Figure 17 and Back Cover), principal ornament on the binding of a precious gospel book. In the

21

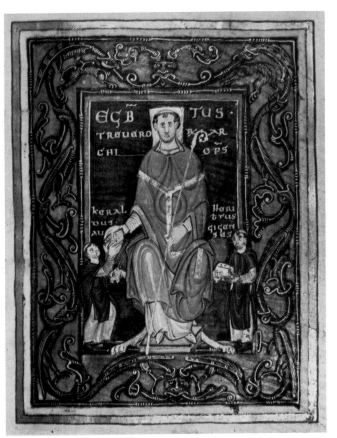

Figure 16. *Archbishop Egbert Receives the Book from Keraldus and Heribertus, Monks of Reichenau.* Tempera and gold on parchment, 10-5/8 x 8-1/4 inches (27 x 21 cm.). Germany, Reichenau (completed in Trier), ca. 985-990. *Book of Pericopes of Egbert (Codex Egberti).* Trier, Stadtbibliothek, ms. 24, folio 2v.

fourteenth century the ivory was incorporated in a book-shaped reliquary, and it is as such that it can been seen today in the collection of the Cleveland Museum.[11] The plaque depicts the Miracle at Cana in two registers within a rich frame of gilt-silver acanthus leaves. In the upper scene Mary meets her son as he approaches the house and informs him of their host's plight: the supply of wine for the wedding celebration has run low. The anxious bride and bridegroom, cup in hand, peer apprehensively from the table toward the incoming guests to whom, they fear, they will not be able to extend the proper hospitality. On the lower register, Christ, after having directed the attendant to fill the six empty amphoras with water, speaks to his mother as the miracle takes place to the surprised delight of the bride who looks over the Virgin's shoulder. The narrative is vividly underscored by the cadenced movements of the large gesturing hands of the tall figures. The spindly architecture rests precariously on twisting columns, draped with slung curtains, which plunge into or rest without inhibition on the sacred vessels, while the solidly rendered water gushes into them from the jugs in tight, sinuous swirls. Apparent here is the expressionistic intent of the carver, also conveyed by the exaggerated facial features characteristic of his style: the staring effects of eyes caused by small drill holes in the pupils, the slight downturn of the mouths, and the full lower lips over protruding chins. Particularly distinctive as well are the irregular large w-shapes engraved on the gown of the Virgin, in the scene where she is depicted greeting her son, and on the pallium of Christ when he is shown balanced on the wine amphoras. Could these be workshop marks?

The Cleveland ivory is a creative, late Ottonian reinterpretation of a Carolingian ivory plaque (Figure 18) carved in Metz around 875 after Reims models. Compared to the rhythmic and spatially integrated composition of the Carolingian prototype, the emphasis in the Cleveland ivory is on the carefully studied, nervous surface relationships between figures in the partitioned areas.

In the Ottonian period, it was customary for self-respecting members of the high clergy, as well as princes, to have one or two ivory plaques set within the binding of their gospel book. This was apparently almost a rule of fashion. The British Museum plaque, for example, was once inset in the cover of a gospel book now in Darmstadt. The Cleveland ivory — because of its dimensions, which are close to those of two recessions at the center of the oak flaps of an eleventh-century codex of a gospel book now in Paris and bearing the colophon "Framegaudo scriptores" (Figure 19) (a scribe probably active at the Abbey

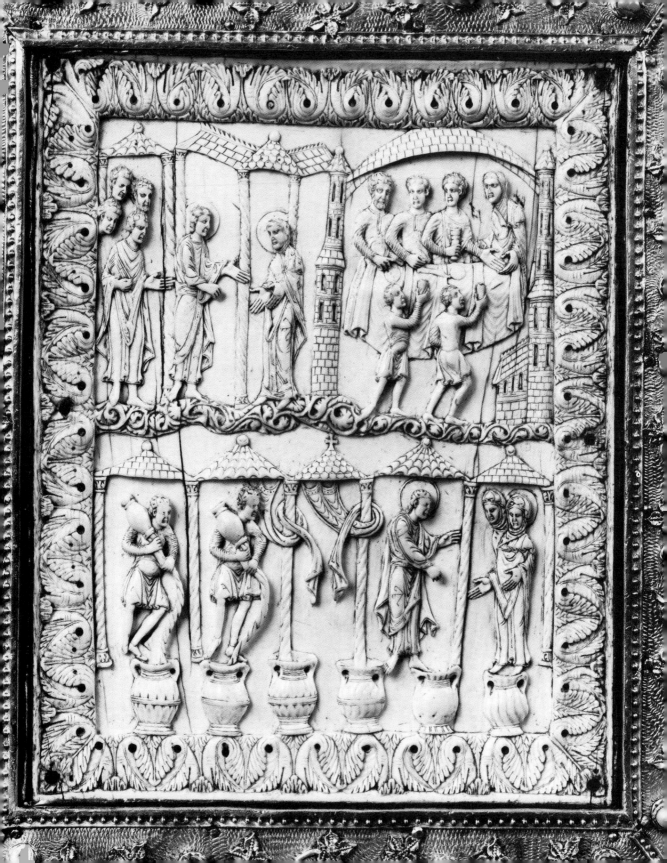

Figure 18. *Miracle at Cana.* Ivory plaque, 5-11/16 x 3-5/16 inches (14.5 x 8.3 cm.). Liuthard Group, Lotharingia, Metz, third quarter ninth century. London, British Museum, Inv. 56, 6-23.17.

Figure 19. *Binding of Gospels of Framegaud.* Oak (the parchment spine is a modern restoration), 10-1/2 x 8-3/8 inches (26.7 x 21.4 cm.). Beveled recession: 8-3/16 (7-1/2) x 6-3/16 (5-11/16) inches (20.8 [19.1] x 15.6 [14.4] cm.) with a depth of 3/8 inch (.8 cm.). France, Corbie, tenth century. Paris, Bibliothèque nationale, lat. 17969.

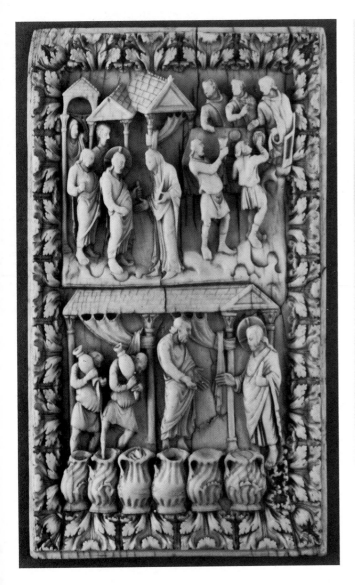

of Corbie in northern France) — was deduced by Adolph Goldschmidt in his monumental census of Medieval ivories to have once been part of this binding. Goldschmidt's matching of the plaque with this bookcover, however, in our view remains hypothetical, the closeness of the dimensions perhaps being a happenstance in a world in which the majority of the covers and their plaques have been disjoined.[12]

Ivory was a highly precious material, and yet in Ottonian times one does not have the impression that it was carved in specialized central workshops, but rather by fairly diverse groups of artists. Most of the time, therefore, little can readily be pinpointed stylistically except in terms of iconographic models. Carvers and patrons fairly consistently seem to have shared a common point of attraction: models of the Carolingian period which was seen as a golden age, culturally as well as politically. Some evidence exists to indicate that ivory carvers were first predominantly active in Trier and Fulda, and then in Liège; as the years passed, they were also to be found in Cologne, Minden, and other bishoprics. Goldschmidt in broad terms proposed a tenth-eleventh century dating and a Meuse Valley origin for the Cleveland *Miracle at Cana*. Although these positions need not be challenged fundamentally, they can be somewhat refined.

Directly bound to the Cleveland ivory is a plaque of *The Marys at the Holy Sepulchre* (Figure 20) that, despite differences in figure scale, bears many similarities in the handling of features and other morphological details, and is also engraved with those curious w-marks. Another plaque, representing the *Crucifixion* in the Victoria and Albert Museum, is characterized by many of the same traits, although here the carving is freer with figures not quite as tightly drawn.[13] The nervous aesthetics of the style of these plaques seem to be distinctively Ottonian and cannot be related in any clear manner to what is commonly held to be Mosan classicism. Ivories of the Meuse Valley of the tenth and eleventh centuries are actually those produced in Liège for the wealthy and independent prince-bishops. From all we can deduce, the first carvers active in that city came from Metz,

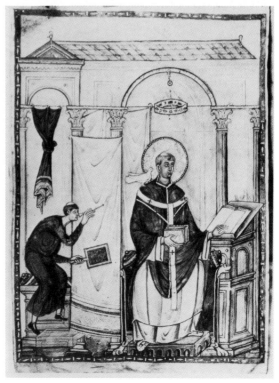

Figure 21. *Pope Gregory the Great, Inspired by the Dove of the Holy Ghost, While Peter, His Secretary, Surprised That the Dictation Has Stopped, Peers Through a Hole in the Hanging Curtain.* Tempera and gold on vellum, 8-9/16 x 7-13/16 inches (21.7 x 19.8 cm.). Master of the Registrum Gregorii, German, active in Trier, 983-84. Single leaf from a copy of the *Registrum Gregorii.* Trier, Stadtbibliothek.

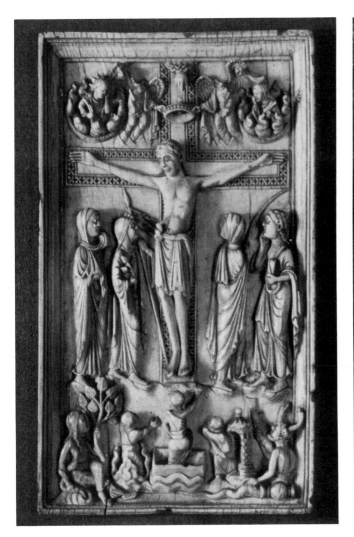

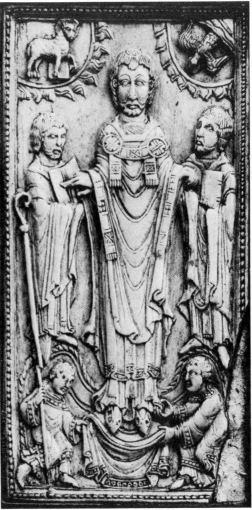

thereby explaining the particular ascendancy of Carolingian art on Liège productions. Both cities belonged to that vast region known as Lotharingia which was considerably larger than the French Lorraine of later times, including present-day Holland, Belgium, and much of the Western Rhineland. By the end of the millennium, Liège seems to have welcomed artists from other centers as well. One of them was the Master of the Registrum Gregorii, a book painter so named for a famous manuscript (Figure 21) he illuminated in Trier before his workshop was disbanded at the death of Archbishop Egbert in 993. The latter had fostered the activity in his see of several important artistic workshops, but they failed to find support from his successor, Liudolf.[14] One work attributed to the Master of the Registrum Gregorii, who also carved ivory, is the Crucifixion plaque (Figure 22) in the Church of Our Lady in Tongeren. It

26

ABOVE LEFT
Figure 22. *Crucifixion, Resurrection of the Dead.* Ivory plaque, 7-1/4 x 4-1/4 inches (18.4 x 10.8 cm.). Master of the Registrum Gregorii, active in Liège, ca. 1000. Tongeren, Church of Our Lady, Treasury.

ABOVE
Figure 23. *Bishop Sigebert of Minden and Two Deacons.* Ivory plaque, 5-9/16 x 2-3/4 inches (14 x 7 cm.). Germany, Weserraum, ca. 1030. Tübingen, Stiftung Preussischer Kulturbesitz, on deposit from the Staatsbibliothek, ms. Germ. quart. 42.

OPPOSITE TOP
Figure 24. *Presentation in the Temple* (detail of bronze doors from St. Michael's of Hildesheim). (See Figure 15.)

OPPOSITE BOTTOM
Figure 25. *Offerings of Cain and Abel* (detail of bronze doors from St. Michael's of Hildesheim). (See Figure 15.)

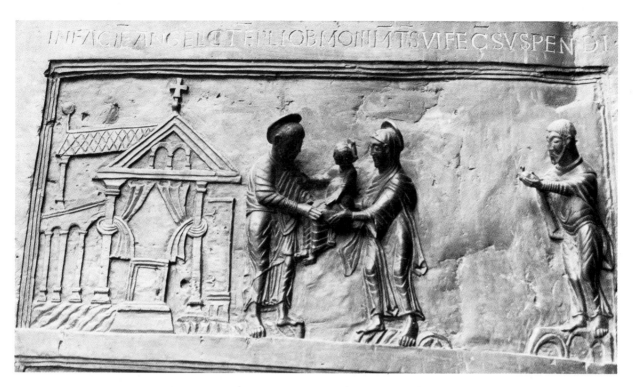

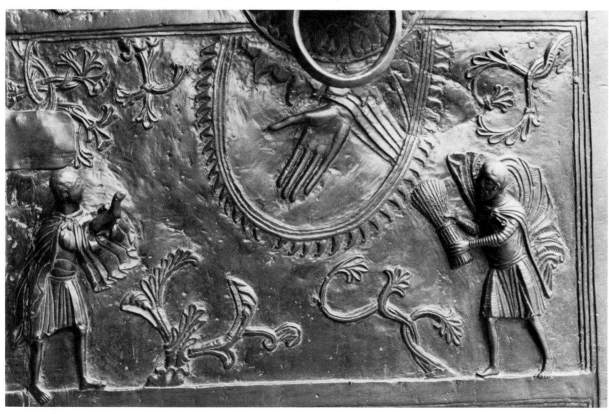

might perhaps be one of his earliest ivories produced in Liège since it reflects much less than other plaques attributed to him the influence of the classicism of Metz embraced at Liège. The elongated figures, with their flatly rendered drapery, nervous gestures, worried expressions, and drilled eyes, are echoed in a very related manner in the Miracle at Cana composition in the Cleveland Museum (Figure 17). This might suggest that the latter may either have been carved in the immediate circle of the Master of the Registrum Gregorii in Liège or else perhaps in another center, but always one reflecting the Trier-Echternach tendencies with their strong Byzantine influence due in great part to the court's — particularly Empress Theophanu's — patronage. If not in Liège or Trier, the Cleveland ivory might perhaps have been produced even much farther north, in Minden, for example, since the plaques (Figure 23) which Sigebert, the local bishop, commissioned about 1030 are also carved in a style rooted in the Trier-Echternach workshops.[15]

Despite a disparity of scale and medium, the schematized makeshift architectural backgrounds of the Cleveland *Miracle at Cana* and the vivacity of the narrative with expressively rendered figures bear a not negligible relationship of style with the scenes on the monumental bronzes doors (Figures 15, 24-25) of Hildesheim, cast between 1007 and 1015. This affinity, first pointed out by Peter Lasko,[16] in our view, however, does not shed any direct light on the relationship between the ivory plaque and the doors but rather suggests a common source which we consider to be the Trier workshops of Archbishop Egbert. It is conceivable though that the Cleveland plaque might have been acquired or commissioned by Bernward or his successor Godehard. In Hildesheim the scene of the Miracle at Cana would have had a particularly relevant iconographic meaning. Abbot Bernward, probably in the course of the years 1001-02, had received from Otto III one of the amphoras that purportedly contained the miraculous wine. Bernward had the porphyry vase, suspended at the center of a large circular chandelier, called a *corona*, made for his abbey of St. Michael. A fragment of this urn (Figure 26) is still in the Treasury of Hildesheim's cathedral.[17]

CHAPTER II

Commissions and Acquistions of the Brunons in Eleventh-Century Brunswick

Saxony is the name of the territory where the Saxon tribe once roamed. During the course of the centuries and endless political upheavals, its boundaries have shifted considerably. Before 1180, it corresponded by and large to the region (see Map) now known as Lower Saxony (Niedersachsen) in the German Federal Republic. In 843 this expanse of sprawling verdant hills had become part of the East Frankish or German Kingdom. By the early tenth century it had emerged as a hereditary duchy, and in 919 it rose to predominance when Duke Henry of Saxony, founder of the Ottonian dynasty, was elected German king. The territory of the future Brunswick, which eventually evolved into an earldom, was a fief of the Duchy of Saxony. It is reported in ancient chronicles that the site was chosen in 861 by two brothers, Bruno and Dankward (Figure 27). While Bruno provided dynastic heirs, his sibling was responsible for building the first castle, the eventual Dankwarderode, or "place of Dankward." The community which in due course sprang up was named Brunswick from "Brunos Wick," or Bruno's village. This account, mingling fact and legend, provided local rulers with an historical framework loosely paralleling the founding of Rome by two brothers.

In the early eleventh century the earldom of Brunswick was ruled by the ambitious Liudolf, who not only used his sword to extend his power and wealth but also exercised diplomacy to negotiate alliances. He secured an advantageous union with Gertrude, the daughter of the powerful count of Holland, Dirk III, and daughter-in-law of Gisela, the duchess of Swabia and wife of Emperor Conrad II. Gertrude, from all indications, brought refinement and new standards to the Brunons. At her instigation, improvements were first undertaken in the old castle. Then Liudolf and Gertrude founded a collegiate church on the adjacent ground. Dedicated to the Virgin Mary and SS. John the Baptist, Peter, and Paul, this structure was strictly meant as a family foundation and was primarily designed as sepulchral ground for the Brunons. It was consecrated in 1030 by Bishop Godehard of Hildesheim, the nearest episcopal see. Liudolf died in 1038, and he had the honor of the first tomb. By 1050 the collegiate chapter composed of some six clerics was filled, its main duty being to pray on the grave. When Countess Gertrude died twenty-seven years later, she too was buried in the church as the surviving lead fragment of her epitaph (Figure 28) attests.[18]

Though probably not possessing unlimited means, Gertrude knew that in order to bring honor to their benefactors foundations should be endowed with sacred relics enshrined in goldsmith work. With the most discerning taste, the countess commissioned three or perhaps even four pieces of the future

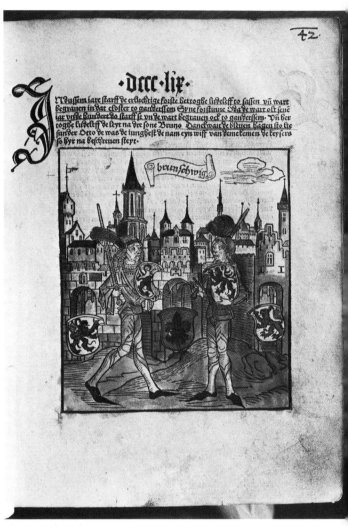

Figure 27. *Bruno and Dankward, Founders of Brunswick in 861.* Woodcut with washes, 11 x 8-1/16 inches (28 x 20.5 cm.). Monogrammist WB, German, second half fifteenth century. Konrad Bote, *Cronecken der Sassen,* 1492. Brunswick, Stadtbibliothek, ms. II/1/204, folio 42.

Guelph Treasure: two crosses (Color Plates I-III) and a portable altar (Color Plates V-IX), now in Cleveland, and perhaps also the reliquary shaped as an arm (Figures 29-31) in the Herzog Anton Ulrich-Museum in Brunswick.

Ten years before Gertrude's death, the heir to the earldom, her son Margrave Egbert I, died, leaving a son Egbert II to rule over the Brunon possessions. There was also a daughter Gertrude, who was of age when Gertrude I died and was already a widow by 1085. Little else is known about her except that she married thrice, ordered the construction of the cloister of the Benedictine monastery of St. Giles, a leading foundation of Brunswick, and became the sole heiress to her parents' possessions when Egbert II was murdered in 1090. She died in 1117. More than three centuries later, this Gertrude is spoken of in laudable terms in the *Chronicle of Saxony* as a donatrix, the passage in the volume being illustrated with a colored woodblock (Figure 32). In it, demurely dressed as a nun, she is posed against the outline of the cloister she founded, holding a large reliquary chest. This historical data will be relevant when examining the commissioning of the four objects discussed here, particularly the Brunswick arm reliquary.

That shrine (Figure 29) was made to hold an arm bone of St. Blaise, a martyr of Diocletian's time said to have been bishop of Sebastea in Armenia and venerated as a thaumaturge. The saintly bone is enclosed within a hollowed-out block of oak shaped as a raised arm on which have been applied delicately embossed gilt-silver sheets. The palm of the hand is open, the fingers extended in a combined gesture of trust and blessing as is clearly shown, for example, in one of the reliefs (Figure 25) on the Hildesheim bronze doors. The arm is represented as if clothed by the sleeve of a dalmatic, the rich sacerdotal vestment enlivened with borders and a diagonal band of stone insets and filigree work. The underpart of the reliquary bears a Latin inscription clearly ringing with the pride of the donor (Figure 31). It reads in translation "I Gertrude have had this vessel made to hold the arm of St. Blaise the Martyr."[19]

The two crosses (Color Plates I-III), which we shall differentiate as the *Cross of Count Liudolf* and the *Cross of Countess Gertrude*, are resplendent in their bejeweled gold and are constructed of beams nearly equal in length in the Byzantine tradi-

Figure 29. *Arm Reliquary of St. Blaise.* Silver, gilt-silver, cameo, sardonyx, gems, and pearls on a core of wood, H. 20-3/16 inches (51.3 cm.). Germany, Lower Saxony, Hildesheim, ca. 1075. Rings: fifteenth century. Brunswick, Herzog Anton Ulrich-Museum, Inv. MA60.

Figure 30. Detail of Figure 29.

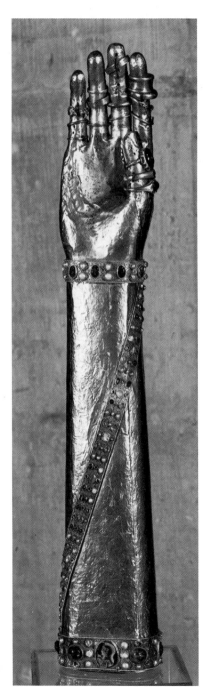

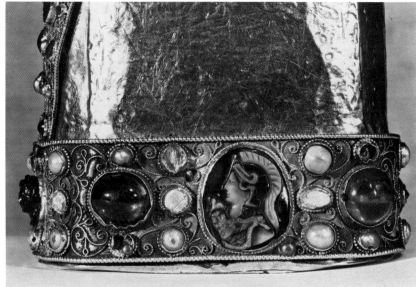

Figure 31. Base Plate of the *Arm Reliquary of St. Blaise* bearing the engraved inscription: BRACHIV̄S SC̄I BLASIIᵐ HIC INTVS HABETVR INTEGRVᵐ / GERTRVDIS HOC / FABRICARI FECIT.

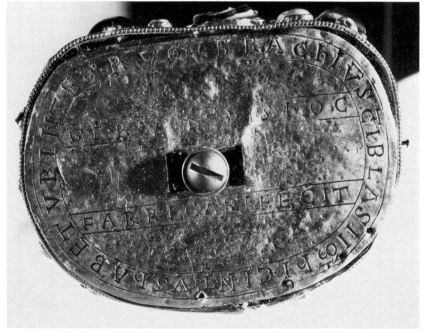

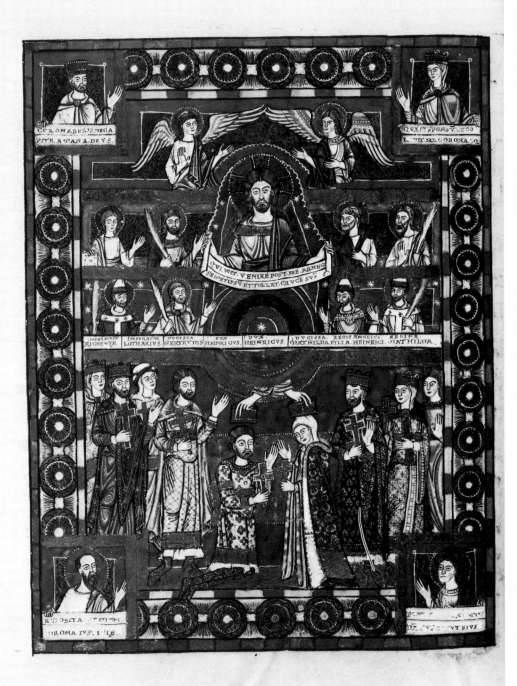

Figure 33. *Christ Flanked by Apostles and Saints; Coronation by Christ of Henry the Lion and Matilda Plantagenet.*
Tempera, gold, and silver on parchment, 13-1/2 x 10 inches (34.2 x 25.5 cm.).
Herimann, German, Helmarshausen, ca. 1185-88. *Gospels of Henry the Lion,* folio 171v.
Wolfenbüttel, Herzog August-Bibliothek.

tion. They are almost identical in design and proportion to those held by Henry the Lion, his consort, and their ancestors in a famous miniature (Figure 33) of about 1185 in the gospel book commissioned by that duke. The two Cleveland crosses consist of an oak core over which have been applied gold sheets embellished with enamel, precious stones, pearls, involved filigree, and embossing. While very similar to one another in general aspect, the crosses vary in detail as well as in the quality of workmanship.[20]

The finest of the two, Countess Gertrude's cross (Color Plates II, III B), is adorned with many precious and semi-precious cabochons — stones cut convexly and highly polished but not faceted — arranged symmetrically in gold settings. The principal ornament on each arm is an evangelist symbol — the eagle, the lion, the ox, and an angel — in cloisonné enamel. Today, only small sharp-colored particles of the fused glass paste remain, separated by their gold sectional walls, and it is the stones that now attract the eye: the epicentral almond-shaped, vertically pierced quartz crystal with its circular satellite of small emeralds, an onyx, a rock-crystal, and mother-of-pearl within the same thin border that marks the perimeter of the cross. On the arms are an onyx, a garnet, an amethyst, a sapphire, and a carnelian carved with the figure of a standing woman in classical garb, all within an array of many smaller stones. This cross actually includes no fewer than forty-eight settings for gems and pearls, the adjoining fields covered with delicate, meandering tendrils of gold filigree — a fine gold wire which has been hammered to form a string of beads. Theophilus, the German goldsmith writing a few decades after the Cleveland crosses were fashioned, described how the minute gold wires could be successfully affixed:

> take some of the fine wires, and beat them lightly on the anvil so that they are rather flat, yet the beads at the top and bottom do not lose their shape. With them you twist large and small flowers and with these you will fill all the grounds between the settings. When you have fashioned them with your fine tweezers, dip them into [a] moist paste [of flour] and set each one in position. When this is done, put them on the fire so that the paste is dried out, and immediately smear the flux over them and solder.[21]

We are further told that the proper flux for gold should be a mixture of beechwood ash, soap, salt, and a little lard from an old hog.

The less ornate reverse of the cross has an embossed gold field with the Lamb of God stamped at center bearing the crossed staff (Color Plate III B). Distributed over the four arms is a Latin

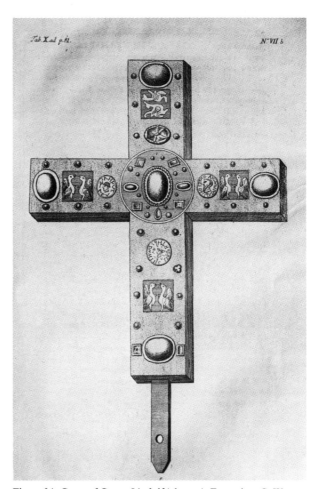

Figure 34. *Cross of Count Liudolf* (obverse). Engraving. G. W. Molanus, *Lipsanographia sive Thesaurus sanctarum Reliquiarum Electoralis Brunsvico-Luneburgis,* 1697, pl. VI.

33

Figure 35. Detail of *Beginning of the Gospel of St. Luke.* Ink, tempera, and gold on parchment. Byzantium, eleventh century. *Gospel Book with Commentaries,* folio 200. Purchase from the J. H. Wade Fund. CMA 42.152

Figure 36. *Nimbed Busts Amid Peacocks.* Cloisonné enamel medallion, Diam. 2-9/16 inches (6.6 cm.). Germany, Weserraum, early ninth century. From the *Reliquary Shrine of St. Peter,* eleventh century. Minden, Cathedral, Treasury.

inscription which translates: "For the relics of the Holy Apostle Peter and the Holy Virgin Liutrudis, Countess Gertrude ordered this made." Delicately embossed in higher relief at the bottom of the vertical beam is a three-quarter length female figure dressed in a mantle and long veil as would befit a widow or a nun. It is undoubtedly a representation of the donatrix. Her glance is directed downward, while her right hand is raised in a traditional orant gesture.

Stones and pearls make for an equally vivid impression in the Liudolf cross (Color Plates I, III A). The central massive opaque quartz is echoed by a large translucent crystal marking the end of each arm. The two beams (each 1.5 centimeters thick) were probably reset at an undetermined date and are no longer flush, the horizontal element protruding forward by six millimeters causing the circular central decoration to run awkwardly over two levels with three cabochon settings crushed and stoneless. Attesting to the Medieval admiration of the glyptic art of classical times are the three deep red stones near the central field. Crudely carved with a profile head surrounded by an inscription in pseudo-Greek lettering, these stones are obviously northern imitations of ancient intaglios.

The cloisonné enamel ornamentation of this cross, no less fragmentary than on the Gertrude cross, consists of a pair of confronting peacocks in blue, red, green, and white pastes on a square gold field in each of the four arms. The upper plaque is incongruously oriented sideways and has been in this position since at least the late seventeenth century when the cross was first reproduced (Figure 34). The peacock, a ready symbol of immortality and of Christ's Resurrection — drawn from the ancient belief that its flesh never decayed — was an iconographic motif prominently used in Byzantine art; for example, on a folio (Figure 35) in a nearly contemporary gospel book, produced in Constantinople and now in Cleveland, bellicose peacocks confront one another at opposite sides of a diminutive rendering of the Fountain of Life. In Germany a frieze of related fighting birds occurs on a cloisonné enamel plaque somewhat earlier in date and incorporated in the *Reliquary Shrine of St. Peter* (Figure 36) of the third quarter of the eleventh century, in the Cathedral Treasury of Minden. The predominance of such a motif on the Liudolf Cross, however, is unmatched on any other German cross of the period.

The reverse of this cross (Color Plate III A) attests to its frequent handling. The delicately embossed work is so worn and battered that it is no longer easily read. In the central field stands the Lamb of God with the cruciform halo and bearing the crossed staff. It is nearly identical to its counterpart on the Ger-

trude cross (Color Plate III B), although in a reversed position. A symbol of the evangelists within a circle figures at the end of each beam, while in the narrow fields above and below the Lamb are two inscriptions. The first translates: "Relics of the saintly bishop Valerius and of Pancratius, martyr [and] of the stones which laid on the tomb of our Lord," referring to small relics which were once probably located under one of the enamel peacock plaques. The second inscription states: "This Gertrude has made for [the salvation of] Count Liudolf's soul."

35

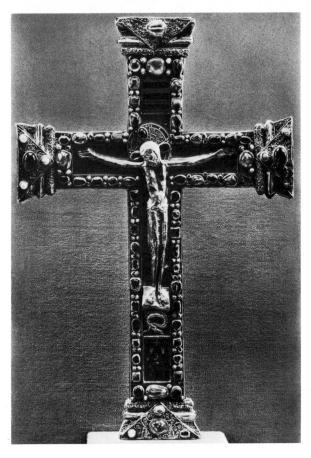

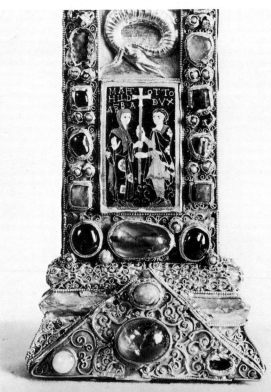

In addition to being reliquaries, the two crosses served obvious funerary and dynastic commemorative purposes. Judging from the pierced iron extension at the base of each, they were intended to fit on long staffs and be carried in ritualistic ceremonies. A similar cross is held by Abbess Matilda of Essen and her young brother Duke Otto of Swabia as depicted at the foot of the large and magnificent cross which this abbess commissioned for her monastery around the year 980 (Figure 37). On other occasions such crosses may also have been placed on an altar. Devoid of the figure of the crucified Christ and shimmering with the multiple fires of their stones and the brilliance of their filigree, such crosses would have attained in the reddish glow of torch lights and the flicker of candles a marked transcendental symbolism.

Higher in its artistic conception, and distinguished by its more exacting workmanship, is the portable altar (Color Plates V-IX) bearing the inscription: "To live in the peace of the Lord, Gertrude presented to Christ this stone glistening with gold and gems." This dedication, unlike that on the Gertrude Cross, does not specify the rank of the donor, but in exalting the omnipotence of God, it clearly magnifies the privileged relationship enjoyed by the noble woman.[22] The use of portable altars had been codified by the Council of Carthage of 401 as a consecrated stone containing a holy relic on which mass could be performed by the clergy. The obvious advantage of a portable altar was that it could be easily transported and used for performing the service outside of a church. The presence of several such liturgical furnishings in the Guelph Treasure suggests that some might have been commissioned by rulers of the House of Saxony for use during their multifarious travels and then, on account of the magnificence of the objects and the relics they enshrined, given to the treasury of their foundation. Portable altars on occasion also assumed the value of ex-votos, due to their small scale and exceptional importance as cult implements. From all appearances, they were then used in churches during special occasions.

Judging from its inscription, which is clearly dedicatory, the portable altar bearing the name Gertrude appears in fact to have been intentionally made for placement in the collegiate church. It is a reduction of an actual altar and is among the earliest known of this shape which became generalized after 1100. It consists of a rectangular red porphyry slab (Color Plate V) inset in a gold-covered oak casket serving as reliquary chest. Among all other semi-precious materials, porphyry was particularly rich in symbolism; its very color recommended it to the cult of martyrs and saints and associated it with imperial

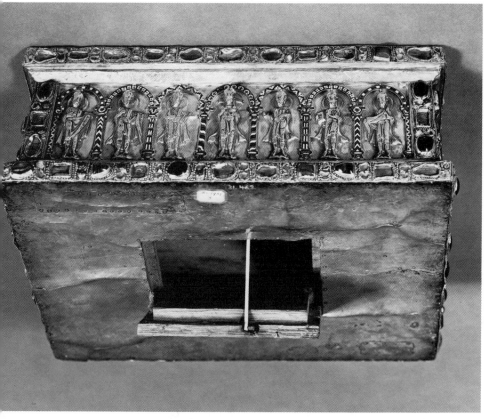

Figure 38.
Base of
*Portable Altar
of Countess Gertrude*
with trapdoor
(CMA 31.462).
(See also
Color Plates V-IX.)

and princely power. Quarried in Lower Egypt until the fifth century, it had been widely used in antiquity. The Middle Ages also valued this hard stone for the chromaticism of its feldspar crystals embedded within the compact purplish ground. When porphyry was available in Ottonian and Romanesque times, it was invariably in the form of an object from antiquity (Figure 26) or as a fragment of an antique monument. The origin of the gleaming stone which crowns the shrine in Cleveland must be no exception to this rule.

At center of the base plate of the portable altar under a sheet of silver, is a trapdoor leading to a hollow cavity (Figure 38). The wooden core by and large seems to have been partly restored or changed in past centuries, while the lock on the small trap door does not date earlier than the eighteenth century. When recently opened for the first time since it entered the Museum, the portable altar revealed a series of small, fabric-wrapped bundles containing bone fragments and a stone (Figure 39). The textiles are Medieval, at least one silk is thirteenth-century Spanish, while others have, it would appear, a Byzantine origin. On some of them are sewn small parchment labels in a fifteenth-century script identifying the bones as those of: (A) St. Hermetis, (B) St. Adelaide, (C) St. Vincent, martyr, (D) St. Gertrude,

and (E) St. Marcian, martyr. The bundle (F) consists of ten unidentified tiny individual packets which, according to the 1482 inventory, contain relics of SS. Stephen, Sophie, Perpetua, Paul, Barnaba, Philip, Simon, Thaddeus, John the Apostle, and James; (G) is a chip of unpolished marble in felt-like white paper identified in 1482 as a fragment of the block used to support the Holy Cross on Mount Golgotha; (H) is an unidentified fragment of an arm or leg bone which the 1482 document suggests to be that of St. Gregory; (I) is an unidentified hip bone, perhaps a relic of St. Januarius in light of the same inventory; (J) is an arm bone identified as St. Bartholomew's.

The surface of the portable altar gleams with embossed gold figures, cloisonné enamels, pearls, mother-of-pearl shaped as pearls, and polished stones. It is unrivaled for its richness among early portable altars. The shrine may once have been raised on claw feet as the St. Andrew portable altar (Figure 13) of Trier, but the corners of the base oak plank — conceivably not the original — do not show signs of perforation. At the top (Color Plate V), the porphyry slab is framed within three bands of gold, slightly restored in the fourteenth century as well as at a later date. The inner and outer borders are decorated with fine filigree work shaped as tendrils, while the central one bears the

37

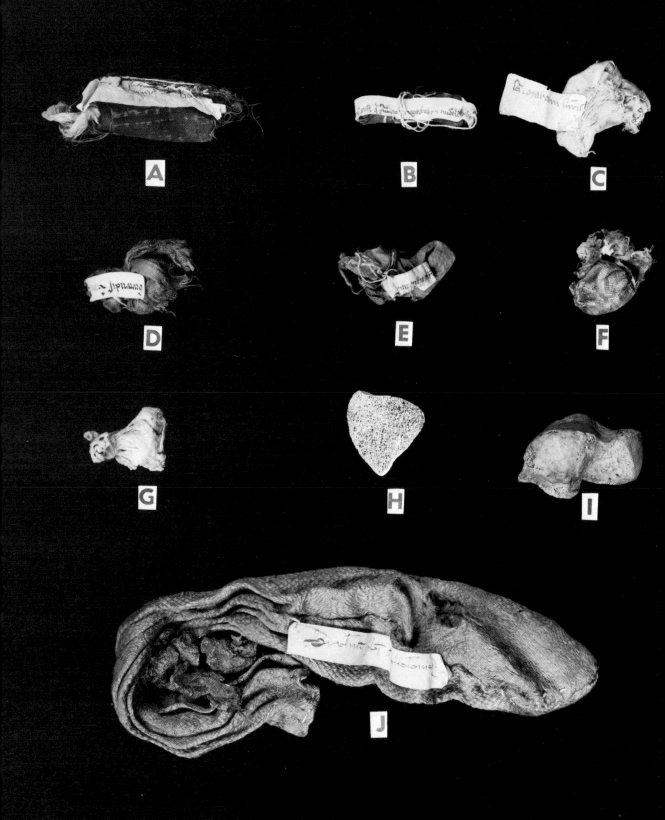

conspicuous, engraved dedicatory inscription inlaid with niello — a sulphur alloy which turns black when fused in fire and serves as legible contrast against the gold field. Particularly striking are the four friezes with embossed figures, each standing on its own small base, which surround the mensa. Enframed by gold borders of filigree work, cabochons, and pearls, each frieze was fashioned by embossing, that is hammering a sheet of gold from the underside to espouse the general desired form. No seams or folds are detectable on any of these surfaces despite the strong outward projection of shapes, especially faces — a feat of consummate craftsmanship. The delicate reliefs were subsequently chiseled while applied to a wooden base carved with a fair degree of attention to modeling and detail. A few miniscule losses of gold on the cloaks and base of the figures clearly reveal the presence of wood, identical in grain to that visible where the cabochon stones are missing. The fact that such a solid carved matrix was used accounts in large part for the near pristine condition of the reliefs, in contrast to most other embossed works of the period which have a more malleable and easily built wax support.

The front panel (Color Plate VI) is divided by seven rounded arches supported on columns. This applied arcade of perfectly preserved cloisonné enamel in a combination of four different geometric designs, shelters Christ, Peter, and five other apostles. These, like sturdy Saxon warriors, are figures with large bearded faces, staring eyes, long broad noses, and heavy jaws. Their inarticulate bodies are clothed in loose layers of garments and a mantle that flutters gently as if blown by a sudden breeze. Peter holds two keys, the other unidentified disciples, a codex or a scroll. The six apostles turn slightly and gesture toward the frontal Christ, forming a balanced group, monumental in its simplicity.

The rear panel (Color Plate VII) is enframed by an embossed gold rather than enameled arcade. At center is the Virgin, austere in mood, with hands raised in an orant gesture; six apostles are symmetrically distributed on either side of her. If the craftsmanship of this panel is no less adept, the general conception and modeling of the figures is somewhat less successful, as if deriving from those on the front side.

The field of each narrow end is in turn divided by a set of five applied arches. Those on the right side (Color Plate VIII) bear nielloed inscriptions and are supported on nielloed patterned columns. Under the central arch, inscribed SANCTA CRVX, is a cloisonné enamel cross. In the arches flanking the cross appear four historical figures, venerable for their sanctity: Emperor Constantine the Great and his mother St. Helena, Sigismund,

the sixth-century king of the Burgonds who brought his people to Christianity, and St. Adelaide, wife of Emperor Otto I, all attired in regal togas and turning to the cross with a slight bow, their hands gesturing to denote a deeply felt emotion. These expressively modeled figures were undoubtedly produced by the master responsible for the front relief. The applied arches and supporting columns on the left end (Color Plate IX) are decorated with niello patterns. St. Michael, treading on the vanquished dragon, presides, assisted by four angels, staves in hand. The goldsmith who fashioned the back panel with the Virgin and apostles was responsible for this relief.

Although perhaps enigmatic at first, the iconographic program of the portable altar is actually a rather focused one. Its message is simple: it propounds ideals of the saintly noble widow, and thus strongly implies that the altarpiece was commissioned by a woman who clearly related to this state. The Virgin, often likened in pious homilies to a widow after the Passion, appears here (Color Plate VII) as if in a state of doleful mourning. On the short right side (Color Plate VIII) only two figures are identified as saints: Helena and Adelaide. Helena, whose faith was so instrumental in her son Constantine's becoming the first Christian emperor and whose sanctity made possible the finding of the True Cross, had lived in Germany, founding the first cathedral church of Trier when that city was the capital of the Roman Empire north of the Alps.

No less purposeful than Helena in the iconographic scheme of the altar is Adelaide, a Burgundian princess by birth and therefore one of Sigismund's descendants. She was an outstanding aristocratic figure widely venerated in the archbishopric of Magdeburg on which depended the sees of Hildesheim and Halberstadt, ruling over the Brunswick region. Married to Otto I, the great emperor, and after his death regent of the empire, Adelaide, of whom a relic is contained within the portable altar (Figure 39B), was hailed for her piety, generosity, and forgiveness. Adelaide died in 999, but her memory lingered on vividly, soon giving rise to a cult in north German convents. The fact that she was not canonized until 1097 might suggest that the portable altar, which bears the clear and evidently not added nielloed inscription SCA ADALHEID (Color Plate VIII), should not be dated any earlier than 1097, and that by extension the inscribed name GERTRVDIS refers to Gertrude II. It should, however, be noted that before the twelfth century, local archbishops and bishops had the power to accept or officially recognize sanctity in venerated individuals before their formal canonization in Rome, so long as the cult was only promulgated in territories over which they held jurisdiction. It was a form

RIGHT Figure 40. Fragments of Goldsmith Work from the Hildesheim *Gold Madonna*. Gold, gems, and pearls. Germany, Lower Saxony, Hildesheim, ca. 1030. Hildesheim, Cathedral, Treasury.

FAR RIGHT Figure 41. Wood Core of *Enthroned Madonna and Child,* originally covered with sheet gold ornamented with filigree and gems, H. 22-1/4 inches (56.5 cm.). Germany, Lower Saxony, Hildesheim, ca. 1040. Hildesheim, Cathedral, Treasury.

of equivalent canonization. When actual canonization did take place, the cult became universal as well as obligatory. Many saints, some of high lineage, were indeed venerated before their formal canonization as, for example, the nearly contemporary King Stephen of Hungary.[23]

Though varying in degrees of quality, the four Guelph Treasure objects here under study bear enough common points of technique and general aesthetics to suggest that they were produced by a group of goldsmiths all related to a single workshop tradition, and were made in the following sequence: the Liudolf cross, the Gertrude cross, the portable altar, and last, the St. Blaise arm reliquary. The fine filigree on these pieces is particularly striking among German eleventh-century goldsmith works. Especially distinctive and similar in thickness and design is the gold thread on the two crosses and on the portable altar with its elegant, controlled heart patterns, diamond-shaped leaves, and small tendrils. The wire on the arm reliquary is thicker and somewhat less successful in layout with a busier design which also lacks the particularly appealing diamond-shaped leaves.

The death of Count Liudolf in 1038 provides a *terminus post quem* for the cross bearing his name (Color Plates I, III A), while the death of his widow in 1077 in turn provides a clear *terminus ante quem* for it. It stands to reason that the cross as an intercessory object would have been made soon after the count was buried. So close is the stylistic relationship of the two crosses that it must be Liudolf's widow who also commissioned and is represented on the other cross. The cross made for Liudolf's spiritual welfare probably slightly preceded Gertrude's own, but both, then, were most likely made soon after 1038. Taking into account the rigidity of Medieval social codes clearly respected in the scheme of the portable altar, it would also indeed be unthinkable that Gertrude I would have commissioned an object bearing only her name unless she were already a widow.

The portable altar, as we have seen, with its iconography of the saintly noble widow is particularly befitting Countess Gertrude I. In addition, it so clearly relates to the two crosses that it seems stylistically indissociable from them and must date to a period close in time. Gertrude II was only widowed for the first time in 1085, a dating which would seem rather late on stylistic grounds for the altar. Of course, the alternative of placing its production after Adelaide's formal canonization date of 1097 would present an even greater hiatus in terms of style.

The arm reliquary (Figure 29), both on stylistic grounds and on the basis of its inscription, can be dated as late as Gertrude I's death or even shortly thereafter. There is, therefore, no clear

gauge for assessing whether she or her granddaughter might have been responsible for this particular commission. Though not actually supported by documents, Gertrude II, as pointed out, is also remembered in Saxon history as a donatrix of goldsmith works.

The *where* of these four commissions is nearly as tantalizing as the *who* and *when*. Located at the point of the Oker at which it ceased to be navigable, Brunswick was a crossroad and as such more than an occasional trading center. It was not yet a town, however, in the eleventh century and hence would not have fostered skilled craftsmanship. The countesses therefore had to look beyond their immediate territories to commission rare goldsmith works.

Henry II's reign, ending in 1024, had set the stage for an unprecedented outburst of activity in the field of smithery. The emperor, a Saxon, had ordered works from leading craftsmen for his many foundations, particularly that of Bamberg. His commissions, as his travels, however, were distributed over a wide geographical area, although St. Gall and nearby Reichenau on the Lake of Constance may have been more particularly favored. After 1024, with the reign of Conrad II and Henry III, Cologne and its satellites on the Lower Rhine and Saxon centers — mainly Hildesheim but also Magdeburg, east of Brunswick, Quedlinburg to the south, and Gandersheim to the southwest, all sites of large wealthy convents closely tied by their foundation to the imperial seat — were favored with court patronage in return for their political support and loyalty. These convents had a particularly important stature since many of their nuns were members of the nobility. The shift north and west strongly affected the artistic production of the third and subsequent decades of the eleventh century, corresponding particularly to Countess Gertrude I's patronage. As in the case of ivory carvers, there was a fair amount of mobility among the skilled goldsmiths who worked for the imperial convents and the court circle, but in their case the necessity of a physically established workshop furnished with furnaces, specialized tools, and equipment was of paramount importance. Hildesheim, located some thirty miles from Brunswick, and whose bishop consecrated the collegiale, had been a center of metalsmithing since the end of the ninth century and received an even greater impetus in this direction in the tenth century under St. Bernward. Besides the great bronzes (Figures 15, 24-25, 53), Bernward had ordered a number of reliquaries, a gilt-silver nielloed candlestick, a silver bishop's crozier, and other implements. His successors Godehard, Azelin, and Hezilo continued in this noteworthy tradition though on a more modest scale.[24]

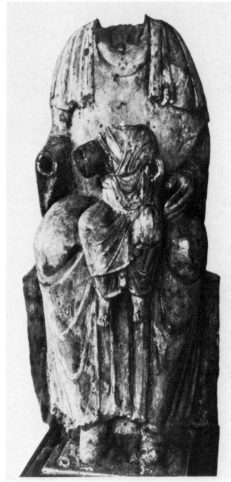

A Hildesheim provenance for the two crosses and for the portable altar in Cleveland is supported by actual stylistic evidence. The filigree of these three objects finds a particularly apt ground of comparison in two small gold elements (Figure 40) with identical heart shapes and squared-off tendrils originally part of the Hildesheim *Gold Madonna*, a famous votive figure once resplendent with goldsmith work before it was vandalized in the Baroque period and reduced to a sad wooden core (Figure 41). In its heyday it was no less renowned and venerated than its better-known counterpart in Essen.[25] The Hildesheim *Gold Madonna* was made around 1040, providing another element for a rather early dating of the Cleveland crosses and portable altar and confirming their probable commission by Countess Gertrude I. A Hildesheim provenance for Gertrude's portable altar would explain the presence of St. Michael on the left side panel (Color Plate IX). The archangel was particularly venerated in that town where St. Bernward had dedicated to St. Michael the monastery to which he destined much of the great art work he had made.

The filigree work of the *Arm Reliquary of St. Blaise* (Figure 30) can similarly be clearly equated to that of an important Hildesheim-made object: the so-called *Great Cross of St. Bernward* (Figure 42) which holds the relic of the True Cross given by the emperor to the saintly bishop. As demonstrated by Hermann Schnitzler, the cross for the most part was not fashioned until late. The late eleventh century rather than the twelfth as he proposes, however, seems a more probable time. The small gold crucified Christ — close in style to the figures on Abbot Erkanbald's crozier made on order of Bernward around the year 1000, which the cross also incorporates and which has been interpreted by another historian as actual proof of the bishop's commission — represents, in fact, but a memento of Bernwardian times.[26] In both the Brunswick arm reliquary and the Hildesheim cross, the cabochons are similarly surrounded with rather thick gold thread with comparatively strong beading. It may also be pointed out that arm-shaped reliquaries seem to be a late eleventh-century development among shrines; identifying the patron of the St. Blaise shrine securely as Gertrude

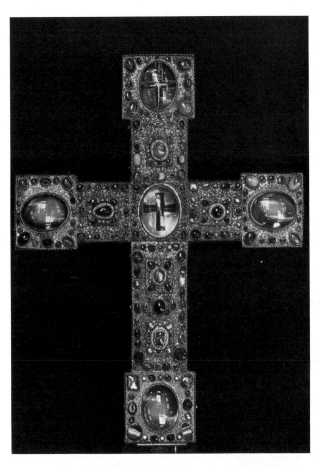

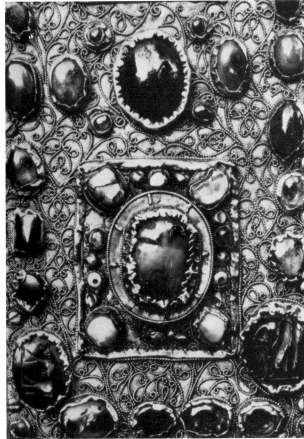

Figure 42. *"Great Cross of St. Bernward."* Gold, gems, crystal, and pearls on a core of oak, H. 18-7/8 inches (48 cm.). Germany, Lower Saxony, Hildesheim, ca. 1070 with later addition and restorations. Hildesheim, Cathedral, Treasury (on deposit from the Kirche St. Magdalenen).

Figure 45. *Mary Magdalene,* or perhaps *Funerary Monument of an Abbess.* Limestone. Germany, Lower Saxony, eleventh century. Gernrode, Former Convent of St. Cyriacus.

I meets with substantive impediments on this count as well.

The two commemorative crosses and the portable altar of the Countess of Brunswick, as in the case of the ivory plaque of the Miracle at Cana, hark back in conception to a group of objects of distinctive quality produced in Trier in the late tenth century for Archbishop Egbert, a granduncle of Count Liudolf's wife. Imperial chaplain as well as chancellor, he fostered, as we have seen, the activity of artists in his see and among them, goldsmiths. It may well be that the success of Trier as an art center depended nearly as much on the inspiration provided by that great artist, the Master of the Registrum Gregorii, as on Egbert himself.

Empress Theophanu ordered noteworthy pieces of goldsmith work from Egbert's workshop, and such was the fame of Trier that Archbishop Adalbero of Reims, as we have seen, requested objects made in this center all the way from the French realm. In Trier were fashioned the *Portable Altar and Reliquary of St. Andrew's Sandal* (Figure 13), the *Reliquary of the Holy Nails*, the *St. Peter Staff* which enshrines another nail of the Passion, the resplendent binding (Figure 43) of a gospel book — the *Codex Aureus* — and probably the small rectangular plaques with the symbols of the evangelists (Figure 44) in cloisonné enamel now in the Victoria and Albert Museum.[27]

A striking element of the Trier pieces is the inclusion of small luminescent cloisonné enamels which are, however, always carefully subordinated to the form of the object. The eight enamel plaques on the two crosses commissioned by Countess Gertrude (Color Plates I-II) bear a clear relationship to the delicate enamels of Trier, particularly those on the *Portable Altar and Reliquary of St. Andrew's Sandal* (Figure 13), as well as to the small plaques in the Victoria and Albert Museum (Figure 44). Though fashioned with artistry and care, the plaques of Gertrude's crosses betray a limited knowledge of the enameling technique on the part of the craftsmen, probably Saxons, who fashioned them. A shallow layer of enamel was distributed on too thin a base of gold and between equally delicate walls, the whole resulting in great fragility and the eventual loss of much of the colorful decoration.

The delicate embossed work of the crosses (Color Plate III) — particularly the figure of the countess with the accompanying inscription seen against the smooth gold ground without ornament and primarily defined by line rather than modeling —

OPPOSITE LEFT
Figure 43. *Empress Theophanu.* Gold, gilt-silver, cloisonné enamel, and gems on a core of wood. Germany, Trier, ca. 990. Detail of binding of *Codex Aureus (Golden Gospels of Echternach).* Nuremberg, Germanisches Nationalmuseum, Inv. KG 1138.

OPPOSITE RIGHT
Figure 44. *The Eagle, Symbol of John the Evangelist.* Gilt-copper with cloisonné enamel, 2-1/4 x 2-3/16 inches (5.7 x 5.3 cm.). Germany, Trier, late tenth century. London, Victoria and Albert Museum, M517-1924.

43

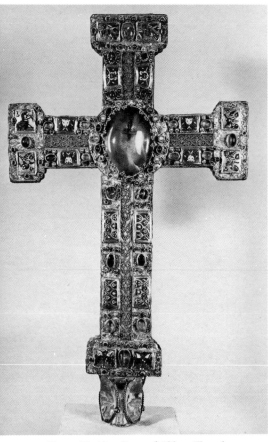

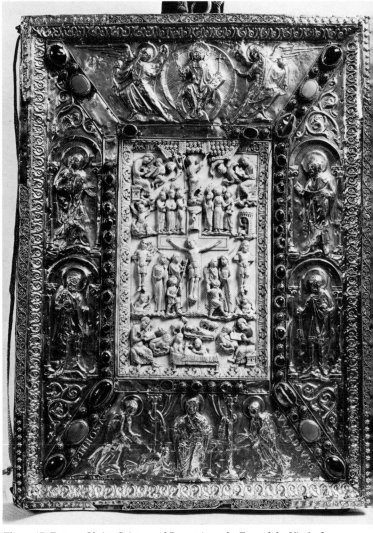

Figure 46. *Altar Cross of Abbess Theophanu.*
Gold, enamels, gems, and pearls, H. 17-1/2
inches (44.5 cm.). Germany, Abbey of
Werden(?), ca. 1040 with later additions.
Essen, Cathedral, Treasury.

Figure 47. Frame: *Christ, Saints, and Donatrix at the Feet of the Virgin.* Ivory:
Ascension, Crucifixion, and Nativity. Gold, gems, pearls, and ivory on a core of
wood, 14-1/16 x 10-1/4 inches (35.7 x 26 cm.). Germany, Abbey of Werden(?), ca.
1050. *Gospel Book of Abbess Theophanu.* Essen, Cathedral, Treasury.

is closely related in technique to the delicate reliefs of the *St. Peter Staff* and the *Codex Aureus* (Figure 43) where Empress Theophanu is represented frontally in Byzantine style, not unlike Theodora in the famous mosaics of San Vitale in Ravenna, surrounded by an embossed inscription identifying her as donatrix. The countenance of Countess Gertrude is obviously more subdued, her glance less direct. If the goldsmith studied Trier works, he was, however, not slavishly dominated by them. Instead, he looked to forms with which he was familiar and

which were appropriate in the Saxon mid-eleventh century context, such as the contemporary Mary Magdalene carved figure (Figure 45) on the exterior of the Convent Church of St. Cyriacus at Gernrode near Quedlinburg in Saxony.

Around 1040, when also ordering a great cross (Figure 46), an impressive reliquary, and a sumptuous binding for a gospel book (Figure 47), Empress Theophanu's granddaughter, of the same name, on becoming abbess of Essen — a House founded in the ninth century by Bishop Altfrid of Hildesheim and

Figure 48. *Second Cross of Abbess Matilda.* Gold, enamel, gems, and pearls on a core of wood, H. 18-1/8 inches (46 cm.). Germany, Abbey of Werden(?), beginning eleventh century. Essen, Cathedral, Treasury.

Figure 49. *Votive Cross of Berengar I.* Gold and gems, 9-1/4 x 9-1/16 inches (23.5 x 23 cm.). Italy, Lombardy, ninth century. Monza, Cathedral, Treasury.

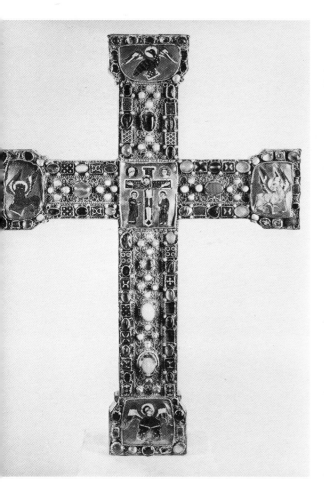

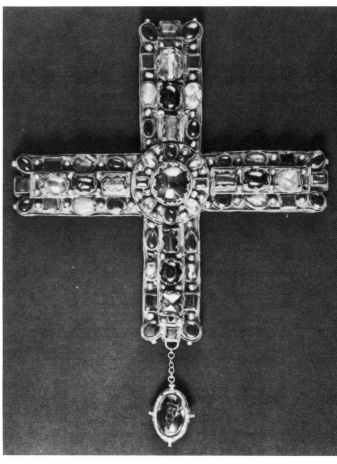

restricted to women of noble blood whose main purpose was to rear children of high lineage—rivaled the generosity of her predecessor Abbess Matilda. The latter, fifty years earlier, had commissioned three large crosses from a workshop apparently active at the nearby Benedictine Abbey of Werden rather than in Essen proper.[28] This group of goldsmiths was clearly atuned to the abstract effects and technical feats of the Trier School, while certainly aware of the Colognese style with its softer and somewhat lyrical forms. As a whole, the four bejeweled crosses commissioned by Abbesses Matilda and Theophanu show a marked progression toward surface abstraction, an aesthetic

evolution worthy of note when reflecting on the Cleveland crosses. The earliest of the three large crosses of Abbess Matilda (Figure 37), dating to about 980, and on which she is represented with Otto of Swabia, bears a large figure of the Savior surrounded by orderly rows of stones. This representation of Christ, fashioned in the Colognese style, is modeled after the *Gero Crucifix* of 970-76 in the Cathedral of Cologne. Matilda's second and third crosses (Figure 48) show a marked reduction in the size of the crucified figure at this stage represented on a small enamel plaque, in direct proportion to a new emphasis on greater and more colorful ornamentation. The entire field of

45

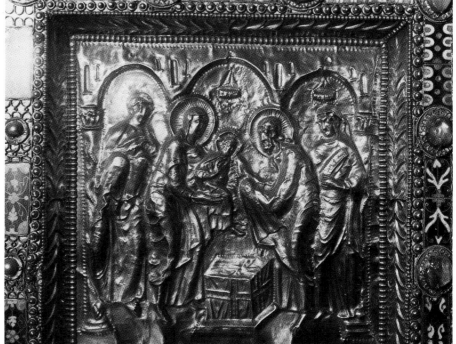

Figure 50. *Presentation in the Temple* (detail of *Paliotto*). Gold, silver, and enamel. Italy, Milan, ca. 850. Milan, Sant'Ambrogio.

Figure 51. *Christ Between Gabriel and Raphael and SS. Michael and Benedict.* Gold and niello on a core of wood, 39-3/8 x 70-1/16 inches (100 x 178 cm.). Germany, ca. 1022-24. *Golden Altar Frontal of Basel Cathedral.* Paris, Musée de Cluny.

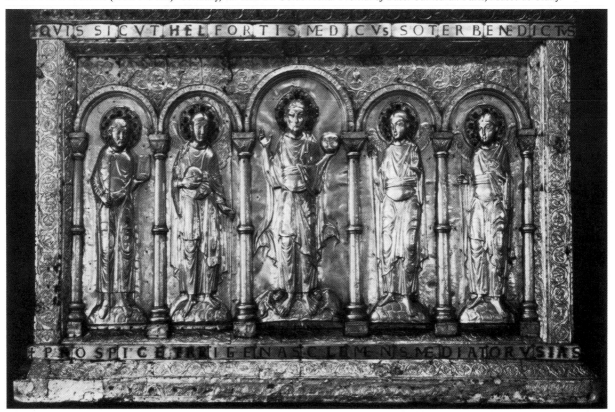

Theophanu's cross (Figure 46), as well as of the reliquary and book cover she commissioned, is given to rich patterns comprised of large glowing stones on bands of gold with rich filigree, and small enamels with stylized animal forms set sideways rather than perpendicularly in a manner similar to the upper peacock plaque of the Liudolf cross. These precious objects were also the work of goldsmiths temporarily active at the Abbey of Werden and the true heirs of the Trier School and who may have worked earlier in Milan, as we shall see. The binding of Abbess Theophanu's gospel book (Figure 47), which can be dated between 1039 and 1056, provides yet another gauge with its delicately embossed reliefs with standing figures on bases under arcades. The two crosses commissioned by Gertrude I (Color Plates I-III) are certainly part of the new aesthetic, yet they do not reach the degree of involved surface abstraction of Theophanu's objects, perhaps a useful element for corroborating the dating of the two Cleveland crosses to shortly after 1038. Despite a close technical relationship to contemporary German goldsmith works, the two crosses commissioned by the countess very conservatively retain both the Greek shape and the personal quality of jewels, centered on a gleaming roundel, sanctified by a long tradition of princely patronage, and clearly seen in the ninth-century *Votive Cross of Berengar I* (Figure 49) in the Monza Cathedral Treasury.

Gertrude's portable altar derives in general outline from those large altars built in churches over the relics of martyr saints. Again, the classic antecedent of such reductions might seem to be a Trier one, the *Portable Altar and Reliquary of St. Andrew's Sandal* (Figure 13), though the direct model might be Byzantine. Indeed, the conception behind the actual layout of Gertrude's portable altar seems to derive from adaptations of Byzantine works first evolved in North Italy by the Lombards with the great *Paliotto* (Figure 50) of Sant'Ambrogio in Milan dating to ca. 850 standing as the prime example and source of inspiration for prominent intermediaries such as the great gold altar front (Figure 51) given by Emperor Henry II and his wife Cunigonde by 1019 to the Cathedral of Basel, and perhaps also for the lost *pala* of Bishop Bernward at Hildesheim.[29] In Henry II's antependium, arcades shelter full-length figures heralding the architecture and layout of Countess Gertrude's portable altar. Although embossed, the figures gracing the imperial gift, with their frontal stance and suspended animation, are still elements of a decorated surface in the time-honored Ottonian tradition. In contradistinction, the figures of Gertrude's altar are solid and pivot, as do those on the binding of Abbess Theophanu's gospels (Figure 47), in order to relate to a central image.

Of likely importance is the role of Magdeburg in the conception of Gertrude I's portable altar. Although Adelaide's tomb was not there but in her native Burgundy, it is in the cathedral which stood as his great foundation; that Emperor Otto I, her husband, was buried. The documentary evidence for Magdeburg is scanty in the eleventh century, but we do know, for example, that Archbishop Engelhardus (1052-1063) commissioned several pieces of now lost goldsmith work including caskets and the cover for the *Codex Wittekindeus* with images in gilt-silver set with gems and the dedicatory inscription ENGELHARDVS ARCHIEPC ME FIERI IVSSIT in a formula similar to that of the dedication on the cross of Countess Gertrude (Color Plate III B).[30] Perhaps on account of its strong imperial connection, the archbishopric also had substantial contact with Italy, where sculpture, unlike in Germany, was widely practiced as an art. Remains of monumental Ottonian carvings at the Cathedral of Magdeburg (Figure 52), rare examples of German large-scale three-dimensional art of the period, though frieze-like, show bodies twisting in their animation as well as possessing some sense of bulk.[31] The program of Countess Gertrude's portable altar as well as the nascent Romanesque layout of its friezes might thereby imply a Magdeburg influence. The strong features given to some of the figures in addition suggest that the master goldsmith had a hard look at the bronze column (Figure 53) — adapted, with christological subjects, from the one of Trajan in Rome — cast in Hildesheim about 1010 before he started what was always to be considered a major and unique piece of art in the Guelph Treasure. In the fifteenth century the shrine was displayed on major occasions in the Brunswick church with a reliquary on it of no less significance than that containing a fragment of the skull of St. Blaise (see Figure 152).[32]

Witness to the fortunes and upheavals of the Brunons, their collegiate church slowly flourished in the shadow of Dankwarderode. In the later years of the eleventh century, as if emulating the ruling family's sumptuous gifts, the canons also contributed to the wealth of the foundation, a largess not uncommon among clerics of the time. Two rather modest portable altars in the Guelph Treasure are evidence of these generous acts, both shrines deriving in their general form from Countess Gertrude's resplendent example. The earliest (Figure 54), dating perhaps to around 1075, is somewhat smaller than its model but likewise enlivened with embossed figures of Christ and the apostles, each also on a base and in an intercolumniation but gesturing in a contrived manner. Rank provincialism marks the craftsmanship of the work, perhaps produced by one of the officiants of the collegiale. The second portable altar, which still contains

Figure 52. *Beatitudes.* High relief limestone figures. Germany, Magdeburg, early eleventh century. Magdeburg, Cathedral.

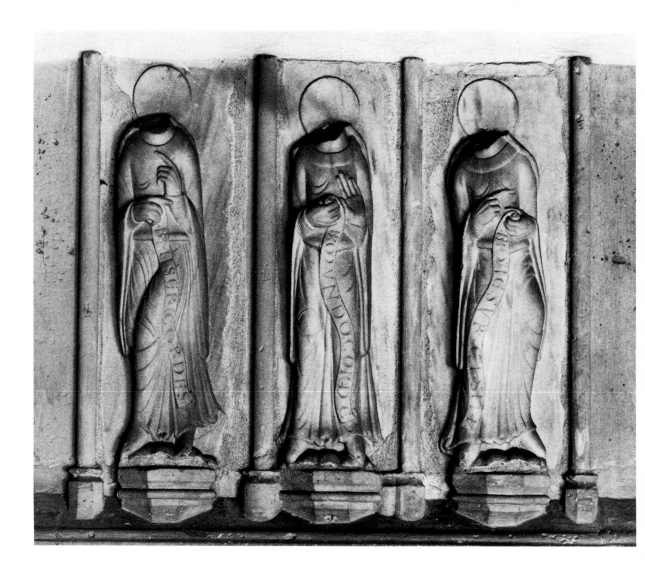

many precious relics, though it is devoid of figural decoration, bears an inscription which states that it was presented by Adelvoldus, the first known head deacon of the foundation who died in 1100.[33] These objects are a clear indication that through the eleventh century Brunswick did not have an established metalsmithing tradition.

The landmarks that firmly dated objects provide are rare occurrences in Medieval goldsmith works. A Saxon document of 15 August 1100 represents the evidence for such a milestone. In a deed bearing that date, Heinrich von Werl, Bishop of Paderborn, grants to the Abbey of Helmarshausen a church as well as tithes in retribution for a gold cross and a reliquary chest made for him by a monk of that institution, named Roger. The reliquary chest, actually a portable altar (Figure 55), is today in the Diocesan Museum of Paderborn. On one side are embossed reliefs of SS. Kilian and Liborius flanking a Christ in Majesty, as specified in the document, while in a nielloed silver plaque on top is a representation of Bishop Heinrich with a dedicatory inscription naming him.[34] Roger of Helmarshausen's work exemplifies a new more exhuberant style with figures clothed in broad, clinging robes with curvilinear folds nesting small v-shaped folds, a drapery effect paralleled only at the time, it seems, in manuscripts produced locally and in monasteries of the Meuse Valley. This style, if a transitional one, heralds the new twelfth-century striving for order, characterized by heaviness and monumentality, in direct contrast to the nervous calligraphic style of Ottonian times. By the turn of the century, portable altars had become highly coveted among ecclesiastical implements and were to be produced in unending numbers at least through the 1170s. A fourth example from the Guelph Treasure (Figure 56), embossed with stumpy figures of apostles nervously gesticulating and set between prominent columns with unusual shafts of carved rock crystal, reflects in a mitigated way that style so clearly expounded in the work of Roger of Helmarshausen.

Egbert II, last male heir of the Brunons, was murdered in 1090, and on the death of his sister Margravine Gertrude, the earldom passed through her daughter Richenza, wife of Emperor Lothar III, to the imperial family. Their daughter, a third Gertrude, in 1127 married Henry the Proud of the House of Guelph, duke of Bavaria and Swabia. Shortly thereafter, the bridegroom was endowed by his father-in-law with the whole of the Duchy of Saxony, Dankwarderode, and its collegiate church passing as part of Gertrude's personal dowry into the Guelph family. From this union, two years afterwards, was born an only son, the future Henry the Lion.

Figure 53. *River of Paradise*. Bronze. Germany, Lower Saxony, Hildesheim, ca. 1000-10(?). Detail of *Column of St. Bernward*. Hildesheim, Cathedral.

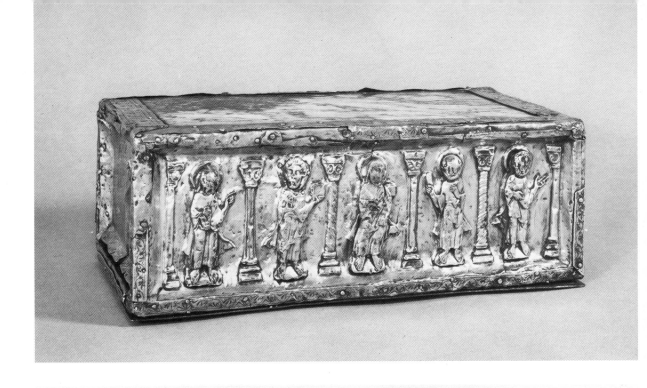

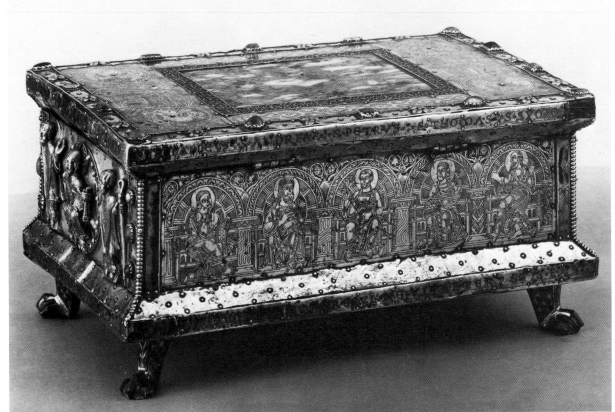

50

Figure 54. *Portable Altar with Embossed Figures of Christ and the Apostles.* Marble, gilt-silver, and niello on a core of walnut, 2-13/16 x 7-13/16 x 4-11/16 inches (7.2 x 19.9 x 12 cm.). Germany, Lower Saxony, Brunswick(?), ca. 1075. Berlin, Staatlichen Museen Preussischer Kulturbesitz, Kunstgewerbemuseum, Inv. W2.

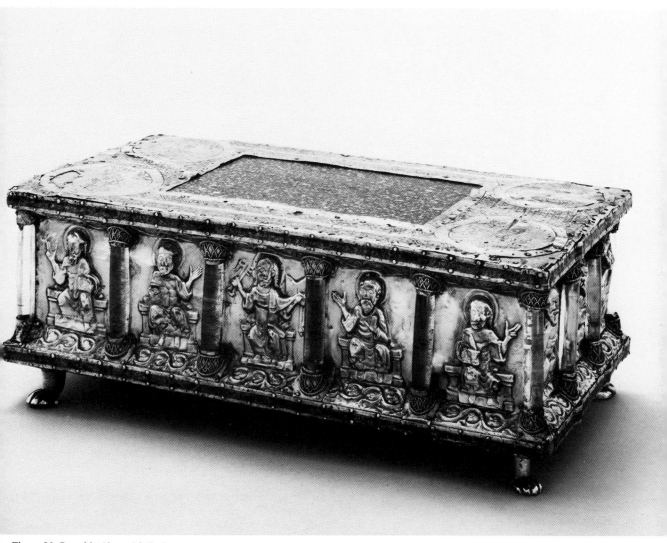

Figure 56. *Portable Altar with Embossed Figures of Christ, the Apostles, and the Evangelists.* Red porphyry, rock crystal, silver, and nielloed gilt-silver on a core of wood, 4-5/16 x 12-3/16 x 6-9/16 inches (10.9 x 30.9 x 16.6 cm.). Germany, Lower Saxony, Brunswick(?), early twelfth century. Berlin, Staatlichen Museen Preussischer Kulturbesitz, Kunstgewerbemuseum, Inv. W9.

Figure 55. *Portable Altar of Bishop Heinrich von Werl.* Marble, gilt-silver, niello, bronze, gems, and pearls on a core of oak, 6-1/2 x 13-9/16 x 8-7/16 inches (16.5 x 34.5 x 21.5 cm.). Roger of Helmarshausen, German, 1100. Paderborn, Diocesan Museum.

Figure 57. *Guelph Cross*. Gold, gilt-silver, niello, cloisonné enamel, gems, and pearls, 13-1/16 x 4-15/16 inches (33.1 x 12.5 cm.). Italy, Milan, ca. 1045. Berlin, Staatlichen Museen Preussischer Kulturbesitz, Kunstgewerbemuseum, Inv. W1.

Figure 58. Detail of *Great Cross of Aribert of Antimiano*. Gilt-copper. Italy, Milan, ca. 1040. Milan, Cathedral Museum, Inv. 131.

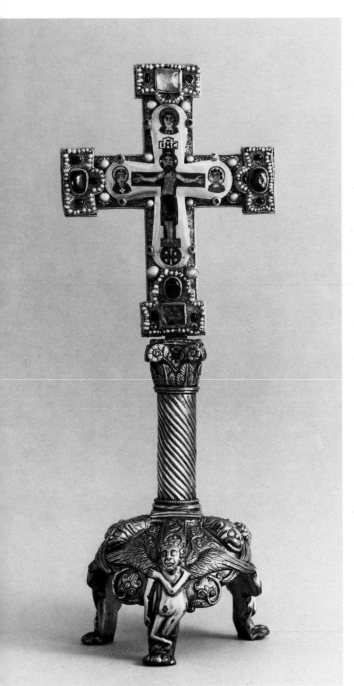

The Guelphs, whose cradle had been Weingarten, a picturesque alpine spot north of the Lake of Constance, had left their mark on German politics beginning in the preceding century. An earlier member of the family, Guelph V, uncle of Henry the Proud, had married Countess Matilda of Tuscany, before whose castle at Canossa, Henry IV, Holy Roman emperor, knelt barefoot in the snow to ask and receive absolution from Pope Gregory VII. It was a crucial moment in the age-long conflict between ecclesiastic and secular power, and marked the complete, if momentary, victory of the pope.

It was probably through Countess Matilda's husband that an eleventh-century object known as the *Guelph Cross* (Figure 57) came to the Treasure of Brunswick. This gold work was produced in Milan sometime before 1045 in the workshop fostered by Aribert of Antimiano, yet another famous princely prelate, who left to the treasury of his cathedral a great cross with an incisive figure of Christ (Figure 58) and also a gospel book with a resplendent binding (Figure 59), including filigree work,

Figure 59. Binding of *Gospels of Aribert of Antimiano*. Gold, gems, and cloisonné enamel, 16-3/4 x 14-11/16 inches (42.6 x 37.3 cm.). Italy, Milan, ca. 1035. Milan, Cathedral Museum, Inv. 1431.

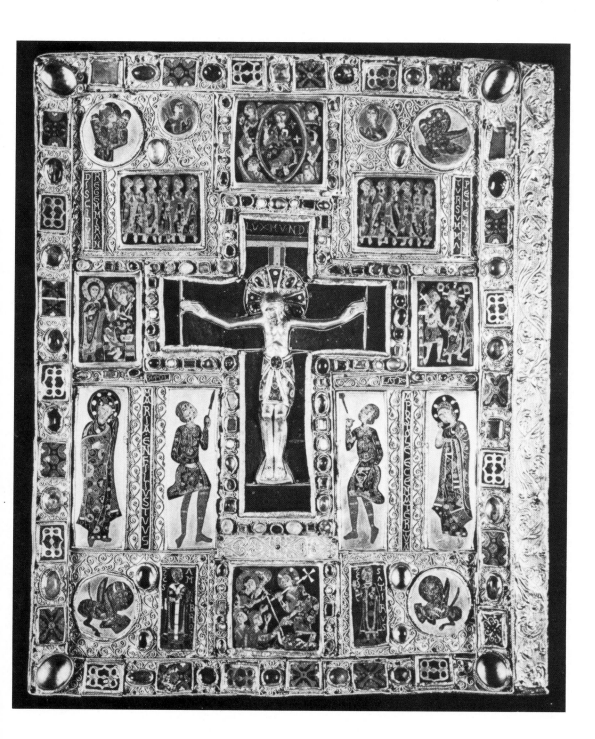

Figure 60. *Altar Cross*. Gold, cloisonné enamel, gems, and gilt-silver, H. 7-13/16 inches (19.9 cm.). Italy, Milan, eleventh century with later additions. Velletri, Cathedral of S. Clemente.

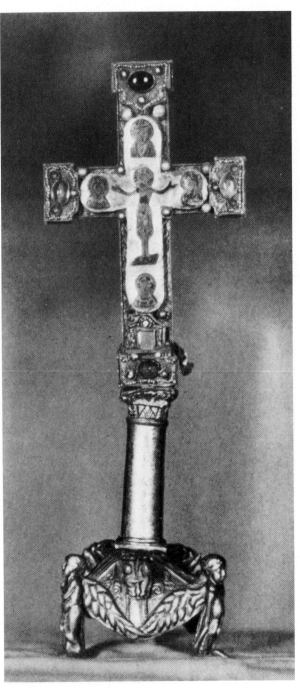

stones, and enamels.[35] The goldsmith work commissioned by the abbesses of Essen bears some relationship to Aribert's gospel cover. The unstructured Christ with large nimbus of Matilda's first cross (Figure 37) and the series of small enamels with stylized beasts on Theophanu's cross (Figure 46) perhaps found a partial inspiration in the Aribert Workshop.

The *Guelph Cross* (Figure 57) enshrines a relic, presumably a fragment of the True Cross. Affixed to its obverse by eight pins delicately entwined with gold wire and bedecked with a small stone, is a flat Byzantine breast cross with rounded ends with Christ and bust-length representations of the Virgin, St. John, and a third unidentified figure, in the finest of cloisonné work. The four ends extending beyond the breast cross are enlivened with translucent stones and pearls on a field given to delicate filigree work shaped as small hooks as on the binding of Aribert's gospels (Figure 59).

Contrasting to the delicate and minute forms of the cross, are the cast gilt-brass shaft and base on which it is set. The solid torsaded column with a Corinthian capital is supported by a base boldly ornamented with three grimacing tiger heads and nude genii; the latter, fitted with outspread wings, are impatiently staring outward, one leg crossed as if unconvinced of their vocation and waiting for relief. Incisively chiseled, these broad forms can readily be associated with the features of Christ (Figure 58) on Aribert's great cross, while their general forms and countenance may derive from such well-known monuments as the façade of Modena's cathedral with its reliefs by Wiligelmo. So admired was the *Guelph Cross*, while probably still in Milan, that a second nearly identical one (Figure 60) was made, though it was subsequently restored in the thirteenth century.[36]

Henry the Lion and the Arts of Twelfth-Century Lower Saxony

Although his ancestors had played a vital role in the formation of the Guelph Treasure, Henry the Lion was its major benefactor, acquiring or commissioning most of the important reliquaries. The chronicler Arnold von Lübeck repeatedly emphasized Henry's zeal in enriching the "House of God" with relics and rich vestments, and specifically referred to the collegiate church, by that time known as St. Blaise. An inscription in golden letters on the fourth folio of the famous gospel book the duke commissioned about 1185 also praises him for decorating and enlarging that edifice ("Templis ornavit ac muris amplificavit"). Henry is the most striking figure of all the Guelphs, "a prince of the princes of the earth" as Helmold von Bosau, another chronicler, spoke of this owner of vast estates in Germany, Poland, and Austria, who fiercely resisted imperial encroachments. Henry contended that a duke had the right — and should have the power as in pre-imperial days — to make all laws necessary for the internal welfare of his lands. Unlike his cousin and rival, Emperor Frederick Barbarossa, who dreamed of re-creating a truly Roman empire, the Lion was against the Hohenstaufen's generally abortive and always expensive campaigns in the Italian peninsula; rather, he was intent on extending the frontiers of Germany beyond the widely open and readily accessible plains of the north across which the Weser, the Elm, the Elbe, and the Oder flow to meet the shores of the North and Baltic seas. There Henry won, after dogged perseverance, considerable tracts of marshland on which he settled tenacious Flemish and Frisian immigrants who reclaimed the soil. The Lion did everything in his power to encourage the slowly developing merchant class of northern Germany and founded what came to be the most flourishing center of commerce in that region, the city of Lübeck. Duke Henry used vigorous methods to increase his territorial hegemony including outright cruelty against the Slavs and much desultory warfare with his neighbors as Helmold von Bosau's chronicle makes evident.[37] It is no coincidence that the astonishing lion (Figure 4), an image of threat as well as vigilance, which the duke placed prominently before his castle at Brunswick in 1166, is reminiscent of the famous Roman she-wolf of 500 BC on the Capitoline Hill, eternal symbol of unbridled might.

Henry was first married to Clementia of Zähringen, whom he subsequently repudiated. Through a new union with Matilda on 1 February 1168, he gained an alliance with the royal house of England, the bride being Henry II Plantagenet's eldest daughter and sister of Richard the Lionheart and John Lackland. Eventually, Henry's own son would rise to be emperor under the name of Otto IV, while his daughter Gertrude became queen of Denmark. A famous page (Figure 33) of the gospel book Duke Henry gave to the future Cathedral of St. Blaise includes the only certain contemporary portrait of him, Matilda, and their progenitors. Here, in a broadened version of Ottonian images of consecration (Figure 11), the kneeling duke and his consort are crowned from the heavens by divine hands.

In 1139 Henry succeeded his father as duke of Saxony and in 1155 received Bavaria, which had also been part of his father's dominions. Henry the Lion was to die in his castle of Dankwarderode on 6 August 1195. Shortly after the middle of the century he had transformed Brunswick from a modest hamlet into an actual town. In addition to seeing to the construction of the quarters near the Burgplatz, he created the new districts of Hagen and Neustadt with settlers from the Netherlands. In about 1175, the duke enlarged the ancestral stronghold, transforming it into an imposing castle with an improved defense system. The new church — now dedicated to SS. Blaise and John the Baptist, and of which the recumbent effigy of Duke Henry holds a model (see Figure 3) close to its original conception — with its large cavernous crypt was the first major structure in Lower Saxony in which vaulting was used.

In 1172, having reached the height of his power and wealth, Henry the Lion set forth "in great glory" on a long pilgrimage to the Holy Land, returning to Brunswick a year later. Accompanied by a retinue of over five hundred, including an archbishop, several counts, and abbots, it was no humble enterprise. Arnold von Lübeck's *Chronicle of the Slavs* fortuitously includes the diary of the learned Abbot Heinrich of the monastery of St. Giles at Brunswick, who journeyed with the Saxon party. In his account, the cleric stressed Henry's veneration for holy relics and related that while returning from Palestine, Henry was presented with fourteen mules loaded with gold and silver and silken vestments by the Byzantine Emperor Manuel Comnenus. While expressing "immense thanks," the duke made it known that however precious these objects might be, he would by far prefer relics of certain saints. Constantinople, where the seat of the church had been transferred in the fourth century, was the great repository of saintly mementos and in fact less than a decade after Henry the Lion's death when the Venetians sacked the city, they greedily took as part of their booty no fewer than 400 reliquaries. Within the twelfth-century political checkerboard, Manuel Comnenus's steadfast ambition was to reestablish the unity of a single empire East and West under his own rule and thus bring down Frederick Barbarossa. The relics Henry the Lion coveted were readily given to him, the emperor

adding "much glory of precious stones" to the gift. Manuel's ready willingness to please his guest was perhaps a political ploy to find a sympathetic ear for his ambitious schemes. When the duke returned to his seat of Brunswick in 1173, the precious relics made for a triumphal entry. The abbot, unfortunately a laconic narrator, related only that Henry presented to the Burgkirche of St. Blaise the "reliquis sanctorum, quas secum attulerat, vestiens eas auro et argento et lapidibus pretiosis, inter quas etiam erant brachia apostolorum plura."[38]

Duke Henry also brought back to Brunswick some of the goldsmith works for which Constantinople was so renowned. Examples in the Guelph Treasure may have also come in part through Otto IV, who may have acquired them from returning crusaders after the great city was basely sacked in 1204. Among

56

the precious Byzantine objects in the Treasury of St. Blaise figured the twelfth-century golden *Icon of St. Demetri* (Figure 61). This warrior saint, often likened to St. George, is here represented on horseback and in the attire of a Roman proconsul. His large staring face with its surface of pink enamel, stands out vividly against the punched gold ground. Floral motifs of blue and white cloisonné enamel and a Greek inscription identifying the saint decoratively fill the surrounding surfaces. This plaque may be related to outstanding Byzantine works of the late eleventh and twelfth century such as the *Icon of St. Michael* (Figure 62) with its equally prominent enameled head, a shrine added to the cathedral treasury of Venice in 1204.[39]

Another object from Constantinople in the Guelph Treasure is a twelfth-century portable altar (Figure 63), or rather "altar

Figure 61. *Icon of St. Demetri.* Gold and cloisonné enamel on a core of wood, reset at a later date in Germany with the addition of pearls and gems, 7-1/8 x 7-1/16 inches (18 x 17.9 cm.). Byzantium, Comnenian Period (twelfth century). Berlin, Staatlichen Museen Preussischer Kulturbesitz, Kunstgewerbemuseum, Inv. W3.

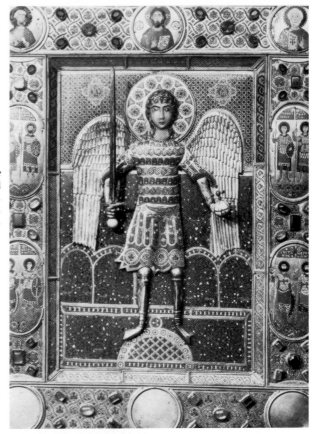

Figure 62. *Icon of St. Michael, Protector of the Gates of Heaven.* Gilt-silver, cloisonné enamel, and precious stones, 18 x 13-3/4 inches (46 x 35 cm.). Byzantium, end eleventh-beginning twelfth century. Venice, S. Marco, Treasury, Inv. no. 6.

Figure 63. *Portable Altar in Tablet Form.* Agate and nielloed gilt-silver on a frame of wood, 9-7/16 x 13-3/16 x 1-3/8 inches (23.9 x 33.5 x 3.5 cm.). Germany, Lower Saxony, ca. 1200, incorporating a twelfth-century Byzantine agate and silver frame. Berlin, Staatlichen Museen Preussischer Kulturbesitz, Kunstgewerbemuseum, Inv. W4.

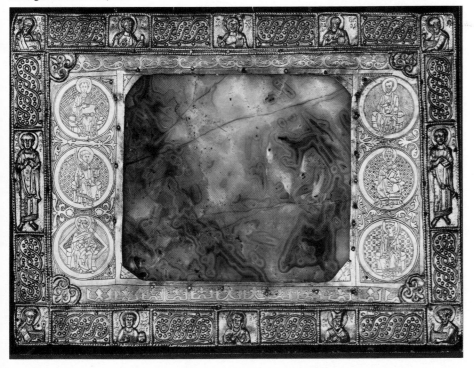

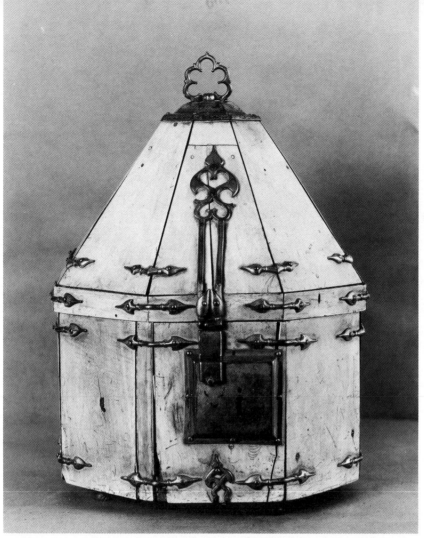

Figure 64.
Casket in Tower Form.
Ivory plaques mounted on a core of oak with gilt-bronze fittings, H. 12-3/8 inches (31.5 cm.), D. 8-1/2 inches (21.5 cm.). Sicily, Palermo(?), twelfth century. Cambridge, MA, Fogg Art Museum, Alpheus Hyatt Purchasing Fund, Acc. 1931.52.

Figure 66.
Hunting Scene
(outer carved ring of *Horn of St. Blaise*). (See Color Plate x.)

Figure 65.
Hunting Horn.
Ivory, L. 16-1/2 inches (42 cm.). Sicily, Palermo(?), eleventh century. Brunswick, Herzog Anton Ulrich-Museum, Inv. MA/L5.

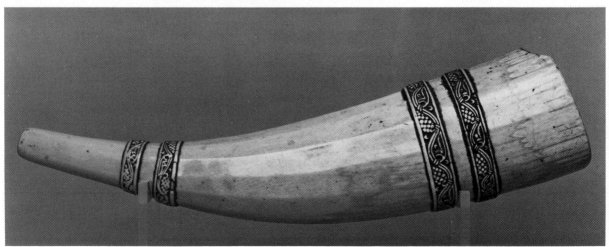

stone" since it only consists of a slab of agate in a gilt-silver frame without a supporting reliquary box. The metal casement is embossed with a distinctive beaded border, while in its field are standing and bust-length figures identified by Greek inscriptions. Indicative of the many changes objects sometimes underwent is the silver plaque with medallions of saints, a Saxon work of the early thirteenth century, inserted over the edges of the agate slab within the Byzantine frame. It may be that the stone had been damaged.

While in the Holy Land, Henry commissioned mosaics and silver doors for a chapel of the Church of the Holy Sepulchre in Jerusalem. It is probably the duke who brought back from his long journey, which also took him to Nazareth and Bethlehem, another "altar stone." Although its rough-hewn quality is seemingly not befitting for a treasury, it is in fact a precious and venerable memento: a purported fragment of the manger in which Christ was born.[40]

Other objects in the Guelph Treasure with a southern provenance and dating of the eleventh, twelfth, and thirteenth centuries are four ivory pieces: a pyx, now at the Fogg Museum (Figure 64), a casket in Berlin, and two *oliphants* (carved elephant tusks). All four share a Siculo-Arabic origin, that is, they were fashioned in Sicily by Muslim craftsmen. The two boxes consist of a wooden core covered by thin ivory plaques with a surface decoration of gold abstract patterns and fastened by heavy brass clamps. Judging from the extant number of such receptacles in northern European museums, they were items frequently brought back by returning travelers. Of the two *oliphants*, one is in Brunswick (Figure 65) while the other is in Cleveland (Color Plate X and Figure 66),[41] the latter be-

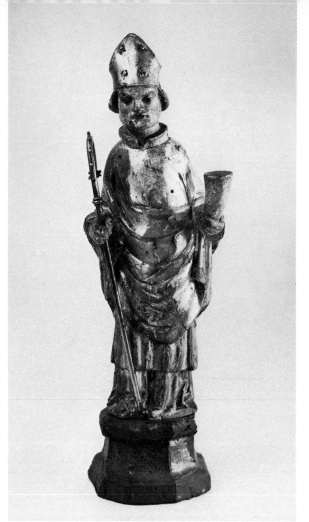

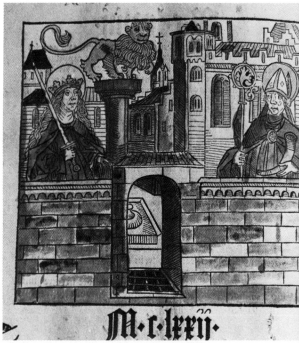

Figure 67. *Reliquary Statuette of St. Blaise.* Linden with polychromy and gilding, and a silver crozier, H. (including base) 10-7/16 inches (26.5 cm.). Germany, Lower Saxony, Brunswick, ca. 1400. Berlin, Staatlichen Museen Preussischer Kulturbesitz, Kunstgewerbemuseum, Inv. W43.

Figure 68. *SS. Catherine and Blaise before the Burgplatz of Brunswick.* Woodcut with washes. Monogrammist WB. Konrad Bote, *Cronecken der Sassen,* 1492. Brunswick, Stadtbibliothek, ms. II/1/204, folio 138v.

ing referred to in the Guelph inventories as the "Horn of St. Blaise" with the further indication that it was held by silver rings inset with precious stones. According to pious lore reported by Neumann, the saint is reputed to have used the horn to summon the faithful to worship as church bells did not yet exist at his time. A fifteenth-century votive statuette (Figure 67) in the Guelph Treasure and an illustration of the *Chronicle of Saxony* of 1492 (Figure 68) depict the saint in his episcopal vestments, a silver crozier in one hand and a large ivory horn in the other. The Cleveland *oliphant* is masterfully shaped with a series of six carved bands, five with a foliage pattern, while the outer ring (Figure 66) depicts sequences from a hunt with a central motif of the *Kriophorus*—an athlete bearing a stag on his shoulder —deriving from antiquity. Such horns, while originally designed for the hunt, primarily served a ceremonial purpose. Every great prince and wealthy treasury vied to own one; there is such a horn, for example, dating to about the year 1000 in the Imperial Treasury at Aachen.[42]

60

OPPOSITE

Color Plate x. *Horn of St. Blaise.* Ivory, L. 19-1/2 inches (49 cm.); Widest Diam. 4-11/16 inches (12 cm.). Sicily, Palermo(?), twelfth century. Gift of the John Huntington Art and Polytechnic Trust. CMA 30.740

Color Plate xi. *Reliquary Casket with Champlevé Enamels of Sharp Colors.* Gilt-copper and champlevé enamel on a core of wood, 3-5/8 x 9-3/16 x 5-5/16 inches (9.3 x 23.3 x 13.4 cm.). Germany, Lower Saxony, Hildesheim(?), early twelfth century. Purchase from the J. H. Wade Fund. CMA 49.16

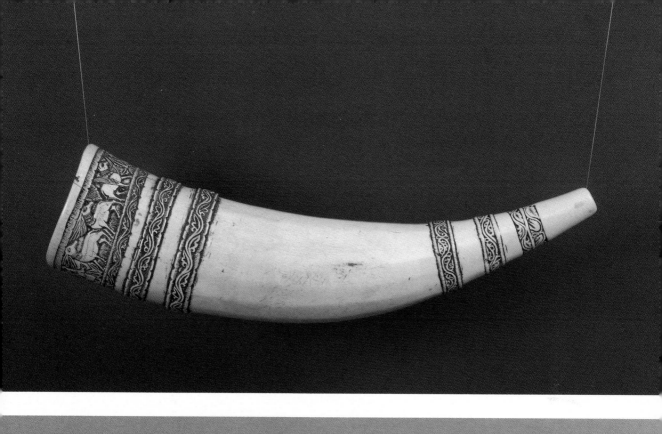
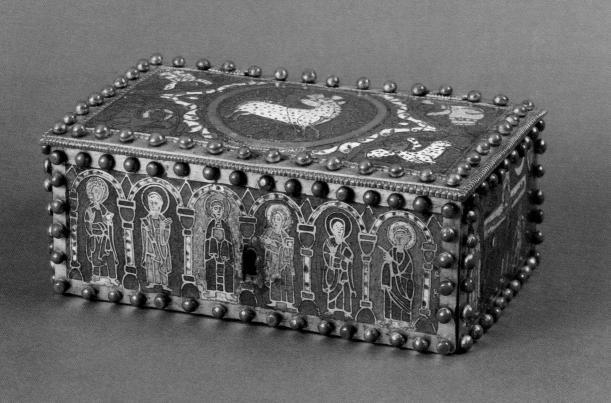

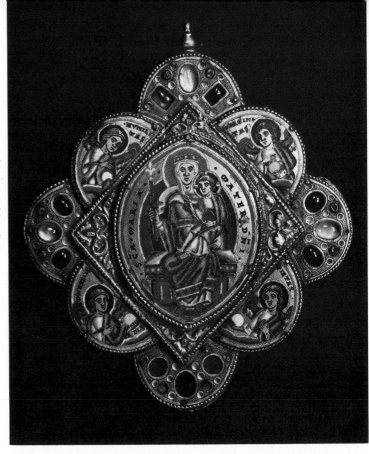

Figure 69.
Disk Reliquary:
*Virgin and Child Surrounded
by the Four Cardinal Virtues.*
Champlevé enamel on gilt-
copper, 7-3/4 x 6-3/4 inches
(19.7 x 17.2 cm.). Circle of
Godefroid de Huy, Meuse Valley,
ca. 1160. Purchase from the
J. H. Wade Fund. CMA 26.428

By 1175, two years after his return to Brunswick, Henry's uneasy relationship with his cousin, Emperor Frederick Barbarossa, was severely strained. Some twenty-five miles south of Brunswick on the western slopes of the Harz Mountains lay Goslar, an imperial possession and a city particularly wealthy for its silver and copper mines. Located so close to his capital, Goslar was highly coveted by the duke, but for both economic and political reasons, the emperor held it tightly in his possession. When Frederick sought Henry's assistance in 1174 to fight the Lombard League, the Lion named his price: Goslar. When Frederick refused, Henry would not contribute to the Italian campaign. As a result, the Lombards, who had received heavy subsidies of gold from Manuel Comnenus, defeated the imperial army at Legnano on 28 May 1176.

A territorial dispute between Henry the Lion and Bishop Udalric of Halberstadt was to provide the emperor with legal grounds for bringing on the duke's downfall. Evading all court assignments and refusing to yield, Henry was finally stripped of his duchies in January of 1180 by the electors of the Imperial Diet. Although his alodial fiefs of Brunswick and Lüneburg were returned to him by 1181, the Lion obviously could not tolerate this compromise. He was soon scheming to reconsolidate his position which eventually led the emperor to banish

him. The duke found refuge from November 1181 until the spring of 1185 at the court of his father-in-law, Henry II of England.

Henry the Lion, in addition to casting a long shadow on the history of twelfth-century Germany, was also a major patron of the arts.[43] From the ablest craftsmen that could be found, he ordered enameled shrines of silver and gold often set with gems for the relics he acquired. Some of these precious works are examined here. Since, with one notable exception, no records exist revealing who the goldsmiths were and where they actually worked, an analysis of this part of the Treasure must introduce related material essential for pinpointing geographical origins as well as for proposing attributions to workshops.

In metalwork, the major development of the twelfth century is the overwhelming adoption of the champlevé enamel technique, first and foremost in the Meuse Valley, but also in Germany, northern France, and England. Unlike the raised cloisonné, this process requires gouging out channels in metal plaques leaving only thin walls of metal as well as supporting pins. Molten glass of different hues is then poured in the depressions. The result is a luminous polychromed image with an ex-

Figure 70. *Crucifixion; Sin-Offering of the Calf.* Ink, tempera, and gold on parchment. Meuse Valley, ca. 1150-1160. *Floreffe Bible.* London, British Library, Add. ms. 17738, II, folio 187.

tremely smooth plane. With this new technique the goldsmith could rival and even surpass the work of the painter, at least in the sense that his art is more enduring. The advent of champlevé was concurrent with, and not independent from, a full commitment to the new Romanesque style in which figures are given greater physical bulk and scenes are depicted with a clear intent on legibility.

Champlevé enameling in its new appealing form (Figure 69), was developed in monastic institutions of the Meuse Valley. Like Abbot Suger of St.-Denis near Paris, who readily looked to new styles and techniques to bring glory to his abbey, the ranking ecclesiastics of the Meuse constantly sought ways to represent vividly that infinite lexicon of patristic symbols, parallels, and anti-types which nurtured the thoughts of the age. Where such depictions first burgeoned in all their spontaneity was obviously not in enamels but in manuscript illuminations (Figures 70-71). The artist-monks visually translated with quick strokes of pen and brush, the concepts developed by their superiors. There can be little doubt that the combination of prosperous abbeys with this vigorous production of illuminated manuscripts, as well as the ready availability of copper and tin from local mines, provided the climate in which the phenomenon of Mosan enamels

Figure 71. *Herod Orders the Massacre of the Innocents.* Tempera and gold on parchment, 3-5/8 x 4-1/2 inches (9.3 x 11.4 cm.). Meuse Valley, ca. 1160. *Psalter.* Berlin Kupferstichkabinetts der Staatlichen Museen, ms. 78A6, folio 8.

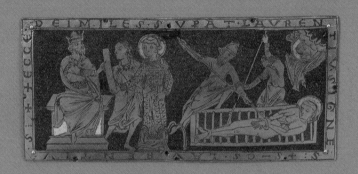

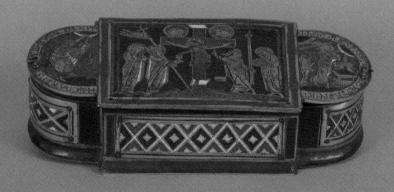

Color Plate XII. A-D (top): *Four Plaques with Seated Prophets: Isaiah, Elisha, Obadiah, and Hosea.* Champlevé enamel, niello, gilt-copper; CMA 50.574: 3-1/2 x 2-3/8 inches (8.9 x 6 cm.); CMA 50.575, 50.577: 3-1/2 x 2-1/4 inches (8.9 x 5.7 cm.); CMA 50.576: 3-1/2 x 2-5/16 inches (8.9 x 5.8 cm.). Weland Workshop, Germany, Lower Saxony, Hildesheim, ca. 1185. Purchase from the J. H. Wade Fund. CMA 50.574-577

E (center): *Judgment and Martyrdom of St. Lawrence.* Champlevé enamel and gilt-copper plaque, 3-3/4 x 8-3/16 inches (9.5 x 20.8 cm.). Germany, Rhine Valley(?), Cologne(?), ca. 1180. Purchase from the J. H. Wade Fund. CMA 49.430

F (bottom): *Pyx.* Champlevé and cloisonné enamel and gilt-copper on a core of wood, 2-1/8 x 8-3/8 x 3-5/8 inches (5.4 x 21.3 x 9.2 cm.). Germany, Lower Saxony, Hildesheim(?). Purchase from the J. H. Wade Fund. CMA 49.431

Figure 72. *Portable Altar of Eilbertus.* Gilt-copper, champlevé and cloisonné enamel, gold, niello, vernis brun, rock crystal, and parchment with tempera and gold on a core of oak, 5-5/16 x 14-1/16 x 8-3/16 inches (13.3 x 35.7 x 20.9 cm.). Eilbertus of Cologne, German, ca. 1150. Berlin, Staatlichen Museen Preussischer Kulturbesitz, Kunstgewerbemuseum, Inv. W11.

could flourish. And flourish they did, not only in Liège but also in abbeys such as Stavelot where the gifted Wibald, a keen patron of the arts, doubled his abbacy with being the powerful chancellor of three German emperors. The earliest dated piece on which typically Mosan champlevé enameling is employed is the *Head Reliquary of Pope Alexander* ordered by Abbot Wibald and completed in 1145.[44]

In Germany, the regions where the new technique particularly took root are Westphalia, with Cologne as center, and Saxony, principally it would appear in Hildesheim. Cologne, geographically not far removed from the Meuse, had the earliest, largest, and longest lasting workshops whose output was geared to a widely scattered market, with a limited direct patronage of bishops and princes. The one important goldsmith-enameler of that city toward the middle of the eleven hundreds is Eilbertus, who fashioned a major shrine of the Guelph Treasure, a portable altar (Figure 72) resplendent with gilt-copper plaques partly in the new champlevé technique and partly in the traditional cloisonné. The base plate (Figure 73) is decorated with

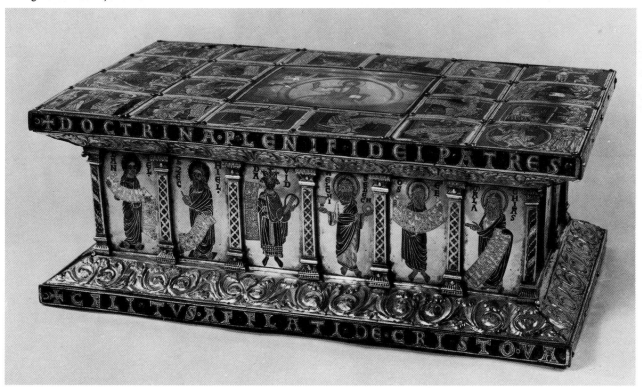

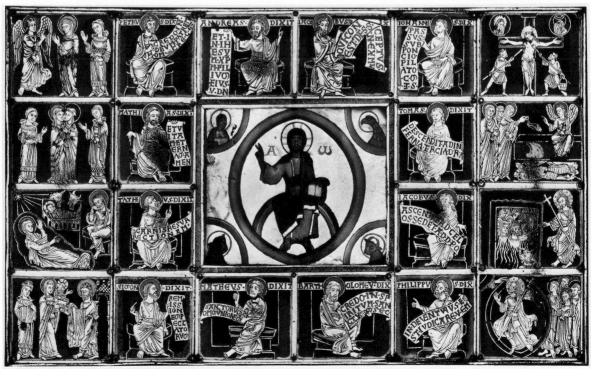

stylized motifs in *vernis brun* — another novel technique involving the careful application of a varnish derived from brown linseed oil — while the plinth of the trapdoor opening on to the relics bears the engraved words EILBERTVS COLONIENSIS ME FECIT (Eilbertus of Cologne made me), distinguishing the shrine as the only signed piece of goldsmith work of the twelfth century.

The top of the altar (Figure 74) is no less innovative in conception than it is masterly in execution. At center, sunk under the nebulous sparkle of a protective sheet of rock crystal, is a miniature of the Colognese School with Christ the Judge holding the book of his teachings between the alpha and omega. Surrounding this visionary image are four champlevé plaques with the twelve seated apostles, each in reserved gilt-copper — that is, not enameled but with features defined by means of engraved lines filled with niello — identified and displaying a conspicuous scroll. Backgrounds are composed of frames of light and dark blue, and sharp green. The copper has been so finely chiseled out that the delicate walls forming compartments for the enamels appear as if mere sketched outlines. On the ends of this altar table are two vertical plaques, each with four scenes depicting events related to Christ's birth, his infancy, and the Redemption. The style, if more linear, is reminiscent of contemporary or slightly earlier Mosan enamels.

Far more thought out in architectonic terms than Gertrude's and Heinrich von Werl's portable altars (Color Plates V-IX and Figure 55), Eilbertus's is articulated by a series of pilasters appearing to support the mensa. In the seemingly recessed spaces are prophets, quietly gesturing. The figures, as well as the architectural elements, are enameled, but here in the time-honored technique of cloisonné with its contrasting rather than melting effect; these glistening forms appearing against the solid gold background easily conjure up the effect of mosaics. The cloisonné enamel technique here adopted by Eilbertus is actually in part the refined tray technique whereby *cloisons* (walls) are removed once the molten glass poured in an area has hardened; another contiguous section is then filled. This was obviously a particularly delicate and difficult procedure as both cracking and mixing of colors could readily occur at multiple stages of production. The masterful handling of the two enamel techniques as exemplified in the Eilbertus altar significantly extended the expressive range of the metalworker's craft.

Where Eilbertus created his altar is unknown. The fact that he specified Cologne in the inscription only informs us surely of his origin. When it was produced and acquired by the Guelphs is not any clearer (all enameled inscriptions are textual quotations); stylistically, a dating of shortly after 1150 would seem highly probable, thereby making it likely that the altar was a commission or purchase of Henry the Lion.

No other work that we know of can be attributed to Eilbertus. Contemporary Colognese enamels seem to echo his style, though certainly never reaching the master's level of artistry and technical perfection. From about 1160 through the early 1180s, champlevé enameling in Cologne came to be dominated by the Gregorius Workshop whose production is best exemplified in a portable altar at Siegburg (Figure 75). The craftsmen here used a very limited range of rather monochrome blue and gray hues in conjunction with a broad drawing and figures with somewhat flattened features. In the mid-1180s, the Colognese style became somewhat more animated, as seems to be exemplified in a plaque of the *Judgment and Martyrdom of St. Lawrence*, now in Cleveland (Color Plate XIIE).[45] Only in the late 1180s with enamels such as the series of trapezoid plaques with busts of apostles divided between the Kestner (Figure 76) and British museums and Bamberg Cathedral, did Colognese enamelers turn away from the Gregorius style, but only after having had a long fresh look at the new and even more subtle Mosan production epitomized in the work of Nicholas of Verdun.[46]

Apart from Cologne, if there is one other area of Germany that was particularly receptive to the style represented by Eilbertus's champlevé enamels, from about 1155 until the 1190s, it is Lower Saxony. This has led the historians Otto von Falke and Georg Swarzenski to propose that Eilbertus worked for Henry the Lion right in Saxony.[47] With no evidence on hand, however, it may be that Eilbertus's influence was simply due to the presence of his work in the region. If we attempt to ascertain where enamelers' workshops might have been established in Saxony during the period of Henry the Lion, Hildesheim, rather than Brunswick, would offer the clearest evidence, as we shall see. Though small enamel plaques might be cast and ornamented in different geographical locations by the same craftsman, it stands to reason that centralized workshops did exist to house the special kiln and tools for fine metalworking. Objects, on the other hand, could easily be transported.

As far as the primary material — metal — is concerned, neither Hildesheim nor Brunswick owned mines. The sole known mining center of any importance in twelfth-century Saxony is the great Rammelsberg under the jurisdiction of imperial Goslar.

Figure 74. Mensa of *Portable Altar of Eilbertus.*

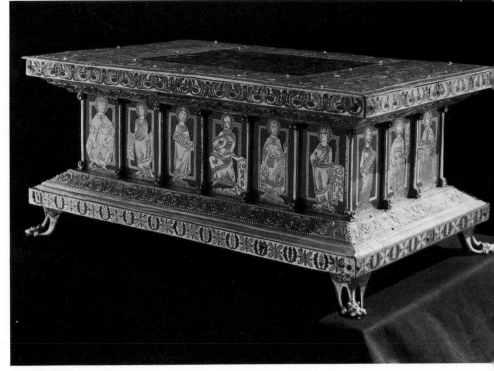

Figure 75.
*Portable Altar
of St. Gregorius.*
Serpentine stone, gilt-bronze,
and champlevé enamel on a
core of wood, L. 14-3/4
inches (37.5 cm.). Gregorius
Workshop, German,
Cologne, ca. 1160. Siegburg,
Church of St. Servatius,
Treasury.

Figure 76. *Apostle Thaddeus.*
Champlevé enamel on gilt-
copper, 3-1/16 x 2-15/16
inches (7.7 x 7.4 cm.).
Germany, Cologne, ca.
1180. Hanover, Kestner-
Museum, Inv. 1915,118.

The massive peak towering south of the city and grown over with wood, used by the smelting furnaces, had produced silver, copper, and lead since the tenth century. Major metal casting in Saxony must have taken place in Goslar; there is evidence, for example, that the lion set before Dankwarderode was cast in a Goslar furnace. Yet no records suggest that Goslar witnessed any artistic activity in this field outside of a tradition of technical mastery in casting which in the previous century had led to the making of the solid but rather crude so-called *Krodo Altar,* actually a large and uncomfortable imperial throne.[48]

There had undoubtedly been some earlier pre-Mosan style champlevé enameling activity in Lower Saxony in the first years of the twelfth century — the principles of the technique were not novel after all. A group of colorful caskets — including an example in the Hildesheim Cathedral Treasury (Figure 77), another in the Guelph Treasure (Figure 78), and a third even more striking specimen in Cleveland (Color Plate XI) — have often been said to hail from Denmark, apparently on the sole basis that another example is in Copenhagen. These boxes, however, should very probably be assigned to a center in Lower Saxony such as Hildesheim. Here metalwork was an active craft, as the great *Shrine of St. Godehard* (Figure 79) of ca. 1132 clearly exemplifies.[49] While displaying rudimentary techniques and still tied to cloisonné in their effect, these early champlevé caskets are appealing for their sharp colors and flat, angular forms clear-

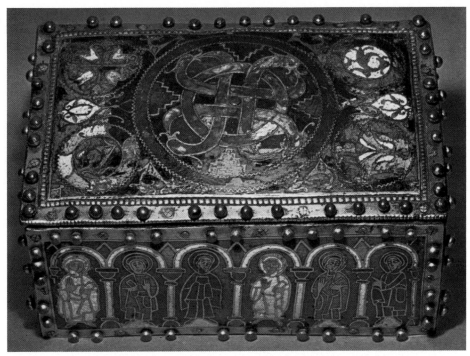

Figure 77. *Reliquary Casket with Champlevé Enamels of Sharp Colors.* Gilt-copper and champlevé enamel on a core of wood, 7-11/16 x 8-7/16 x 5-1/8 inches (19.5 x 21.5 x 13 cm.). Germany, Lower Saxony, Hildesheim(?), early twelfth century. Hildesheim, Cathedral, Treasury.

Figure 78. *Reliquary Casket with Champlevé Enamels of Sharp Colors.* Gilt-copper and champlevé enamel on a core of oak, 5-5/16 x 8-3/8 x 5-1/8 inches (13.5 x 21.4 x 13 cm.). Germany, Lower Saxony, Hildesheim(?), early twelfth century. Berlin, Staatlichen Museen Preussischer Kulturbesitz, Kunstgewerbemuseum, Inv. W16.

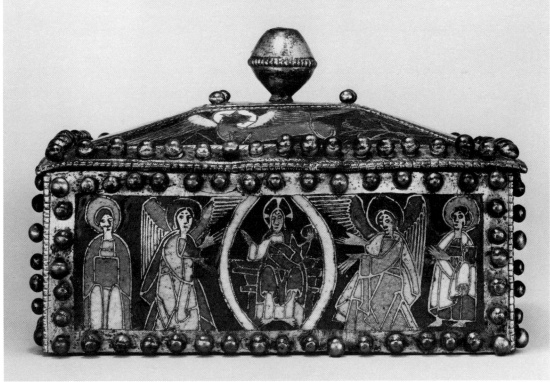

Figure 79. *SS. Bernward and Godehard, and Pope Innocent(?)* (end of *Shrine of St. Godehard*). Gilt-silver, niello, and crystal on a core of wood, 25-9/16 x 20-1/16 inches (65 x 51 cm.). Germany, Lower Saxony, Hildesheim, ca. 1132. Hildesheim, Cathedral.

ly fitting against each other, distinctive stylistic elements characteristic of Hildesheim miniature painting (Figure 80) since the preceding century.

Shortly after 1150, the making of champlevé enamel increased markedly in Saxony with the fashioning of a considerable number of reliquaries, portable altars, and bookcovers. If many were to enrich the Treasure of the Guelphs, others were ordered by ecclesiastics and institutions of Hildesheim, such a traditional patronage not being readily apparent in Brunswick or other Saxon centers. With an increase in the number of plaques produced, technical refinements took place, while individuality of style also became more apparent. In the treasury of Hildesheim Cathedral are six unusually large champlevé enamel plaques (Figure 81) recorded to have decorated the frame (of which parts of the wood core were still in existence in the nineteenth century) of a twelfth-century altar antependium of the cathedral. Produced in the 1150s, these plaques with scenes from the life of Christ have reserved figures which are more firmly drawn with their rounded forms, than those in the light sketch-

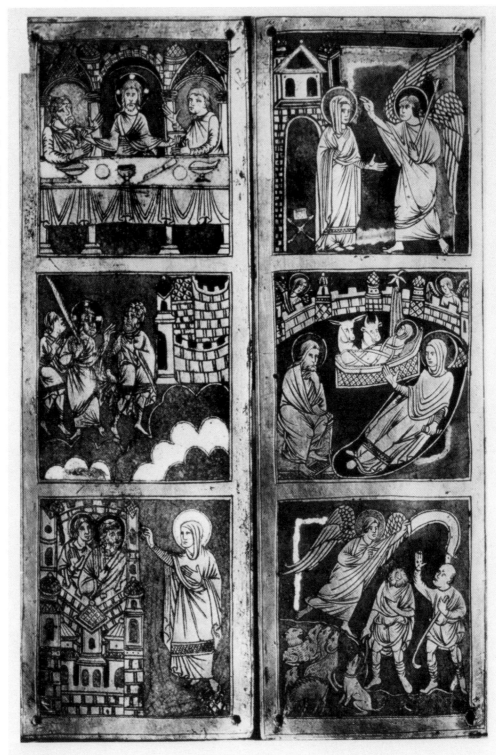

Figure 81.
Supper at Emmaus,
The Road to Emmaus,
and A Woman Announces
the Resurrection to the
Apostles; Annunciation,
Nativity, and Annunciation
to the Shepherds. Two
plaques of champlevé enamel
on copper, each 15 x 5-1/2
inches (39 x 14 cm.). Germany,
Lower Saxony, Hildesheim,
ca. 1155. Hildesheim,
Cathedral, Treasury.

Figure 80.
Bishop Bernward Placing
the Book on the Altar
of St. Michael of Hildesheim;
Coronation of the Virgin.
Tempera and gold on parch-
ment, each folio 10-13/16 x
8-1/16 inches (27.5 x 20.5
cm.). Text of volume copied
by Deacon Guntbald of
Hildesheim. Germany, Lower
Saxony, Hildesheim, ca. 1015.
Gospels of St. Bernward,
folios 16v.-17. Hildesheim,
Cathedral, Treasury.

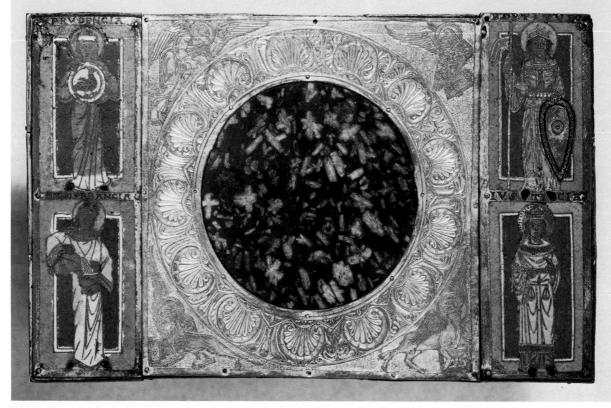

Figure 82. Mensa of *Portable Altar of the Four Cardinal Virtues.* Green porphyry, gilt-copper, and champlevé enamel on a core of oak, 6-15/16 x 11-3/8 inches (17.6 x 28.8 cm.). Germany, Lower Saxony, Hildesheim, ca. 1155. Berlin, Staatlichen Museen Preussischer Kulturbesitz, Kunstgewerbemuseum, Inv. W12.

Figure 83. *Virgin and Child Amid the Evangelists* (back of *Portable Altar of the Four Cardinal Virtues).* Gilt-copper, champlevé and cloisonné enamel, gilt-bronze, and vernis brun on a core of oak, 5-5/16 x 11-3/8 x 6-15/16 inches (13.5 x 28.8 x 17.6 cm.).

Figures 84-85.
St. Walpurgis Shrine.
Gilt-copper, silver, champlevé enamel, vernis brun, and wax on a core of oak, 12-3/8 x 15-15/16 x 9-1/4 inches (31.4 x 40.5 x 23.5 cm.). Germany, Lower Saxony, Hildesheim, ca. 1158. Berlin, Staatlichen Museen Preussischer Kulturbesitz, Kunstgewerbemuseum, Inv. W13.

like style of Eilbertus. Both the more systematically organized folds and the full faces with carefully delineated hair and beards seem influenced by Mosan art (Figures 69-71), though perhaps through more linear Rhenish intermediaries. The Hildesheim Treasury plaques, however, show one characteristic typical of Eilbertus's altar and of subsequent "Hildesheim" enamels: internal rectangular frames in two colors separated by a thin white line.[50]

The tradition of the Eilbertus altar can be traced in a group of enamels, from Lower Saxony, some of which are part of the Guelph Treasure, particularly two shrines: the *Portable Altar of the Four Cardinal Virtues* (Figures 82-83) and the much-damaged *St. Walpurgis Shrine* (Figures 84-85).[51] On the top of the *Portable Altar of the Four Cardinal Virtues* (Figure 82), datable to the middle to late 1150s, is a circular porphyry stone surrounded by a gilt-copper plaque. This plaque has a particularly appealing border stamped (that is, hammered over a die) with a palmette motif and engraved with the figures of the evangelists. At either side are two plaques each with the figures of a Cardinal Virtue in full enamel with only the heads and hands as well as the shield of Fortitude in reserved gilt-metal. The drawing of these figures, somewhat clumsy in their proportions and clad in unrhythmic draperies, is comparatively

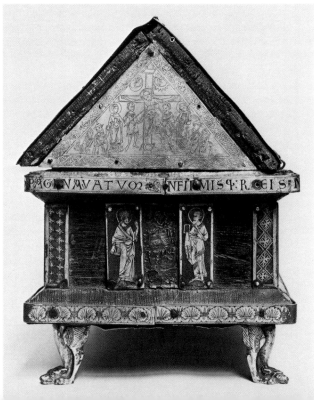

Figure 86. *Crucifixion Attended by Saints* (mensa of *Portable Altar in Tablet Form*).
Gilt-copper on porphyry set in a frame of wood, 15-1/8 x 9 inches (38.4 x 22.8 cm.).
Germany, Lower Saxony, Hildesheim, ca. 1140-1150. London, Victoria and Albert Museum, Inv. 10-1873.

simplified compared to the volumetric effects of Mosan enamels or to Eilbertus's involved stroke system. Broad areas of uniform enamel are juxtaposed in a manner which actually seems to hark back to the technique used in the earlier sharp-colored caskets (Color Plate XI, Figures 77-78) with their fully enameled figures.

In contradistinction, the enameled plaques on the back of the *Portable Altar of the Four Cardinal Virtues* (Figure 83) — representing the seated Virgin between the four Evangelists, with involved drapery folds and the upper horizontal inscriptions identifying the figures — recall in a striking manner the style of the Eilbertus altar. Also reminiscent of this altar is the swirling embossed gilt-metal design on the beveled edges.

The *St. Walpurgis Shrine* (Figures 84-85) is undoubtedly related to the *Portable Altar of the Four Cardinal Virtues*. One close element between the two, for example, is again the band with engraved palmettes decorating the base of the shrine; it vividly echoes the embossed elements around the porphyry stone of the probably earlier altar. The *St. Walpurgis Shrine* reflects two Hildesheim productions. First, its construction and extended size recall the shape of the *Shrine of St. Godehard* (Figure 79). Second, the naturalistic, soft approach to figure drawing is closely related to a somewhat earlier "portable altar stone" with its series of gilt-copper figures (Figure 86) enfram-

74

ing the central porphyry and containing relics particularly venerated in Hildesheim.[52] The similar treatment of forms is emphasized in the *St. Walpurgis Shrine* by the series of small parallel folds of the drapery in the enamel plaques and by the two lateral engraved copper gables with the Enthroned Christ and the Crucifixion (Figure 85), the latter being infused with a quiet sense of drama.

The *St. Walpurgis Shrine* is also of interest from a technical viewpoint. The six apertures in the gable (Figure 84) once included thin gilt-copper plaques embossed with a figure, and below (Figure 85) a series of similar reliefs originally alternated with the enamels. While nearly all the metal has disappeared, some of the areas still show the support for the embossed work which is clearly a compound of wax and resin. This substance, judging from other metalwork objects of the period, was standardly used as filler in order to prevent the embossed works from being easily crushed. The use of wooden cores as support for the embossed figures on Countess Gertrude's portable altar, which provided a stronger and more durable base, confirms the obvious greater care in the conception of that shrine.

If the *St. Walpurgis Shrine* may be related to the *Portable Altar of the Four Cardinal Virtues* on the one hand, it can also be compared for the style of its figures to the larger gilt-bronze plaque (Figure 87) with the figure of Christ treading on the beasts

Figure 87. *Christ Treading on the Beasts.* Pierced gilt-bronze and crystal on a core of wood, 13-15/16 x 9-5/8 inches (35.4 x 24.5 cm.). Germany, Lower Saxony, Hildesheim, 1159. Binding of the *Ratmann Sacramentary.* Hildesheim, Cathedral, Treasury, ms. 37.

Figure 88. Binding of *Gospels of Tegernsee.* Ivory plaque, champlevé enamel, gilt-bronze, and gems, 13-13/16 x 9-13/16 inches (35 x 25 cm.). Germany, Lower Saxony, Hildesheim, ca. 1175. Trier, Cathedral, Treasury, ms. 140/129/69.

in ajouré technique (openwork) on the binding of a sacramentary, firmly dated to 1159. This volume is also undoubtedly connected with Hildesheim since it was copied there by the monk Ratmannus of the Abbey of St. Michael. The figure of Christ is subtly drawn with a series of well-emphasized v-folds in the freely flowing, though not abundant, drapery. The style of the *Ratmann Sacramentary* in turn relates to two other pieces. The first is the cover (Figure 88) of the so-called *Gospels of Tegernsee*, a volume now in Trier but which is recorded to have been in the Church of St. Godehard of Hildesheim until 1799. Its

binding comprises a series of champlevé plaques of reserved figures also with v- and parallel-fold drapery, but drawn in a harder manner.[53] The second is a portable altar with gilt-copper plaques of Abraham and Melchizedek (Figure 89), a Guelph Treasure shrine which displays a softer and slightly mannered version of this style with tall figures taking dance-like steps and a decorative curving drapery. The enamels flanking the sides of this portable altar are in a somewhat different style with sharply delineated puppet-like figures, closely allied to those of some of the contemporary Colognese productions (Color Plate XII

75

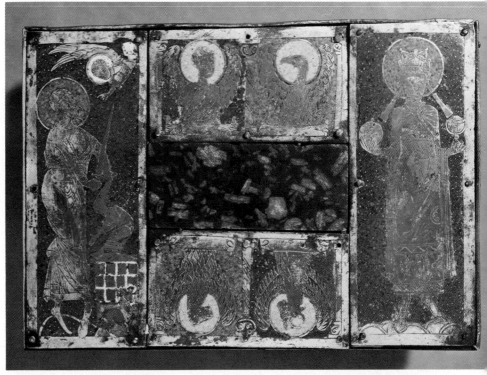

Figure 89.
Mensa of *Portable Altar with Abraham and Melchizedek.* Green porphyry, gilt-copper, and champlevé enamel, 5-13/16 x 8-7/16 inches (14.7 x 21.5 cm.). Germany, Lower Saxony, Hildesheim, ca. 1162. Berlin, Staatlichen Museen Preussischer Kulturbesitz, Kunstgewerbemuseum, Inv. W14.

Figure 90.
Crucifixion with Ecclesia and Synagogue (plaque from a reliquary). Champlevé enamel and gilt-copper, H. 3-9/16 inches (9 cm.). Germany, Lower Saxony, Hildesheim, ca. 1165. Paris, Musée de Cluny.

Figure 91. *Book Cover
with Enameled Scenes of the Passion.*
Gilt bronze, champlevé enamel,
ivory, and gems, 14-9/16 x 10-1/4
inches (37 x 26 cm.). Germany,
Lower Saxony, Hildesheim, ca.
1170. *Gospels* from the Church of
St. Godehard, Hildesheim. Trier,
Cathedral, Treasury, ms. 141/126/70.

Figure 92. *Sacrifice of Abel,
Crucifixion, Sacrifice of Abraham*
(crowning plaque of a pyx).
Champlevé enamel and gilt-copper,
8-3/8 x 3-5/8 inches (21.3 x 9.2
cm.). CMA 49.431 (See also Color
Plate XII F.)

Figure 93. *Scenes from the Passion, Old Testament, Ecclesia, and Synagogue,* framing an altar stone (top of *Portable Altar from Stavelot Abbey*). Champlevé enamel, 3-15/16 x 10-13/16 inches (10 x 27.5 cm.). Meuse Valley, Stavelot, ca. 1150-1160. Brussels, Musées royaux d'Art et d'Histoire, Inv. 1580.

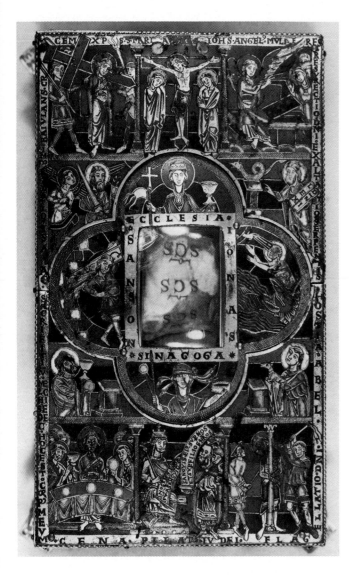

E). The narrow strips of enamel on the plinths with white, yellow, and blue quatrefoil designs may suggest another element of Colognese influence since they are in the cloisonné technique and the use of the two enamelings is a characteristic found in the shrines made in the immediate circle of Eilbertus. The combination of cloisonné and champlevé, if uncommon in Hildesheim metalwork is, nonetheless, also distinctive to the slightly earlier *Portable Altar of the Four Cardinal Virtues.*

Still connected to the *St. Walpurgis Shrine,* but with a more fluid drawing style and a softer effect of volume again due, it seems, to the influence of Cologne (Figure 76), is the plaque with the bust-length figure of St. Matthew, sole remaining decoration of a beechwood casket once in the Guelph Treasure and now in Brunswick. The more ambitious compositions of three plaques depicting the Crucifixion connected stylistically to the St. Matthew enamel further suggest a renewal of influences from the Mosan region, particularly from Stavelot, as well as from Cologne. These plaques are now in Paris (Figure 90), Trier (Figure 91), and Cleveland (Color Plate XII F, Figure 92).[54] The Crucifixion scene as it appears on one of the gables of the *St. Walpurgis Shrine* (Figure 85) might have stood as distant model, but a new modus operandi is now evident.

The first (Figure 90) of the three plaques, with a rounded top — once part of a reliquary now in the Musée du Cinquantenaire in Brussels — is the crispest in design. It is also probably the earliest, judging from the many small supporting pin-like elements within the enamel fields left to securely hold the poured enamel (further technical refinements in enameling processes eventually made these pins unneccessary). The crucified Christ, as he dies on the Cross before his grieving mother and favorite disciple, sheds his blood into the chalice of his spouse Ecclesia. She is the crowned Church holding the long staff with the cross and the pennant of Victory, clear symbol of the Redemption. On his left, a blindfolded figure, whose cap falls as she gestures emphatically and strides away, is Synagogue, symbolizing those who knowingly refuse the evidence of Christ's godliness and sacrifice. The ecclesiastic donor (unless he be the enameler) is portrayed prostrated under the cross. Apprehensively looking up, his broad-featured face nearly approaches a caricature. The figures, reserved in gilt-copper with the inclusion of some white enamel, are outlined against a cobalt blue background, while the cross and ground line are a deep green. The rich iconography flowing with narrative verve, as well as the figural style with its rather soft forms and accidental folds defined by reserved figures, can clearly be related to Mosan enamels such as the *Portable Altar from Stavelot Abbey* (Figure 93), whose involved

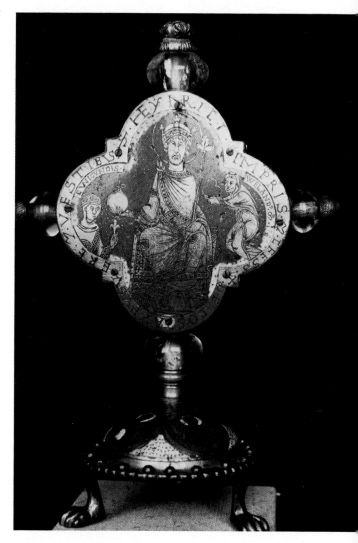

Figure 94. *Henry II Flanked by Cunigonde and the Monk Weland* (detail of *Reliquary of Henry II*). Gilt-bronze and champlevé enamel, H. of quadrilobe: 4-3/4 inches (12 cm.). Germany, Lower Saxony, Hildesheim(?), ca. 1185. Paris, Musée du Louvre.

compositions also include prominent representations of Ecclesia and Synagogue.[55] Yet major elements suggest Hildesheim for the Paris plaque, with its broad forms, rather stubby proportions, more detailed folds, and lack of spatial efffects.

Important as concurring evidence for a Hildesheim origin of the Paris enamel is the plaque incorporated in the cover (Figure 91) of a gospel book now in the Trier Cathedral Treasury but which, as in the case of the *Tegernsee Gospels*, is also firmly recorded as having been in the Church of St. Godehard of Hildesheim until 1799. The field of this second plaque is divided into three registers. The central one reproduces, in a nearly identical though less bold and rhythmic fashion, the same dramatic Crucifixion scene, suggesting that the Paris composition served as its example. While intent on conveying some modeling, the drawing in the second plaque has become relatively linear, more closely akin to that of the enamels on the *St. Walpurgis Shrine*.

A rectangular plaque with the same Crucifixion (Figure 92) enframed by large lobed scenes, one depicting the sacrifice of Abel, the other that of Abraham, forms the lid of a box now in Cleveland (Color Plate XII F). The hues are slightly lighter in shade than those of the plaque (Figure 90) in Paris though they are not as luminescent in quality. The box — which might conceivably be referred to as a pyx, but by no means as a portable altar as has been suggested (it never contained a consecrated stone) — is highly unusual in its shape for this period. Also of note is the fact that the large plaque simply rests unsecured on the walls of the box; the small hooks, probably not original elements, at the end of each lobe of the plaque serve no purpose as the object now stands. Similarly uncommon are the curving end plaques along the sides of the "pyx." All four narrow side elements, as in the case of the *Portable Altar of the Four Cardinal Virtues* and that of *Abraham and Melchizedek*, are in the cloisonné technique bearing a pattern of large diamonds in the same shades of blue and green as on the crowning plaque. Two styles of drawing as well as sources of inspiration are involved in the main plaque of the Cleveland "pyx." The central scene — if it indeed depends on the enamel from the *Gospels of St. Godehard* (Figure 91), as it would appear — is relatively heavy, angular, and somewhat inarticulate in contours, while some details are summarized (falling crown of Synagogue), exaggerated (Ecclesia's staff, gushing blood of Christ), or misunderstood (Virgin's gesture, placement of Christ's feet). The scenes in the lobed areas, especially the sacrifice of Isaac, seem freely borrowed from the *Portable Altar with Abraham and Melchizedek* (Figure 89) both in terms of their iconography and more freely flowing forms. Nonetheless,

the whole plaque was certainly executed by one hand; witness such a particular detail as the choppy ground line with small treacherous cavities carried through each of the three fields. Such preliminary observations might suggest that the "pyx" is a transitional piece and that a more thorough reassessment of its components is necessary.

A third group of enamels, which seems to be a more refined outcome both of the *St. Walpurgis Shrine* and the Paris-Trier Crucifixion plaques, is represented by the *Reliquary of Henry II* (Figure 94) and by a series of ten small rectangular gilt-copper plaques with rounded tops, each with a seated gesticulating prophet (Color Plates XII A-D, Figures 95-97).[56] These are the crowning achievement of twelfth-century Lower Saxony enamels. Though their style ultimately derives from the Co-

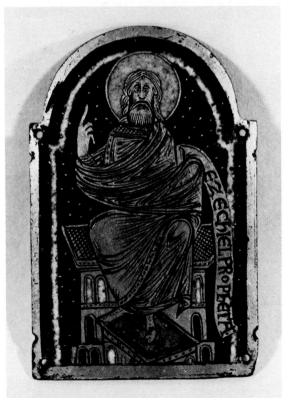

lognese mode of Eilbertus, the artists, perhaps two, are passionate draftsmen, influenced in our opinion, by new models which seem English and Byzantine rather than Mosan.

The *Reliquary of Henry II* (Figure 94) is composed of addorsed quatrefoil enamels mounted on an enameled base carried on three gilt-bronze feet. On the obverse surrounding Christ appear three kings in bust-length: SS. Oswald and Sigismund, kings of Northumbria, and "EVGEVS" (probably Owain of Scotland). On the reverse quatrefoil the saintly emperor (canonized in 1152), solemn and hieratic in his full regalia, is shown with his wife Cunigonde (not represented as a saint as she was canonized only in 1200) in bust-length on his right. Nearly as unassured as his brother on the Paris Crucifixion plaque, an older monk, represented in reduced scale, humbly presents to our view a conceptual rendering of the reliquary echoing the shape of the imperial orb. An inscription in niello behind the bent figure identifies the cleric as "Weland." While he is otherwise unknown to us, he might be the donor or the goldsmith. Since the art historian Georg Swarzenski's writings in 1932, this aristocratic reliquary has been connected with the patronage of Henry the Lion, who would have seen in his eleventh-century namesake, also of Swabian ancestry and a great patron of the arts, the embodiment of his own personal ambitions.[57] Although there is no indication on the reliquary substantiating this hypothesis, it is a very tempting one which would in turn suggest that Weland was not the donor but indeed the goldsmith who fashioned the object. Historically as well as artistically, the work seems to be an appropriate ducal commission, particularly during the decade 1185-1195 when Henry returned to Brunswick from England after his fall from power and stressed his ties to the English throne, perhaps to compensate for his vanished dukedoms, a loss which he never accepted. This also seems to be the time when the Lion ordered his gospel book in which two miniatures (Figure 33) clearly emphasize this same compensating imagery.

Figure 99. *St. Paul Disputing with the Greeks and the Jews; St. Paul among His Disciples.* Copper plaques with champlevé enamel, 3-7/16 x 5-1/16 inches (8.7 x 12.8 cm.), ca. 1170-1180. England, Winchester Abbey. London, Victoria and Albert Museum, M.223-1874; New York, Metropolitan Museum of Art, 17.190.445, respectively.

The enamel plaques of the Henry II reliquary (Figure 94) are particularly fluid in style with small drapery folds either converging on the diagonal or forming rounded contours to suggest three-dimensional effects. A very similar treatment of forms, though less defined, is apparent in some English manuscripts and enamels of the 1170-1180s; for example, in a miniature of the seated Christ (Figure 98) likely to have been produced at the Abbey of Ramsey and a series of plaques (Figure 99) that have been connected with Winchester.[58]

Figure 100. *St. Mark.* Ink and tempera on parchment, 10-3/16 x 7-7/8 inches (25.9 x 19.9 cm.). France, Monastery of Hautvillers, ca. 816-823. *Gospels of Archbishop Ebbo.* Épernay, Bibliothèque municipale, ms. 1, folio 60v.

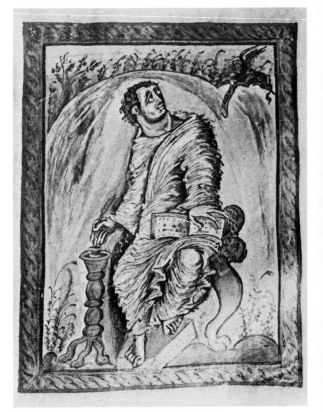

Of the ten Lower Saxony plaques with prophets, four are in Cleveland (Color Plate XII A-D), two in a private collection in Switzerland, and one in each of the following cities: Cologne (Figure 95), Dijon (Figure 96), Leningrad, and Düsseldorf (Figure 97). They obviously once belonged on a reliquary such as the *St. Walpurgis Shrine.* This is made all the more apparent by the letter marks incised on the back of each plaque which served to indicate their placement. The style of these enamels, though showing a somewhat mannered stage, is in essence the same as that of the Henry II reliquary, but the drapery folds now swirl energetically as if controlled by an intense life of their own. This nervous agitation nearly suggests the experiments of the Reims School of Carolingian times, as best represented in the series of seated evangelists (Figure 100) in the famous gospel book made for Archbishop Ebbo by the Utrecht Psalter Workshop, though in fact it is probably more simply a mannered reflection of Byzantine art of the Comnenian period (Figure 131), whose modes, as we will find, deeply influenced contemporary minature painting and early thirteenth-century sculpture of northwestern Germany.

In conclusion, it is evident from the preceding paragraphs that enamelers who produced plaques in the style we call "Hildesheim" were not working under the rigid rules of a single workshop; each experienced the influence of different models —probably both simultaneously and in quick succession. Shortly before 1200 there is an abrupt cessation in the production. The group that had executed many of the finest shrines of the Guelph Treasure was perhaps disbanded at the death of Henry the Lion or following some political upheaval. We do not know.

When a large and particularly venerated relic was obtained, it was not uncommon in Romanesque times to make a shrine for it reproducing the shape of the memento but in a state *ad vivum.* In this manner, the receptacle became a tangible representation that could be held up before the faithful. Such are the five arm reliquaries of the Guelph Treasure dating to the time of Henry the Lion. As in the case of the St. Blaise arm (Figure 29), they are constructed of a carved wooden core over which sheets of silver have been carefully modeled. Distinctive to these arm reliquaries, however, is a new aesthetic: the limb has become more graceful and is clothed in a vestment usually represented in gilt-silver with delicate die-stamped borders rather than with cabochons and filigree.

Figure 103. Base plate of *Arm Reliquary of St. Innocent* (Figure 102) which bears the inscriptions: BRACHIV SCI INOCEII MR DVCIS TEBEORV (Arm of St. Innocent Martyr, leader of the Theban Legion); DVX HEINRICVS ME FIERI IVSSIT AD HONOREM DEI (Duke Henry had me fashioned for the glory of God).

Figure 101. *Arm Reliquary of St. Theodore.* Partially gilt-silver on a core of pear wood, H. 20-1/16 inches (51 cm.). Germany, Lower Saxony, Brunswick(?), shortly after 1173. Berlin, Staatlichen Museen Preussischer Kulturbesitz, Kunstgewerbemuseum, Inv. W20.

Figure 102. *Arm Reliquary of St. Innocent.* Gilt-silver on a core of pear wood, H. 19-3/4 inches (50.2 cm.). Germany, Lower Saxony, Brunswick(?), shortly after 1173. Berlin, Staatlichen Museen Preussischer Kulturbesitz, Kunstgewerbemuseum, Inv. W19.

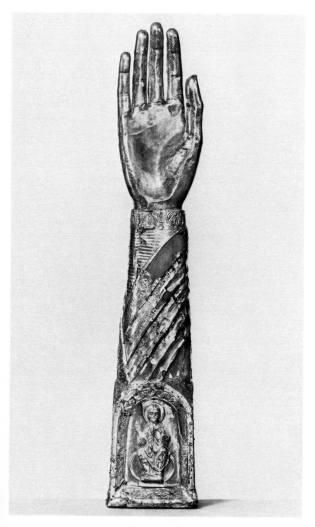
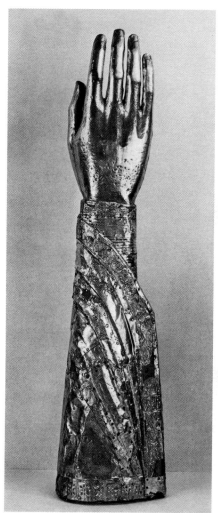

One of our principal historical sources, the abbot of St. Giles in Brunswick, recorded through Arnold von Lübeck's *Chronicle* the presence of arm relics among the important mementos brought back by Henry the Lion from the Holy Land and Constantinople in 1173. The duke, it would appear, had some enshrined with no delay and others later on when the reconstruction of the Church of St. Blaise was well under way. The *Arm Reliquary of the Apostles* (Color Plates XIV-XVIII), however, appears to have been made during the very last years of the Lion's life.

Two of the earlier reliquaries, that of St. Theodore (Figure 101) and that of St. Innocent (Figure 102), bear the inscription DVX HEINRICVS ME FIERI IVSSIT AD HONOREM DEI (Duke Henry had me fashioned for the glory of God) on their base plate (Figure 103). A third, that of St. Caesar, though lacking this indubitable proof, was also clearly made in this workshop, as can be seen from the same die-stamped armband and sleeve border. All three reliquaries were probably made soon after January 1173.[59]

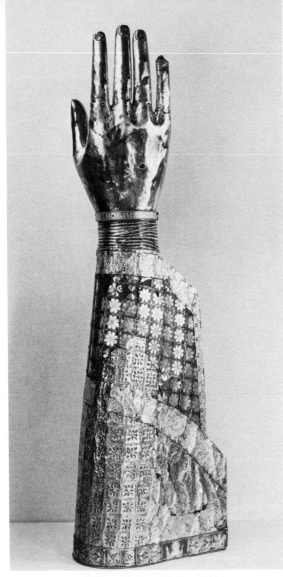

Figures 104-105. *Arm Reliquary of St. Lawrence.* Partially gilt-silver, niello, and rock crystal on a core of cedar, H. 21-3/16 inches (53.8 cm.). Germany, Lower Saxony, Hildesheim(?), ca. 1175-1180. Berlin, Staatlichen Museen Preussischer Kulturbesitz, Kunstgewerbemuseum, Inv. W23.

Another, the *Arm Reliquary of St. Lawrence* (Figure 104) of a somewhat later date is especially important for it is connected by style and technique to several other Saxon metalworks of particular quality, all associated with Henry the Lion in some manner. In comparison to its earlier counterparts, this arm is now bedecked in two wider sleeves decorated with seven different punched floral designs within small squares; the crude four-leaf cut-out pattern is a fourteenth-century restoration. On the border of both sleeves have been applied delicate sheets of gilt-silver with die-stamped motifs. Particularly important is the band which circumscribes the base of the reliquary (Figure 105). It includes, in addition to restorations, small gilt-silver mounted plaques with a nielloed acanthus design and others with busts of gesticulating apostles and angels seen against a tight spiral foliate pattern in the same technique. The base plate, a fourteenth-century replacement, simply bears the name S:LAVRENCII.M'.

The same spiral pattern and delicately nielloed figures recur on two superb chalices today in Vienna and Gniezno, on the so-called *Bernward Paten* from the Guelph Treasure, now in Cleveland, and on the *Head Reliquary of St. Oswald* in the Hildesheim Cathedral Treasury. The latter (Figure 106), a particularly striking object, is a domed octagonal structure with nielloed silver plaques depicting a seated king on each of the eight sides. Somewhat incongruously surmounting the whole is a gilt-silver crowned head. In the lunettes around the dome alternate representations of the Four Rivers of Paradise (Figure 107) and the symbols of the evangelists, some with the recurring nielloed spiral pattern. The fact that Oswald was king of Northumberland and that seven of the rulers appearing on the

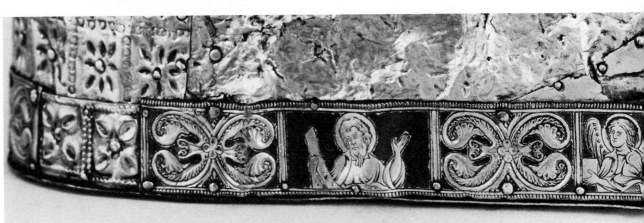

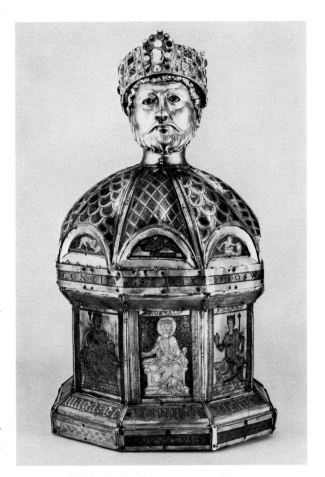

Figure 106. *Head Reliquary of St. Oswald.* Partially gilt-silver, niello, on a core of oak, ca. 1180; crown: gold, cloisonné enamel, gems, and pearls of ca. 1000, H. 17 inches (43.2 cm.). Germany, Lower Saxony, Hildesheim(?), ca. 1180. Hildesheim, Cathedral, Treasury.

silver plaques are English suggests that the relic enshrined within the reliquary was acquired by Henry the Lion after his marriage to Matilda Plantagenet in 1168, and that he may have commissioned the metalwork.

The earliest known pieces attributable to the goldsmiths responsible for the St. Oswald reliquary are probably two chalices made for political allies of Henry the Lion.[60] Most prominent among them is the example (Figure 108) executed with its paten — the plate designed to hold the bread of the Eucharist — for Count Berthold III of Andechs (1148-1184), who is named in the inscription on the rim of the foot. The count, who is recorded to have frequently been very useful to Henry the Lion in patching up quarrels with his enemies, gave the chalice to Wilten Abbey. Fifteen Old Testament scenes are represented in medallions on the foot of the chalice, while on the cup itself appear eighteen from the New Testament. All are on a background of the characteristic nielloed spiral decoration.

Highly important among Guelph Treasure objects is the "*Paten of St. Bernward*" now in Cleveland (Front Cover and Color Plate XIII), another product of the St. Oswald Reliquary Workshop. Probably made for the Treasury of St. Blaise at the commission of Henry the Lion,[61] it was mounted two centuries later in a Gothic monstrance as if it actually were a remain of the saint's body. The Cleveland paten was undoubtedly originally designed to serve in conjunction with a magnificent chalice.

Figure 107.
River of Paradise
(detail of *Head Reliquary of St. Oswald*).

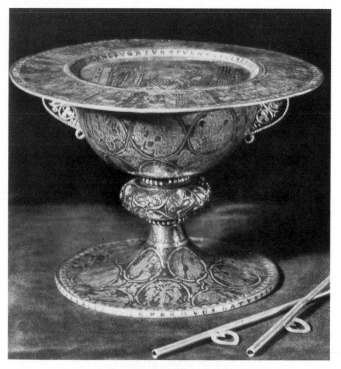

Figure 108. *Chalice, Paten, and Fistulae* presented by Count Berthold III of Andechs to Wilton Abbey (Innsbruck). Gilt-silver, niello, chalice: H. 6-9/16 inches (16.7 cm.); paten: Diam. 9-1/4 inches (23.5 cm.). Germany, Lower Saxony, Hildesheim(?), ca. 1172. Vienna, Kunsthistorisches Museum, Inv. 8924.

Its rather small size suggests that it was probably not a *patena ministeralis* to be used for the distribution of communion to the faithful. A Latin inscription on the exterior rim emphasizes its intended function: "The bread which is broken in me is the body [of Christ]: he shall live eternally he that receives it in faith." In the central field Christ is shown seated upon the rainbow of the Covenant, arms outstretched; a Latin inscription surrounding the image didactically emphasizes its promise of salvation: "Be witness! You have been redeemed by His death." Medallion-like with its strong niello band, the central field is surrounded by acanthus shoots and by the symbols of the evangelists alternating with representations of the Four Cardinal Virtues, all within a series of lobes and on a background of the typical spiral decoration.

Because of its association with the saint, the paten was greatly revered and was mounted in the late fourteenth century in its present monstrance flanked by turrets, and surmounted by a triangular gable bearing the Latin inscription "The Sign of the Lord," containing two slivers of the True Cross protected by plaques of rock crystal. Eight small bags of identified relics wrapped in alternating red and green silk are set on the reverse of the paten (Figure 109) and are visible through another protective rock crystal plaque. An inscription on a horizontal band of vellum attributes the making of the paten to St. Bernward (ISTA[M] PATENA[M] FECIT S[ANCTUS] BERWARDUS). That the object was actually fashioned by the saint (who died in 1022) might be possible, but then it would have been left strangely unadorned, for its decoration clearly dates from over a century and a half later. The fragments of the True Cross set above the paten might be there in order to reinforce the attribution of its making to Bernward, since it was always well known that the saintly bishop received a particle of this most distinguished relic from Otto III. Yet by 1482 there might have been some doubt as to the authenticity of the attribution since the inventory of that date describes the monstrance as: "Item, una magna [monstrancia] in qua continetur pathena quem fecit sanctus Godehardus" (a large monstrance in which is held the paten which St. Godehard made).

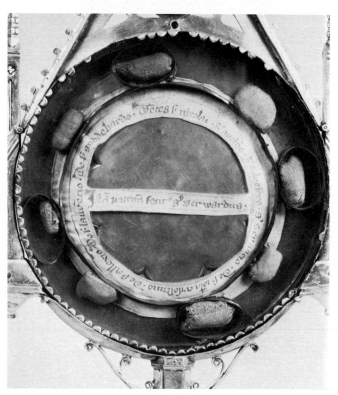

Figure 109. Back of *"Paten of St. Bernward"* (CMA 30.505) with relics and parchment bearing inscriptions. Center horizontal band: *Istā patenā fecit S Berwardus.* Clockwise around: *De re S nycolai. S'auctōe. S'Silvestro. S'Servacio. De S iohn crisostimo. De S allexio. De S laurēncio. De S goddehardo.*

The series of objects attributable to the St. Oswald Reliquary Workshop has traditionally been connected with Hildesheim because the head reliquary has been owned by the treasury of this cathedral since time immemorial, and because of the Cleveland paten's association with St. Bernward.[62] The commission of the reliquary clearly falls within the tight web of relations that Henry sustained with England, and in this context it may be pointed out that the niello spiral motif recurs in nearly identical forms on the clasps (Figure 110) of the *Puiset Bible* and on the reverse of a matrix for a seal of Lincoln Cathedral, both produced in England around 1160. Irregardless of the actual location of the workshop in Saxony, be it Hildesheim or the court of Brunswick, the duke may well have been instrumental in its activity more than in that of any other workshop. The English connection with the spiral niello designs, although it cannot be blown to a full relationship, should perhaps not be overlooked, nor should the free drawing of the figures which recalls, for example, the Virtues and Vices on the *Troyes Casket*, an English enameled work of about 1170.[63]

Particularly striking among objects of the Guelph Treasure dating from Henry the Lion's time or perhaps to the beginning years of his son's rule, is an arm reliquary (Color Plates XIV-XVIII) in Cleveland.[64] The absence of the closing plaque at the base may deprive us of an inscription such as that on the arms of SS. Theodore and Innocent. In the silver capsula, rolled in linen which is tightly jammed in the cavity (Figure 111), might very well be relics of the apostles, judging from the very prominently displayed chased figures of Christ and his disciples at the base and cuff of the sleeve of the object (Color Plates XVI-XVIII). The shrine would then have been made to hold some of the relics which the chronicler refers to unspecifically as "brachia apostolorum plura." This arm reliquary, however, did not belong to the Treasury of St. Blaise until the sixteenth century; historical evidence would suggest that it had been originally presented by the Lion to a second foundation of which his family had been the major benefactor since 1079, the Monastery of St. Cyriacus, built east of Brunswick on a hill near the Oker.[65]

The raised hand, not quite life-size (Color Plates XIV-XV), is more subtly modeled than that of any of the other arm reliquaries in the Guelph Treasure. The extended arm is clothed with a finely woven silk-like garment forming a series of tight ripples and ending at the wrist with a braid of delicately stamped acanthus leaves vividly recalling the border surrounding the stone of the *Portable Altar of the Four Cardinal Virtues* (Figure 82). Over the chemise is the sleeve of a rich ecclesiastical vestment, with cascading diagonal v-folds that flow much more

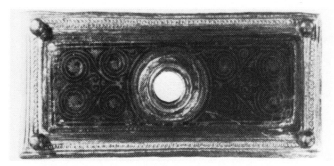

Figure 110. *Clasp from the Puiset Bible.* Nielloed copper, 1-3/16 x 2-5/8 inches (3 x 6.7 cm.). England, ca. 1170-1180. Durham, Dean and Chapter of Durham Cathedral, ms. A.II.

Figure 111. Base of *Arm Reliquary of the Apostles* showing oak core and cavity with a bone-shaped silver capsule enrobed in linen (CMA 30.739).

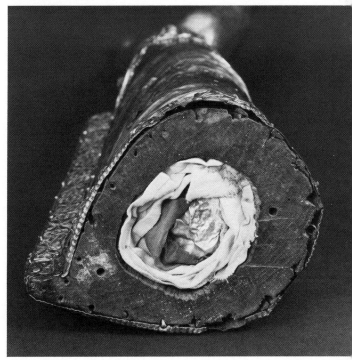

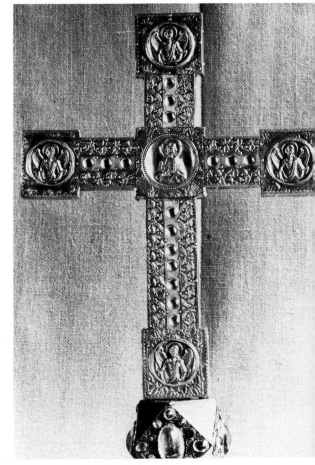

Figure 112. *Reliquary Cross of Henry the Lion* (back). Gilt-silver and gems on a core of wood, H. 16 inches (40.7 cm.). Germany, Lower Saxony, Hildesheim or Brunswick(?), ca. 1200, with later additions. Hildesheim, Cathedral, Treasury (on deposit from the Pfarrkirche Heiliges Kreuz).

freely than the drapery of the St. Lawrence arm. The effect is but slightly marred by the damages which the shrine has incurred from being carried in countless processions and from frequent unskilled restorations. Along the upright inside edge of the sleeve is a series of delicate jewel-like champlevé enamel plaques (Color Plate XVIII) in a coloristic palette of dark and pale blue, turquoise, green, and yellow, forming symmetrical floral motifs to my knowledge encountered in Lower Saxony only in some of the nielloed plaques at the base of the *Arm Reliquary of St. Lawrence* (Figure 105). The outer garment is essentially delineated by two striking borders of large medallions (Color Plates XVI-XVIII) in which the embossed bust-length figures, each with an individualized head, also adopt a distinct pose. Apart from Christ, with his cruciform halo, and Peter, holding the key, however, none can be identified. The handling of draperies with naturalistically rendered folds and the free movement of the figures stylistically confirm a very late twelfth-century development of Lower Saxony art. The sophisticated beading outlining the semicircular spaces in addition to the surrounding elements — the convoluted tendrils, luxuriant foliage, and admirably stylized grapes, probably an eclectic Byzantine reminiscence — as well as the general soft effect of forms on the whole arm, are equally telling.

The only related objects we know of are the bejeweled gilt-silver cross (Figure 112) with embossed medallions, documented as having been given by Henry to the Church of the Holy Cross at Hildesheim before his death, and the outer silver frame produced in Lower Saxony for the *Portable Altar in Tablet Form* (Figure 63) of the Guelph Treasure. Though to our knowledge unequaled among metalwork objects of the period, such outstanding pieces became models for monumental Saxon sculpture which until around 1200 was in fact very limited in number. The relief figures in the tympanum of St. Godehard (Figure 113) at Hildesheim and those of the choir screen (Figure 114) of the Liebfrauenkirche in Halberstadt, with the rich effect of their free flowing garments and new vitality in the characterization of physiognomies, are primary examples of sculptures which are seemingly enlarged versions of particularly high quality metalwork.[66]

It is evident that bronze casting in Saxony owed much to Hildesheim, though Magdeburg and Goslar, and perhaps even Brunswick, also later produced large bronzes. The casting location of the columns, with their nearly three-dimensional ornament of leaves and birds made for the altar (Figure 115) that Duchess Matilda endowed in 1188 in the new St. Blaise, and of the candelabrum (Figure 2), sixteen feet high, with a similar

OPPOSITE
Color Plate XIII. *Monstrance* with the *"Paten of St. Bernward."* Monstrance: gilt-silver and rock crystal, with relics wrapped in silk, and a parchment with inscriptions, H. 13-1/2 inches (34.4 cm.). St. Oswald Reliquary Workshop, Germany, Lower Saxony, Brunswick, end fourteenth century. Purchase from the J. H. Wade Fund with additional Gift from Mrs. R. Henry Norweb. CMA 30.505 (See also Front Cover.)

OVERLEAF
Color Plates XIV-XV. *Arm Reliquary of the Apostles.* Silver, gilt-silver, and champlevé enamel on a core of oak, H. 20 inches (51 cm.). Germany, Lower Saxony, Hildesheim(?), ca. 1190-1200. Gift of the John Huntington Art and Polytechnic Trust. CMA 30.739

Color Plates XVI-XVIII. Details of *Arm Reliquary of the Apostles.*

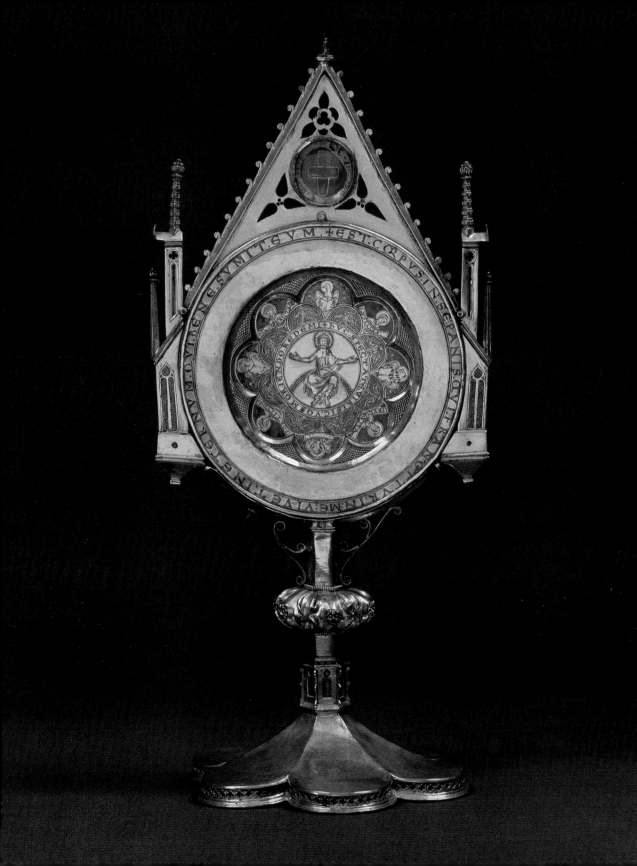

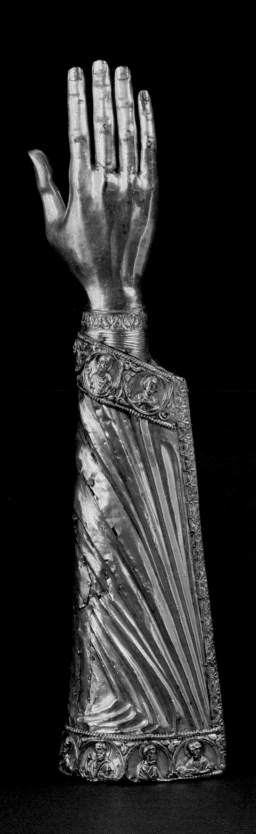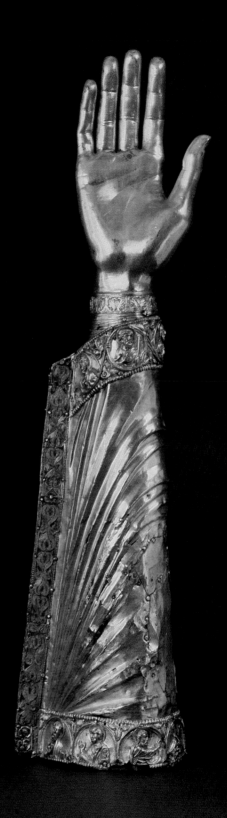

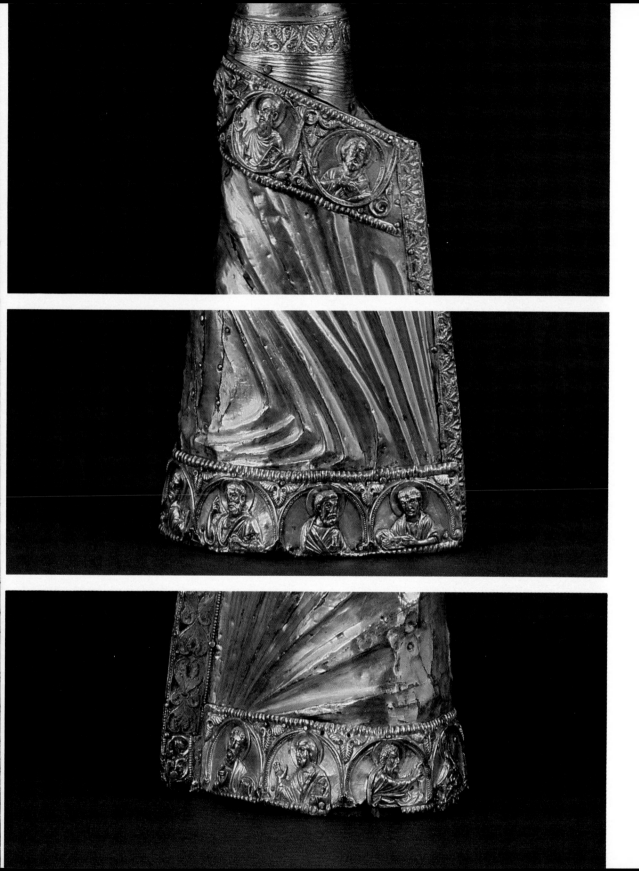

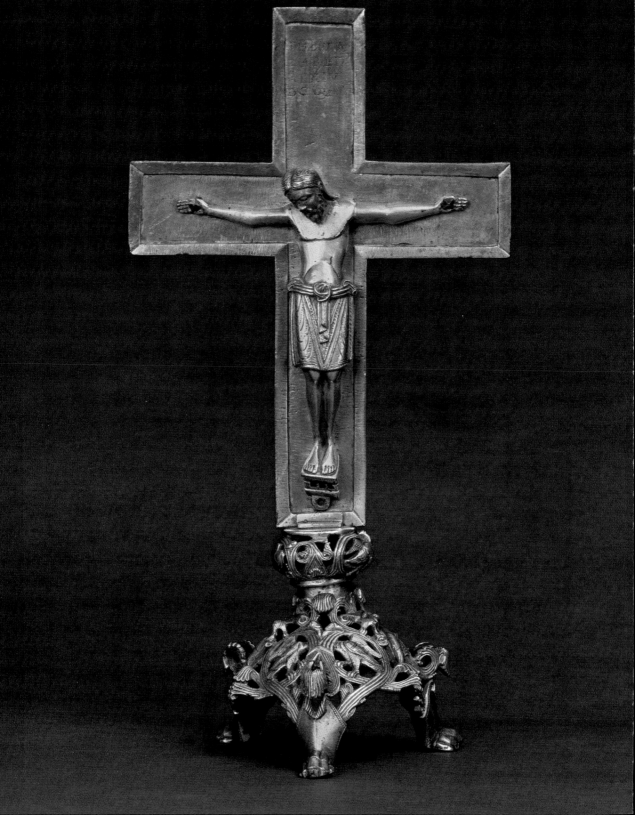

Figure 113. *Christ Between the
Bishop-Saints Godehard and
Epiphanus.* Limestone, 41 x 80 inches
(105 x 205 cm.). Germany, Lower
Saxony, Hildesheim, ca. 1200.
Hildesheim, Church of St.
Godehard, north portal.

Figure 114. *SS. James the
Lesser and Philip.* Lime-
stone with polychromy, H. of
figures: ca. 45 inches (114 cm.).
Germany, Lower Saxony,
ca. 1200-1210. Choir Screen.
Halberstadt,
Liebfrauenkirche.

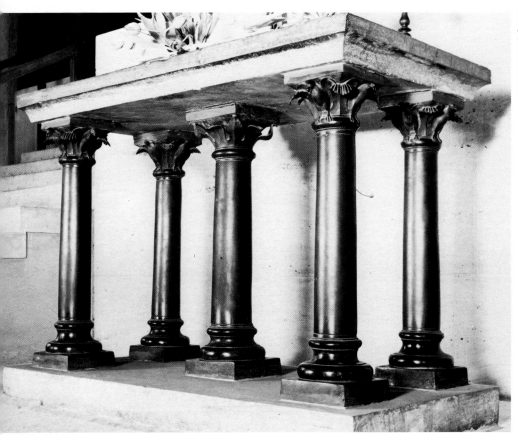

Figure 115.
Altar of the Virgin Mary.
Cast bronze, limestone, and marble. Germany, Lower Saxony, dedicated 1188. Brunswick, Cathedral of St. Blaise.

RIGHT
Figure 116.
Anthropomorphic Bird (detail of *Bronze Candelabrum*). Germany, Lower Saxony, by 1188. Brunswick, Cathedral of St. Blaise.

FAR RIGHT
Figure 117. *Cross of Bishop Bernward.* Cast silver, 7-15/16 x 5-1/2 inches (20.2 x 14 cm.). Germany, Lower Saxony, Hildesheim, ca. 1007-08. Hildesheim, Cathedral, Treasury.

vocabulary of forms (Figure 116), which was placed at center of the nave that very same year, remain unrecorded.[67] Bronze, or any copper alloy, was used not only in monumental works but also for objects for the *ministerium* and *ornamentum* such as crosses and candlesticks. The style of these smaller bronzes considered to have been produced in the Hildesheim-Brunswick axis is marked by simple flowing forms and a general restraint in the ornamentation, in contradistinction to Colognese works, as we shall see.

Two late twelfth- or early thirteenth-century non-Guelph Treasure gilt-bronze objects in The Cleveland Museum of Art seem particularly appealing examples of this Saxon production. The first is an altar cross (Color Plate XIX) which reflects, as do a number of other examples produced in the region, the *Cross of Bishop Bernward* (Figure 117) in its general canons and in the suffering face of Christ full of pathos and dignity. Closer in time to the Cleveland cross are two other gilt-bronze crucifixes (Figues 118-119) in the Hildesheim Treasury, one of which also rests on an involved base with an ornamentation of twisting and overlappng acanthus leaves on four low feet.[68] Distinctive of the Cleveland cross decoration are the large birds

perched on the convolutions of the heavy acanthus (see detail, Color Plate XIX). Twisting their heads over branches, they echo those creatures (Figure 116) bound within the leaves of the monumental Brunswick candelabrum.

The second Cleveland object (Color Plate XX) is fashioned like a Byzantine central-plan church with four main roofs, a lantern roof crowned by a turret, and semi-circular apses, the whole resting on four dragon-shaped feet. A nearly identical object in Berlin (Figure 120) has been proposed as its model, but the argument lacks conviction; of the two, Cleveland's is of higher aesthetic quality with more felicitous proportions and a greater finish in the chiseling.[69] Both objects are devoid of religious symbolism with their decoration of florid acanthus and masonry courses. Although they have been considered as reliquary bases for crosses like the one in Hildesheim (Figure 118), the round tower crowning each of the fanciful constructions lacks a slot into which a cross prong would fit, thus invalidating that hypothesis. In addition, relics which are always rendered inaccessible could have been easily withdrawn from these structures since at least one of the four hinged apsidal doors, secured only with a hook, can be lowered at will. Such

94

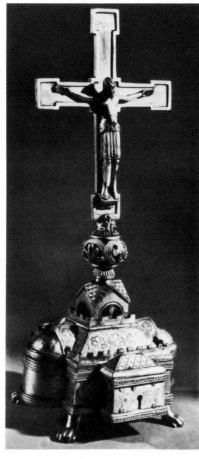

FAR LEFT
Figure 118. *Altar Cross*
from the Abbey Church
of St. Michael at Hildesheim.
Gilt-bronze, 11-3/8 x 5 inches
(29 x 12.7 cm.). Germany,
Lower Saxony, Hildesheim(?),
ca. 1175-1190. Hildesheim,
Cathedral, Treasury.

LEFT
Figure 119. *Altar Cross
with Reliquary-Pyx Base.*
Gilt-bronze, 14-1/2 x 7-13/16
inches (36.8 x 19.8 cm.).
Germany, Lower Saxony,
Hildesheim(?), ca. 1175-1200.
Hildesheim, Cathedral,
Treasury.

Figure 120. *Perfume* or *Incense Burner*. Gilt-bronze, 6-15/16 x 3-5/8 inches (17.7 x 9.2 cm.). Germany, Lower Saxony, Hildesheim, second half twelfth century. Berlin, Staatlichen Museen Preussischer Kulturbesitz, Kunstgewerbemuseum, Inv. 97.4.

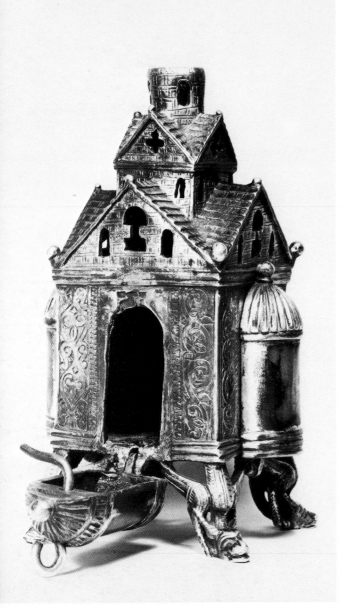

free access to the interior, on the other hand, would be essential in a perfume or incense burner, which is indeed what these objects appear to have been designed as originally. Such receptacles might have been used to burn dried flower petals or leaves valued for their fragrance or purificatory properties. They were not censers as there are no holes or hooks for attaching chains. First devised in Byzantine art (Figure 121), these burners are intended to recall, by their shape, the great temple that, according to textual sources, David had built in Jerusalem. They are related by their technique as well as their symbolism to those elaborate richly gilded metal chandeliers, nine of which are credited to the supervision of Bernward and his successors to the see of Hildesheim.[70] Referred to as *coronas*, those large (approximately five feet wide), wheel-shaped structures were fashioned as a ring of fortified walls interspersed with twelve gates, clear visual translation of the heavenly Jerusalem as it is envisioned in the sacred texts.

If in his patronage Henry the Lion generally seems to have drawn on talents in his own territories, he also appears to have prevailed on a workshop in distant Cologne to produce a major piece of the Guelph Treasure. This is the *Dome Reliquary* in the shape of a church on a Greek cross plan and covered by a ribbed cupola (Figure 122), now in Berlin.[71] The design of the two-storied structure, more than in the case of the perfume burners, could hardly have been conceived without a familiarity with Byzantine architectural forms, even if it is primarily meant to evoke the so-called Omar Mosque in Jerusalem believed in the Middle Ages to have once been the Temple of Solomon. According to the 1482 inventory, the reliquary held the skull of St. Gregory of Nazianzus which Henry the Lion acquired in Constantinople; apart from this information, there is no indication on the shrine itself that it was ordered or purchased for this purpose.

The dome of the Berlin shrine is made of champlevé enamel in coloristic foliate patterns. Enameled columns with large Corinthian capitals in cast gilt-bronze support the arcades of the lower part. The figured decoration is not made of precious metal but of carved walrus ivory which was readily imported from Scandinavia into Cologne, a bustling trading center. (The commerical ties between the Rhineland and the Norse Peninsula through natural waterways, made walrus ivory easily available, replacing the more difficult to find elephant tusk.) Beneath the arcades of the Berlin shrine, against panels of yet differently patterned enamels, are eight pairs of prophets framing each of the four façades bearing a plaque with scenes from the life of Christ in shallow relief against a shell motif background as in

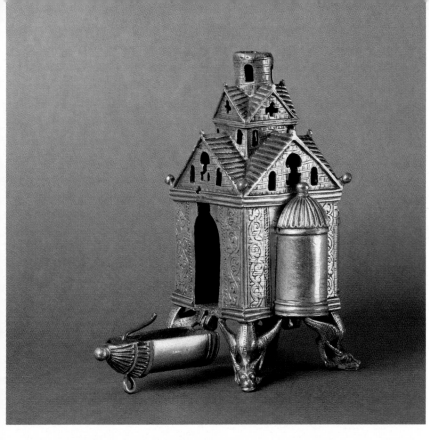

Color Plate XX. *Perfume* or *Incense Burner.* Gilt-bronze, 7-1/8 x 5 inches (18.1 x 12.7 cm.). Germany, Lower Saxony, Hildesheim, second half twelfth century. Purchase from the J. H. Wade Fund. CMA 26.555

Color Plate XXI. *Lion Aquamanile.* Brass, 10-1/2 x 11-7/8 x 5-7/8 inches (26.7 x 30.2 x 15 cm.). Germany, Lower Saxony, Brunswick(?), early thirteenth century. Gift of Mrs. Chester D. Tripp in honor of Chester D. Tripp. CMA 72.167

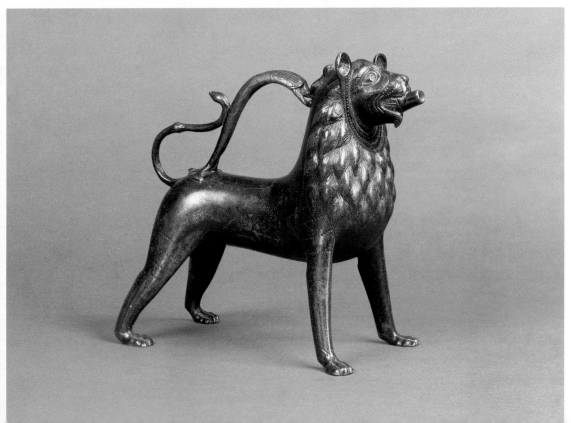

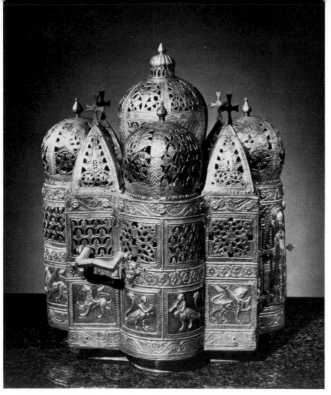

Figure 121. *Perfume Burner* (transformed after 1231? into a reliquary). Silver, gilt-silver, 14-3/16 x 11-13/16 inches (36 x 30 cm.). South Italy (under Byzantine influence), end twelfth century. Venice, San Marco, Treasury, Inv. 142.

antique sculpture. Around the tambour of the dome, also in walrus ivory, are the seated figures of Christ and eleven [sic] apostles.

Traditionally considered as having been commissioned by Henry the Lion, this reliquary, with the Mosan-like floral enamel opulence of its ribbed dome, would speak for a dating of no earlier than the late 1180s. Its Colognese origin is evidenced by its relationship to such late twelfth-century productions from Cologne as the *Shrine of St. Aetherius* (Cologne, Church of St. Ursula), while the colors and style of the floral and geometrical enamels, with their somewhat mechanical contours, evoke the work of the Gregorius Master (Figure 75).[72]

This exquisite shrine is not unique; another (Figure 123), very closely related in shape, materials, techniques, and iconography, was once at the Convent of Eltenberg on the German/Dutch border and is now in London. It was made by the workshop that produced the enamel *Shrine of St. Maurinus* in the Colognese Church of St. Pantaleon and is about three times the size of the

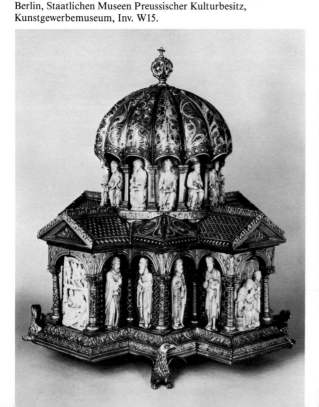

Figure 122. *Dome Reliquary* from the Guelph Treasure. Gilt-copper, champlevé enamel, and walrus ivory on a core of oak, 17-7/8 x 16-1/8 inches (45.5 x 41 cm.). Germany, Cologne, ca. 1185. Berlin, Staatlichen Museen Preussischer Kulturbesitz, Kunstgewerbemuseum, Inv. W15.

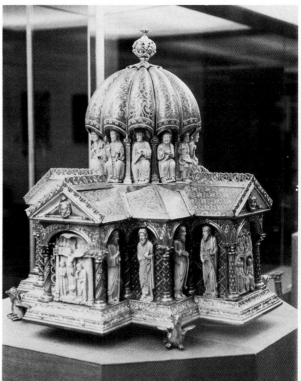

Figure 123. *Dome Reliquary* from Eltenberg. Gilt-bronze and gilt-copper, champlevé enamel, ivory, 21-1/2 x 20 x 20 inches (54.5 x 51 x 51 cm.). Germany, Cologne, ca. 1185-1190. London, Victoria and Albert Museum, 7650.1861.

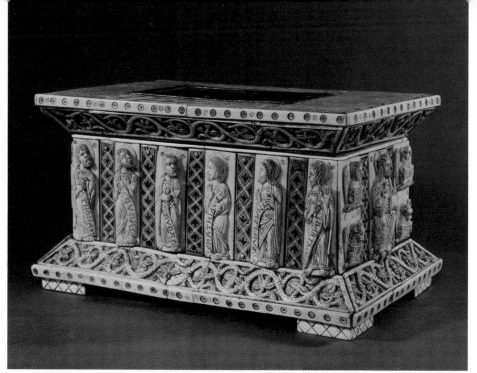

Figure 124. *Portable Altar.* Porphyry, walrus ivory, champlevé enamel, and gilt-copper on a core of wood, 5-1/8 x 10-9/16 x 6-5/8 inches (12.7 x 26.5 x 17 cm.). Germany, Cologne, ca. 1200-1220. Purchase from the J. H. Wade Fund. CMA 27.29

Figure 125. *Enthroned Virgin Surrounded by SS. Nicholas and Medarde, and by Two Other Unidentified Saints.* Limestone with polychromy, 17-11/16 x 30-11/16 inches (45 x 78 cm.). Germany, Cologne, 1175-1180. Braunweiler, Former Benedictine Abbey of SS. Nicholas and Medarde.

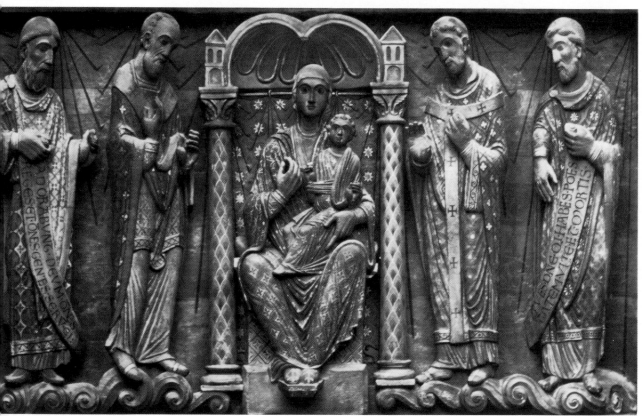

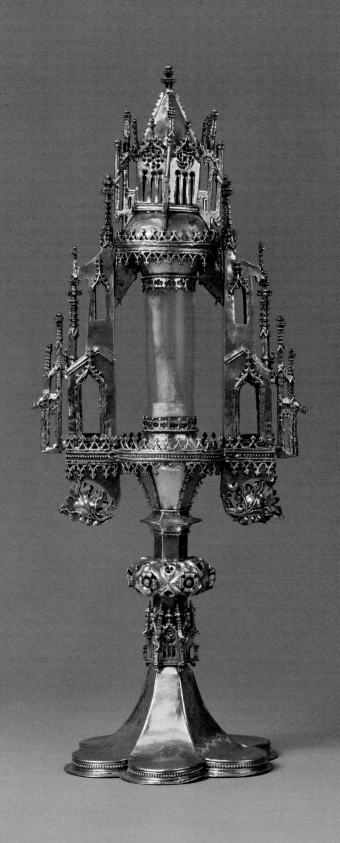

one acquired for the Guelph Treasure. Although it has been proposed that the Eltenberg reliquary served as the model for the Guelph shrine, in our opinion the more obvious, sparkling quality of originality of the Berlin shrine, in contradistinction to a less precise and drier workmanship on the one in London, alone would firmly suggest that the reverse is more likely to be true.[73]

The Cleveland Museum owns a Colognese portable altar (Figure 124), which is nearly contemporary to the Victoria and Albert *Dome Reliquary*. The decoration of the longer sides is composed of the usual series of apostles, while the seated Virgin between the Magi and Christ the Judge between the four symbols of the Evangelists appear on the shorter sides.[74] The carvings on this portable altar are also made from walrus ivory and reveal typical Colognese workmanship as well as taste for highly decorative surfaces with no contrasting plain areas. Each figure is divided by a panel of cloisonné enamel work in a uniform geometric and stylized floral design. A stylistic analogy can be made between the rather inarticulate figures with oversized faces and sharp profiles and clothed in panel drapery, and the Virgin with standing saints on the larger carved stone relief (Figure 125) of about 1175-1180 in Braunweiler, the site of a Benedictine abbey which evidently directed its major commissions to nearby Cologne.

OPPOSITE
Color Plate XXII *Architectural Monstrance with a Relic of St. Sebastian.* Gilt-silver and crystal, H. 18-1/2 inches (47 cm.). Germany, Lower Saxony, Brunswick, ca. 1475. Gift of Julius F. Goldschmidt, Z. M. Hackenbroch, and J. Rosenbaum in Memory of the Exhibition of the Guelph Treasure Held in The Cleveland Museum of Art from 10 January to 1 February 1931. CMA 31.65

When twelfth-century princes commissioned manuscripts, they still called primarily for gospels, as had their forebears. Famous among codices of the period is the gospel book made on order of Henry the Lion and Matilda Plantagenet. In 1983 the volume was sold at a well-publicized auction and is now deposited at the Herzog August-Bibliothek in Wolfenbüttel. The large volume with its 226 leaves had been commissioned about 1185 for the express purpose of being given to the Church of St. Blaise, and in all likelihood it was presented when the altar with the bronze columns (Figure 115) was dedicated by the duchess to the Virgin Mary in 1188.[75] A full miniature in the volume (Figure 126) represents Henry effortlessly supporting the thick codex with one hand and conspicuously offering it to the Virgin through the intercession of St. Blaise as if it should unquestionably guarantee his salvation. On the right is the regal Matilda, officially posed (she may well have paid for the volume) with her right hand held by the goodly St. Giles. Judging from its representation in this miniature, the manuscript then had a rich binding including some goldsmith work in the shape of a large cross. The actual volume is quite unusual among contemporary codices, not only because of its forty-one full-page elaborate mosaic-like miniatures with their intense colors and highly ornamental construction, but also on account of its layout including the spectacular use of gold uncial letters on purple-tinted vellum, harking back to the tradition of Carolingian luxury volumes which in turn is traceable to classical antiquity. The use of gold on purple had been partially revived in Germany before Henry's time, as seen, for example, in the marriage contract of Empress Theophanu in 972 in the Niedersächsisches Staatsarchiv in Wolfenbüttel and in the *Double Leaf from a Roman Gradual* (Figure 127) of about 980 now in the Cleveland Museum. Never in Romanesque times, however, was it employed to such an extent and in so elaborate a volume.[76]

The dedicatory page of the *Gospels of Henry the Lion* not only records the virtues of the duke but also the making of the manuscript at Helmarshausen Abbey by the monk Herimann during the abbacy of Conrad (ca. 1168-1189). As such, it is a particularly important documentary record of the duke's patronage and also provides the basis for localizing and attributing all other contemporary Helmarshausen books.

A prosperous Benedictine house founded in 997, the Abbey of Helmarshausen (Figure 128), of which only scanty ruins remain, stood near Kassel, a good sixty miles southwest of Brunswick. It was undoubtedly a chief artistic center of twelfth-century northwestern Germany. Metalwork had been its greatest output, as underlined by the portable altar made there by Roger

Figure 126. *Virgin and Child in a Mandorla Surrounded by SS. John the Baptist and Bartholomew; Henry the Lion Presents the Manuscript, His Hand Held by St. Blaise, While St. Giles Greets Duchess Matilda.* Tempera, gold, and silver on parchment, 13-1/2 x 10-1/16 inches (34.2 x 25.5 cm.). Herimann, German, Helmarshausen, ca. 1185-88. *Gospels of Henry the Lion,* folio 19. Wolfenbüttel, Herzog August-Bibliothek.

(Figure 55), but it also emerged as a manuscript center perhaps as early as the end of the eleventh century, succeeding the great abbeys of Fulda and Corvey. The monk Theophilus, in his manual of craftsmanship *On Divers Arts*, in fact devotes a few paragraphs to the technique of painting on vellum as it was apparently practiced at Helmarshausen.

Nineteen known manuscripts are securely attributed to Helmarshausen, including eleven gospels, two psalters, one sacramentary, two volumes of the lives of saints, and two undecorated codices. Many of those volumes were produced for members of sister institutions (Abdinghof, Corvey, Helmstedt, Hersfeld, Gnesen, Lippoldsberg, and Lund).[77] The only dated volume is a gospel book of 1194 now in the Wolfenbüttel Library.

One of the earliest volumes known is a gospel book which might have been made about 1130. It is a small codex with canon tables and a representation of each of the gospel writers. These evangelists (Figure 129) — with their patterned hair, mask-like faces, contrived, nearly dancing poses, and highly decorative metal-like draperies — seem to be direct descendants of the effervescent twisting apostles on Heinrich von Werl's portable altar (Figure 55). The extremely ornamented forms, down to minute details, and the somewhat frozen looks of the figures indeed seem to depend to a large extent on models drawn from metalwork. The seated authors in another gospel book of a somewhat later date (Figure 130) in fact appear as if presiding within the ends (Figure 79) of a metal shrine. The colorful and

Figure 127.
Double Leaf from a Roman Gradual. Gold and silver on purple parchment, 11-1/4 x 7-5/8 inches (29 x 10 cm.). Germany, Trier(?), last quarter tenth century. Purchase from the J. H. Wade Fund. CMA 33.446

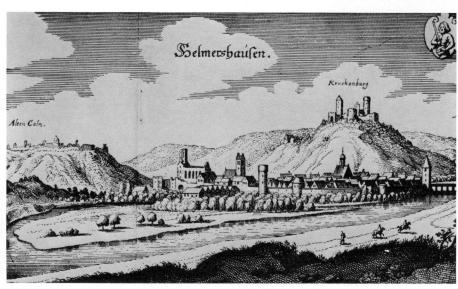

Figure 128.
View of the Abbey of Helmarshausen before Its Destruction. Engraving. Germany, second half sixteenth century.

103

Figure 129. *St. Luke.* Tempera, gold, and silver on parchment, 8-15/16 x 6-5/8 inches (22.8 x 16.8 cm.). Germany, Helmarshausen, ca. 1130. *Gospel Book.* Malibu, The J. Paul Getty Museum, Ludwig ms. II.2, folios 83v.-84.

Figure 130. *St. Matthew.* Ink and tempera on parchment, 12-7/8 x 9-3/8 inches (32.7 x 23.9 cm.). Germany, Helmarshausen, early twelfth century. *Gospel Book.* Trier, Cathedral, Treasury, ms. 139/110/68, folio 14v.

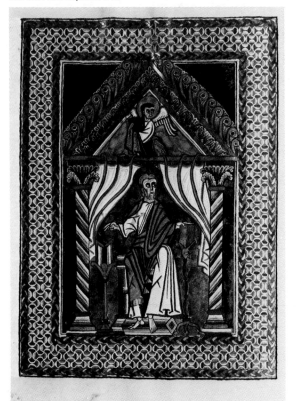

fastidious sumptuousness of these minatures duplicates with pigments the effects of goldsmithing and champlevé enamels, a tradition to which Helmarshausen painters persistently clung.

Another often striking aspect of these compositions is the inclusion of silver surfaces. Throughout the Middle Ages, this metal was rarely used in painting as it tarnishes on contact with the air. Miraculously, the shiny surfaces of the Helmarshausen manuscripts seem to have hardly lost any of their glimmer, a technical feat which should no doubt be seen as an application of the abbey's wide metallurgical knowledge. Either the silvery surfaces have been somehow sealed or, more probably, are composed of a silver alloy containing tin, a whitish, malleable, and unoxidizing metal.

OPPOSITE
Color Plate XXIII. *Solomon(?), Sponsa, Justice, and Truth; Nativity.* Tempera, gold, and silver on parchment, 13-9/16 x 9-1/4 inches (34.4 x 23.6 cm.). Herimann and Byzantinizing Master, German, Helmarshausen, ca. 1190. Leaf (recto) from a *Gospel Book,* ms. 142/124/67 in Trier. Purchase from the J. H. Wade Fund. CMA 33.445

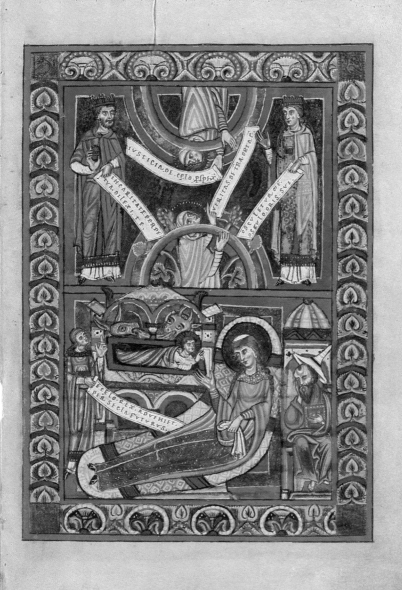

Figure 131. *Ascension.* Tempera and gold on parchment, 8-3/4 x 4-13/16 inches (22.2 x 12.2 cm.). Byzantium, mid-twelfth century. *Gospel Book.* Berlin, Preussischer Staatbibliothek, ms. Graec. quart. 66.

In a broad context, Helmarshausen miniatures were increasingly influenced by Byzantine models, available, it seems, mostly through manuscripts (Figure 131). If such prototypes also prevailed in the productions of major monastic institutions in Westphalia and the Meuse region and at Winchester Abbey in England, they were particularly potent at Helmarshausen. The effects of such an influence are already perceptible in the gospel book of about 1150 in Uppsala (Figure 132), but atttained their full impact in the *Helmstedt Gospels* dated 1194 (Figure 133), with greater expressive and dramatic movements.[78]

Besides the *Gospels of Henry the Lion,* Helmarshausen produced at least two other manuscripts for lay commissions. These are small psalters, probably dating from the late 1370s or 1380s, one in the Walters Art Gallery and the other in London. They

are also generally held to be Henry's commissions. The standing woman (Figure 134) who prominently occupies the entire field on the first illuminated folio in the Walters's volume has been identified as Matilda Plantagenet by Martin Gosebruch on account of the strong resemblance of pose and costume with the duchess as she appears in the gospels ordered for St. Blaise (Figure 33), thus challenging the hypothesis of Goldschmidt who suggested she is the duke's daughter Gertrude, who married the crown prince of Denmark. The man and woman at the foot of the cross (Figure 135) in the fragmentary volume at the British Library have been held to be Henry and Matilda. Though these identifications might conceivably be on the mark, they are not substantiated by inscriptions or iconographic details such as the many precise ones overrunning the gospels which

Figure 132. *St. Jerome Presents His Translation of the Bible to Pope Damasus.* Ink and tempera on parchment, 9-13/16 x 6-11/16 inches (24.9 x 17 cm.). Germany, Helmarshausen, ca. 1150. *Gospels of Lund Cathedral.* Uppsala, Universitätsbibliothek, Cod. C83, folio 1v.

Figure 133. *Last Judgment.* Tempera, gold, and silver on parchment, 12-7/8 x 8-7/8 inches (32.8 x 22.6 cm.). Byzantinizing Master, German, Helmarshausen, 1194. *Helmstedt Gospels.* Wolfenbüttel, Herzog August-Bibliothek, Cod. Guelph. 65 Helmst., folio 13v.

RIGHT ABOVE
Figure 134. *Donatrix.* Tempera, gold, and silver on parchment, 4-7/16 x 2-9/16 inches (11.4 x 6.5 cm.). Germany, Helmarshausen, ca. 1188. *Psalter.* Baltimore, The Walters Art Gallery, ms. W.10, folio 6v.

RIGHT
Figure 135. *Crucifixion with Donor and Donatrix.* Tempera, gold, and silver on parchment, 8-3/16 x 5-1/8 inches (20.9 x 13 cm.). Germany, Helmarshausen, ca. 1170. *Psalter.* London, British Library, Landsdowne ms. 381, folio 10v.

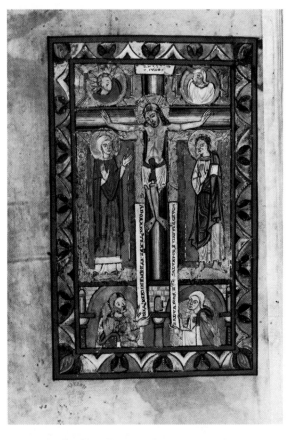

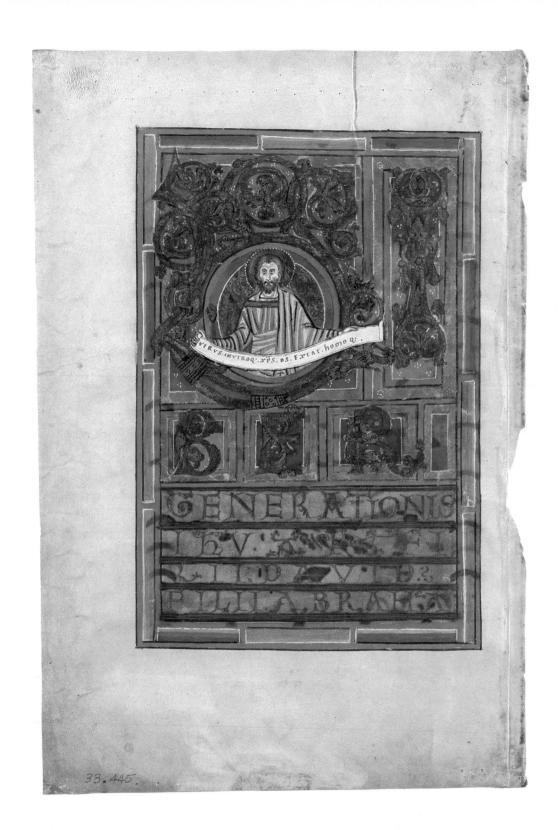

Figure 136. *Teaching Christ, Apostles, Symbols of the Evangelists, Holy Ghost, Virgin, and Child.* Gold, copper, and gems on a core of wood. Germany, Helmarshausen, ca. 1190. Binding of *Gospel Book.* Trier, Cathedral, Treasury, ms. 142/124/67.

Figure 137. *Binding of a Gospel Book from Helmarshausen.* Gilt-silver, gems, pearls, and enamels, 12-7/8 x 9-7/16 inches (32.7 x 23.9 cm.). Roger of Helmarshausen, German, early twelfth century. Trier, Cathedral, Treasury, ms. 139/110/68.

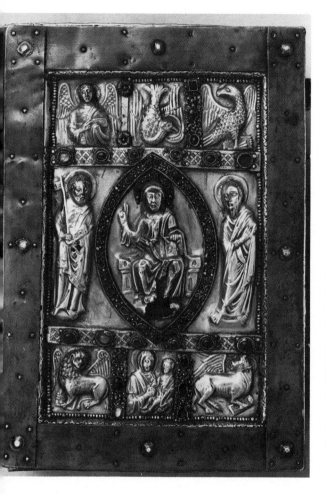

the duke presented to his foundation (Figures 33, 126, 141).[79]

Another Helmarshausen gospel book, lavish if not as sumptuous as Henry's own, has come to the Trier Cathedral Library via the Cathedral Chapter of Paderborn. It is a volume of 195 folios held in a rich binding of goldsmith work (Figure 136). The cover is also probably a Helmarshausen product, the iconographic forms of its signs of the evangelists and its filigree deriving from an early example (Figure 137) widely held to be the work of the monk Roger.[80] The manuscript itself is a late twelfth-century production which can stylistically be dated fairly precisely to the time between the completion of the gospels

Figure 138. *Tree of Jesse*. Tempera, gold, and silver on parchment, 13-11/16 x 9-7/16 inches (34.7 x 24 cm.). Herimann and Byzantinizing Master, ca. 1190. *Gospel Book.* Trier, Cathedral, Treasury, ms. 142/124/67, folio 1v.

Figure 139. *St. Luke*. Tempera and gold on parchment, 13-11/16 x 9-7/16 inches (34.7 x 24 cm.). Herimann and Byzantinizing Master, ca. 1190. *Gospel Book.* Trier, Cathedral, Treasury, ms. 142/124/67, folio 91.

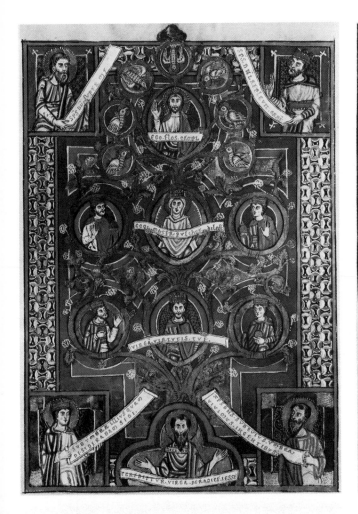

of Duke Henry around 1188 and sometime before 1194 when the *Helmstedt Gospels* (Figure 133) were finished. It is composed of quires of eight folios with pricking marks slightly over a quarter of an inch apart in the upper margins in a manner consistent with similar perforations which have been noted in Henry the Lion's gospels. The Trier gospels now contain seven large miniatures. On the opening folio is the Tree of Jesse (Figure 138), while three other folios bear on their verso the image of an evangelist (Figure 139) and the beginning of his text, and on the preceding recto (Figure 140), a scene from Christ's life. Long ago, when rebound and before entering the Trier Cathedral Treasury, a leaf was detached, which is now in Cleveland (Color

110

Plates XXIII-XXIV).[81] With this folio the missing evangelist is accounted for. On its verso is the beginning of St. Matthew's Gospel: "The Book of the Generation of Jesus Christ, the son of David, the son of Abraham," while its recto represents the *Nativity*. This page was meant to follow directly in the time-honored tradition the miniature of the Tree of Jesse (Figure 138), and in fact may have formed a bifolium with it. The present folio 2 recto of the manuscript, actually the original third, clearly contains the continuation of Matthew's text ("Abraham genuit Issac, Issac autem genuit Iacob . . . ") begun on the verso sheet in Cleveland.

Figure 140. *The Dove Brings an Olive Branch to Noah in the Ark; Baptism of Christ.* Tempera, gold, and silver on parchment, 13-11/16 x 9-7/16 inches (34.7 x 24 cm.). Herimann and Byzantinizing Master, ca. 1190. *Gospel Book.* Trier, Cathedral, Treasury, ms. 142/124/67, folio 54.

Figure 141. *Adoration of the Magi; The Magi Consulting with Herod about where Christ is to be Born.* Tempera, gold, and silver on parchment, 13-7/16 x 10-1/16 inches (34.2 x 25.5 cm.). Herimann, ca. 1185-88. *Gospels of Henry the Lion,* folio 20. Wolfenbüttel, Herzog August-Bibliothek.

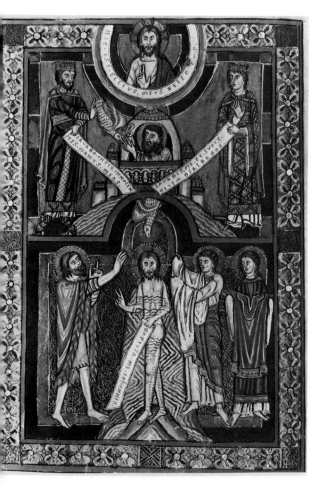

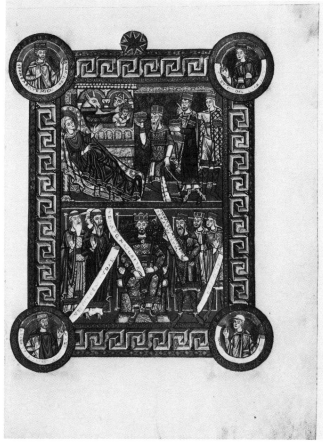

The recto of the Cleveland folio, a particularly attractive page, is divided into separate fields within a decorative border, a format directly depending on that evolved in the *Gospels of Henry the Lion* as clearly illustrated, for example, in the double scene (Figure 141) of the *Epiphany* and of the *Magi Consulting with Herod*. In the upper register of the Cleveland folio stands a crowned couple who calls the attention of witnesses to the Nativity which has taken place below. There, within a standard iconographic layout found on the bronze doors of Hildesheim and in other contemporary manuscripts, the Virgin reclines on a curved couch with wide bands of patterned fabrics. She gestures above to the Christ Child who in turn blesses her from the manger in a manner similar to that of the correspond-

ing figures blessing the Magi (Figure 141) in Henry the Lion's gospels. Old Joseph, his hat askew, slumbers over a book in adjacent quarters. Unusual here is the presence of the Erythrean Sybil, who has replaced the doubting nurse with her withered hand at the foot of the Virgin. Looking up, the Sybil unfurls her timely prophecy: "A future king will arrive from Heaven for eternity." The upper scene is particularly noteworthy for its involved theological equations. The crowned figures are King Solomon and the *Sponsa* (or mystical bride). Each holds a scroll with quotations drawn from the Song of Songs reading as follows in translation: "I have loved you with constant charity"; "May he that kisses with his mouth be kissed on his own mouth." One of the two personifications at center, Justice

111

Figure 142. *Last Judgment.* Tempera and gold on parchment, 13-11/16 x 9-7/16 inches (34.7 x 24 cm.). Byzantinizing Master, ca. 1190. *Gospel Book.* Trier, Cathedral, Treasury, ms. 142/124/67, folio 146v.

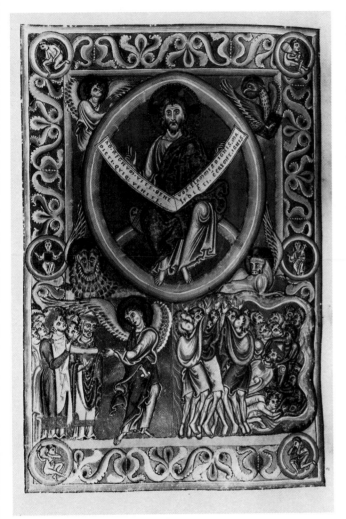

descending from heaven bears a scroll stating "The justice from Heaven has shown through," while the other young woman representing Truth and rising from the earth, proclaims verse 11 of Psalm 85: "The truth has sprung out of the earth."

The topological significance of the miniature and the clear delight in juggling a variety of textual quotations suggest a great familiarity by the cleric who designed the program and probably also the layout of the miniature with the scriptures, the texts of the Church Fathers (particularly St. Augustine), and contemporary theologians and mystics such as Richard of Saint-Victor.

On the verso (Color Plate XXIV) of the Cleveland folio in the large capital letter L (for "Liber") the Evangelist Matthew emerges from a medallion and looks sternly past our world. He holds a scroll with an inscription which in English would read: "Christ is the true God and the true man." The color scheme juxtaposing sharp and pastel tonalities — blues, greens, reds, grays, beiges, and white, with gold acanthus and lettering — is nearly the same as that of the *Gospels of Henry the Lion*, though here more vivid. Historiated initials of this kind represent one of the most favored forms of manuscript decoration of the Romanesque period. Elaborate ornamental initials at the beginning of important sections of text had been an artistic device used in the North ever since the great period of Hiberno-Saxon illumination, and figural elements had been added soon after contact with the Mediterranean world had been established.

The German historian Ekkehard Krüger in his recent study of the scriptorium of Helmarshausen considers that the Trier volume was written by the very scribe who wrote the *Gospels of Henry the Lion*, namely the monk Herimann. Almost nothing is known about Herimann apart from the appearance of his name in the duke's gospels and on a list of contemporary Helmarshausen monks.[82] Because of its wide differences with the *Gospels of Henry the Lion*, the decoration of the Trier gospels can by no means be attributed solely to Herimann. In fact it reveals itself as the collective enterprise of a workshop with two main masters. One is indeed very probably Herimann himself, active in the layout of the volume and in devising the composition of most miniatures. He or his best pupil also painted the majority of the ornamental gold initials characteristically outlined with the saffron color also found delineating figures in the *Gospels of Henry the Lion*.

The second artist of the Trier gospels might be dubbed the "Byzantinizing Master" for he was particularly conversant with late Comnenian modes (Figure 131). This is evident in his sym-

Figure 143. *Lion Aquamanile*. Brass, 10-1/4 x 10-1/16 inches (26 x 25.5 cm.).
Germany, Lower Saxony, Brunswick(?), early thirteenth century. Stockholm, Nationalmuseum, Inv. 4409.

metrically arranged groupings of figures with their somewhat looming faces, glancing out rather intently, and in the fluttering movement of draperies with sharply broken folds painted over a greenish undertone. The painter adapted this vocabulary and array of forms, however, to the more naturalistic German tendencies. At the same time he consciously moved away from the time-honored crowded background so typical of Helmarshausen manuscripts, as is made clearly apparent in the *Last Judgment* (Figure 142) of the Trier codex entirely of his hand,

and even more so in the same scene (Figure 133) of the *Helmstedt Gospels* of 1194, a manuscript for which he was conceptually as well as physically responsible. This second artist was given the largest share in the decoration of the Trier volume which he in fact seems to have completed, often painting over some existing preparatory drawings by Herimann, constantly making modifications to suit his own personal style with larger figures. It was not all that easy a procedure, and some elements, such as the Virgin in the *Nativity*, are fitted in rather than proper-

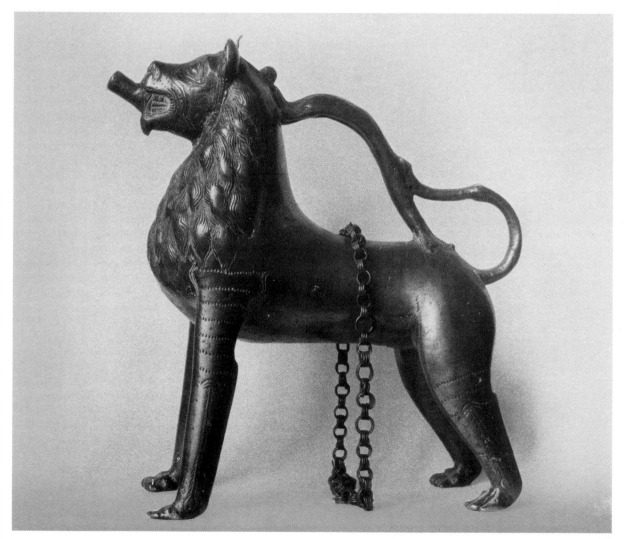

ly integrated. When comparing the *Last Judgment* (Figure 133) with the *Nativity* (Color Plate XXIII) of the same codex, the faces of the figures in both works bear the imprint of the Byzantinizing Master's style, whereas the bodies of the allegories conform to Romanesque canons as known in Herimann's *oeuvre*. The figures in the *Nativity* seem flat when contrasted to the more bulky and agile forms found in the *Last Judgment*. Comparing details of garments from each miniature shows that the pictorial topography of the *Nativity* is governed by a more fluid and continuous approach to modeling with less emphasis on impasto contrasts. Already in such scenes as the *Nativity* or the *Baptism of Christ* (Figure 140), there is an obvious elimination of the chalky ground and a reduction in the layers of pigments which are so characteristic of the miniatures in Henry the Lion's gospels. The Cleveland leaf, therefore, though designed by Herimann, was painted by the Byzantinizing Master who accommodates his figural painting to the flatter, less modulated color scheme of Herimann's tradition. Placing the *Nativity* page (Color Plate XXIII), once part of the Trier gospels, and the *Gospels of Henry the Lion*, side by side, shows the continuity of Herimann's ideas in the later manuscript. They are, however, now exposed to new criteria, especially in the facial renderings, as can be noted in the powerful image of the Evangelist Luke (Figure 139) set within the ornate golden framework of the initial Q — certainly still of Herimann's conception — in the Trier gospels. Herimann thereby appears as the consecrated but aging head of the Helmarshausen workshop into which entered a younger painter of high artistic ability trained in a different and more progressive milieu. By 1194 the Byzantinizing artist had completed the decoration (Figure 133) of what seems to be the last known volume of the Helmarshausen School, infusing a new dynamism into Herimann's constraints and replacing the older master's spirit of *horror vacui* with open gold grounds. His style was continued in Lower Saxony in such a manuscript as Codex 3, produced around 1210, in the Halberstadt Cathedral Museum.

The long series of important works dating from the time of Henry the Lion in the Guelph Treasure clearly emphasizes the vitality of artistic life of northwestern Germany in the twelfth century. They are related in a tapestry of technique, style, decoration, and source, yet mediums by and large remain independent from one another. In no specific way though do they prove that workshops were actually established at the instigation of Henry the Lion and that some were active in the proximity of Dankwarderode. Yet, a consistent thread running through them is the patronage of the duke who, in encouraging the rise of the mercantile class, must by extension have seen to the multiplication and well-being of craftsmen. Henry the Lion's commissions with their relative degree of personal choice and involvement, however, finally did not lead to the creation of a truly indigenous and cohesive style.

Henry nonetheless did leave his mark on Saxon art in a variety of ways, as can be seen, for example, in a series of at least nine cast brass aquamanilia — water vessels used in the Middle Ages for washing hands — two of which dating to the first half of the thirteenth century, are in Cleveland (Color Plate XXI) and the Nationalmuseum in Stockholm (Figure 143). Their source of inspiration is clearly derived from the monumental lion (Figure 4) of 1166 with outstretched rear legs and characteristic ears cast as part of his voluminous mane spreading over the entire upper part of his body. These charming if modest offsprings are likely to have been produced right in Brunswick from metal of the Rammelsberg mine at Goslar of which Henry the Lion's descendants were now part owners.[83]

CHAPTER IV

A Time of Steady Growth: Thirteenth-Fifteenth Centuries

Henry the Lion's son, who was chosen German king and became Holy Roman emperor in 1209 as Otto IV, is an ill-fated figure in German history. Lacking political acumen, he was pitted by the German electors against his cousin Frederick II Hohenstaufen, and was eventually forced to abdicate after much turmoil and the loss of a major battle against the French in 1214. He died tragically at Harzburg Castle, a short distance from Goslar, in May 1218. He had clung tenaciously to his imperial title, defending to the last his right to wear the crown and demanding that he be buried in full imperial regalia. In his will he required his elder brother to retain at least momentarily not only the emblems of power but above all the most sacred imperial relics — fragments of the cross, the holy lance, the crown of thorns, and the tooth of St. John the Baptist — so powerfully did the possession of these objects symbolize for that age protection from heaven as well as supernatural authority.

What role, if any, Duke Henry's son played in the formation of the Guelph Treasure is unclear. Before he died, the Lion had planned to place the Treasure in St. Blaise, but as the edifice was not completed by 1195, the objects were probably kept in the small chapel dedicated to SS. George and Gertrude within Dankwarderode and were not transferred to the collegiale until 1218, only a few months before Otto's death. Their hasty removal at this time to the foundation church was obviously dictated by the great political insecurity of the moment. The document cursorily recording the presentation of the Guelph Treasure speaks of reliquaries "in our father's possession and in ours," perhaps suggesting that Otto himself might have commissioned some of them. Born at the court of his grandfather Henry II of England, Otto was thoroughly influenced by his mother's family, following in this aspect his father's example. Unquestionably he looked up in all ways to his cousin John Lackland and his court, despite their wavering support. Otto's coronation mantle enlivened with bold lions (Figure 144) is an *opus anglicanum*. He and his brothers Henry Count Palatine and Wilhelm of Winchester commissioned the double tomb of Henry the Lion and Matilda (Figure 3). That monument is clearly based on the tombs of Matilda's parents at Fontevrault, with naturalistic effigies imposing in their quiet authority. Yet their vivacity and their overly rich drapery speak in terms of a German idiom allied to the contemporary and striking sculpture of Bamberg Cathedral. Also due to the commission of Henry the Lion's sons are the mural paintings (Figure 2) of the apse and transept of St. Blaise.[84]

After 1218 Brunswick was ruled by Wilhelm of Winchester, so called for his birth at the site of the famous abbey during

Figure 144. *The Virgin Amid Lions* (detail of the coronation mantle of Otto IV). English embroidery with gold thread *(opus anglicanum)* of ca. 1208 on purple Byzantine silk. Brunswick, Herzog Anton Ulrich-Museum, Inv. MA1.

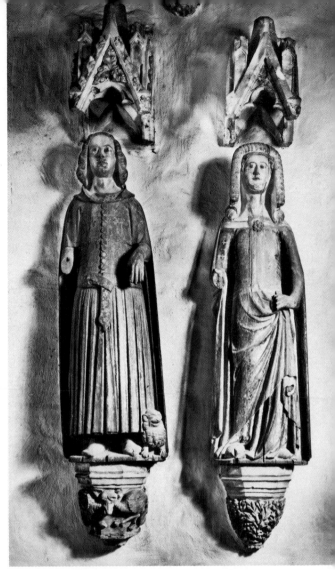

Figure 145. *Bust Reliquary of St. Cosmas.* Partially gilt-silver, niello, and rock crystal on a core of oak, 12-1/8 x 8-3/4 inches (30.8 x 22.2 cm.). Germany, Lower Saxony, Brunswick(?), 1275-1300. Berlin, Staatlichen Museen Preussischer Kulturbesitz, Kunstgewerbemuseum, Inv. W29.

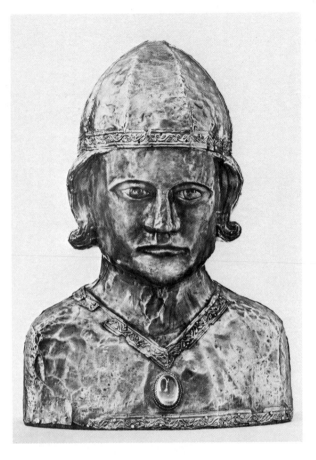

his parents' exile. Eight years later, the construction of the Burgkirche, as planned during Henry the Lion's lifetime, was finally completed. It was then newly consecrated with SS. John the Baptist, Blaise, and Thomas of Canterbury as patrons. After the death of Wilhelm's son Otto the Child in 1252, the alodial territories of Henry the Lion were divided into two separate, if related, dukedoms, that of Brunswick and that of Lüneburg. Wilhelm's grandson Albrecht the Great became duke of Brunswick and continued the main line. The repeated division of the Brunswick-Lüneburg land between the various heirs of the line (the will of Albrecht the Great, for example, had to provide for three sons), was a decisive factor in the steadily waning power and diminishing wealth of the Guelph House.

Nevertheless, numerous objects were added to the Treasure in the thirteenth, fourteenth, and fifteenth centuries, surpass-

ing in number those of earlier periods. Yet it is with rare exception that these additions match from an artistic standpoint the importance of the Ottonian and Romanesque pieces. The House of Brunswick, though, continued in its role of protector and principal patron of the foundation that eventually became the Cathedral of St. Blaise.

In northern Germany, transition to the Gothic style was late in coming, and in the thirteenth century Romanesque art simply took on a hybrid and baroque richness. Particularly striking among such "early Gothic" objects in the Treasure is the *Bust Reliquary of St. Cosmas* (Figure 145), rutilant in the shimmer of its metalic surfaces and having strong, flat, broad forms. The saint's military cap was once crowned by a crest and his lost gaze nearly betrays a barbaric mood, but details, such as the carefully combed gilt hair and the delicate embossed interlace motif of

116

Figure 146. *Duke Otto the Mild and His Wife Agnes of Brandenburg.* Wood (once polychromed). Germany, Lower Saxony, 1346. Brunswick, Cathedral of St. Blaise, south aisle.

Figure 147. Binding of *Plenar for Sundays.* Partially gilt-silver on a core of oak, 10-11/16 x 8-1/4 inches (27.2 x 21 cm.). Germany, Lower Saxony, Brunswick, 1326. Berlin, Staatlichen Museen Preussischer Kulturbesitz, Kunstgewerbemuseum, Inv. W31.

the band on the cap and chemise, imperceptibly speak of the new stylistic current.

The fourteenth century was unequivocally the second most important period for the Treasure. This was primarily due — and this point seems to have been little emphasized — to the benevolent patronage of Duke Otto the Mild (1318-1346), who saw to the general prosperity of Brunswick which under his rule became a center of the Hanseatic League. Otto the Mild ordered the addition (1322-1346) of the Gothic south aisle to the Cathedral of St. Blaise, where sculptures of him and his wife, Agnes of Brandenburg (Figure 146), were placed. Attentive, the duke gave and encouraged others to give to the Treasury of St. Blaise. At the same time he spared no efforts to see to the restoration and enhancement of the valuable objects which had been the gifts of his ancestors, such as the two crosses (Color Plates

I-III) and the portable altar of Countess Gertrude (Color Plates V-IX) and the arm reliquary of St. Lawrence, (Figures 104-105) from Henry the Lion's time. There is also clear evidence of the activity of a goldsmith shop in Brunswick by this time.

During Otto the Mild's reign, the collegiate chapter ordered the binding of a plenar. The book, a venerable manuscript of the tenth century with masses and special prayers for Sundays, according to an inscription on the back flap of the binding, was rebound in 1326. The front cover (Figure 147) is of embossed silver with chased gilt medallions of christological scenes as well as others of the four evangelists against a background of large, symmetrically arranged engraved ivy designs. The central field is occupied by six standing figures: that of the Virgin and Child between SS. Peter and Paul, and below, the protectors of the cathedral, John the Baptist flanked by SS. Blaise and Thomas

117

of Canterbury. Slightly retardative, the style, design, and finish of the object suggest the activity of a provincial workshop familiar with the soft style of courtly child-like figures prevalent in the art of Germany, France, and England around 1300, and bent on the ready appeal of an easy imagery.

Produced by the very same workshop is a large gilt-silver cross (Figure 148) also formerly in the Guelph Treasure and since 1931 in the collection of the Art Institute of Chicago. Mounted on a six-sided copper foot in the fifteenth century, this object, meant to be placed on an altar, bears the figure of Christ in chased relief. Each of the arms ends in a roundel with one of the symbols of the evangelists which are cast from the very same molds as the corresponding forms on the *Plenar for Sundays* (Figure 147), while the swirling tendril punch design on the sides of the cross closely parallels the conceptualized ivy frieze on the binding of the plenar.

An important object only slightly later in date is the reliquary in the shape of a book (Back Cover and Figure 149) in the Cleveland Museum. This noteworthy example of goldsmith work consists of partly gilded silver plaques mounted on a wooden core and framing the large ivory relief of the *Miracle*

Figure 148. *Circular Monstrance with a Relic of St. Christine.* Silver, champlevé enamel, and crystal, H. 8-9/16 inches (21.8 cm.). Germany, Lower Saxony, Brunswick, second half fifteenth century. Chicago, The Art Institute of Chicago, Gift of Mrs. Chauncey McCormick, Acc. 62.90.

Altar Cross. Partially gilt-silver on a core of wood, H. 10-15/16 inches (27.8 cm.). Germany, Lower Saxony, Brunswick, ca. 1326 (the foot is of a later date). Chicago, The Art Institute of Chicago, Gift of the Antiquarian Society, Acc. 31.263.

Figure 149. *Book-Shaped Reliquary* (CMA 30.741). (See also Back Cover.)

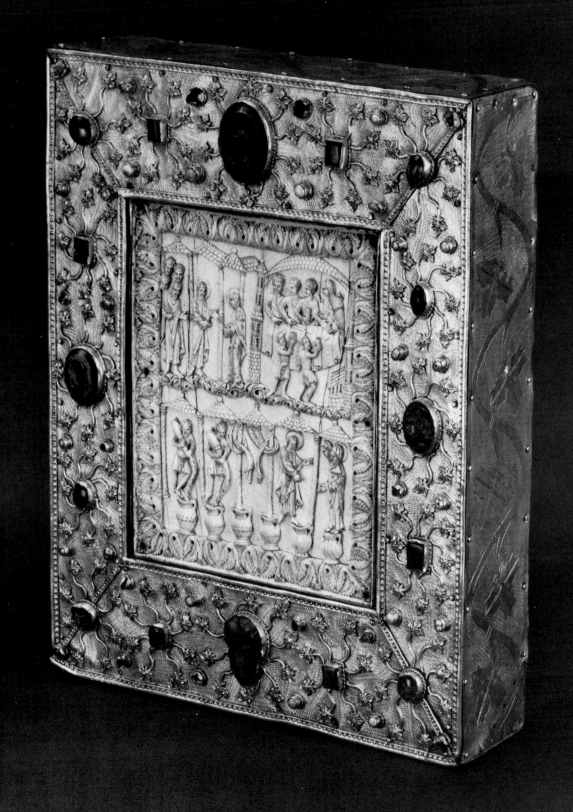

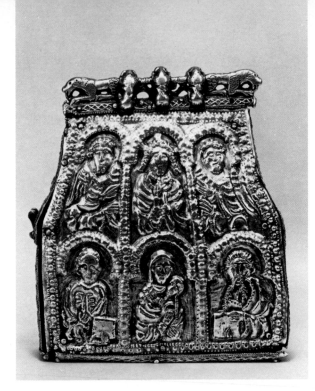

Figure 150. Back of *Enger Burse Reliquary.* Gilt-Silver, H. 6-5/16 inches (16 cm.). Germany, early ninth century. Berlin, Staatlichen Museen Preussischer Kulturbesitz, Kunstgewerbemuseum, Inv. 88.632.

at Cana (Figure 17) set in a recess. A simulated codex, the object was designed as a reliquary and until at least 1482 held four pages of text from an ancient gospel as well as some relics of the 11,000 Virgins of Cologne and those of four other unspecified saints.[85]

That the reliquary was greatly valued is clearly suggested by the preciousness of the material used and by its wealth of ornamental details. On the four metal plaques framing the ivory are the settings for thirty-two pearls (ten lacking), four rubies (three remain), eight green stones (emeralds and paste glass), and four crystals underlaid with blue pigment. The most important insets, however, are carved gems of the late Roman Imperial period, that is, of the third or fourth centuries: a large onyx intaglio with a man and a woman in bust-length, an onyx cameo with the bust of Minerva, and a cornelian intaglio with a Gorgon head. In the lower frame a fourth inset of a hard red stone, perhaps a bezoan, now very damaged, apparently seems to have been crudely shaped as a bearded man's face, recalling those wild figures (Figure 150) on the ninth-century *Enger Burse Reliquary* in Berlin. Radiating from each stone in the Cleveland *Book-Shaped Reliquary* are soldered metal wires terminating in large ivy leaves. All of these ornaments have been applied on a metal surface worked with patterns of stippling that recall scales of snakeskin, and they contrast dramatically to the smooth, milky ivory.

The reverse of the Cleveland reliquary is covered with a thick sheet of partly gilded silver which has slightly buckled with age and has been repaired (Figure 151). In an architectural setting appears John the Baptist pointing to the image of the Holy Lamb and flanked by SS. Thomas of Canterbury and Blaise represented as blessing bishops. As if statues, they stand on individual piers under narrow Gothic gables against an etched, tightly knit, patterned background identical to the one on the obverse. The thick silver sheets which line the surface of the four narrow sides (Figure 149) are decorated with a pattern of ivy and large undulating tendrils, similar, though not identical, to that on the *Plenar for Sundays* (Figure 147).

The most important relic enshrined by order of Otto the Mild must have been the fragment of St. Blaise's skull. For it, a full bust representing the bishop saint was fashioned of gilt-silver (Figure 152) with precious stones and even an enamel medallion, possibly French, representing somewhat incongruously a music-making centaur. Again, technical elements link this shrine to the ducal workshop. The sprays of wide ivy leaves forming a decorative net for the cabochons are identical with those crowding the background decoration of the *Book-Shaped Reliquary.*

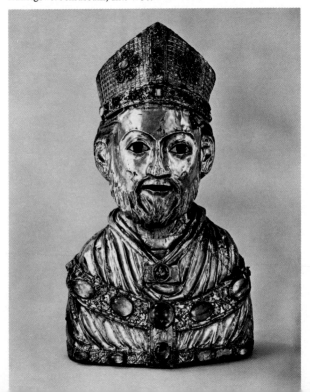

Figure 152. *Bust Reliquary of St. Blaise.* Gilt-silver, champlevé enamel, gems, rock crystal, and polychromy on a core of oak, H. 20-9/16 inches (51.5 cm.). Germany, Lower Saxony, Brunswick, ca. 1335. Berlin, Staatlichen Museen Preussicher Kulturbesitz, Kunstgewerbemuseum, Inv. W30.

Figure 151. *SS. Blaise, John the Baptist, and Thomas of Canterbury.* Partially gilt-silver, 12-1/4 x 9-1/2 inches (31.1 x 24.1 cm.). Back of *Book-Shaped Reliquary* (CMA 30.741).

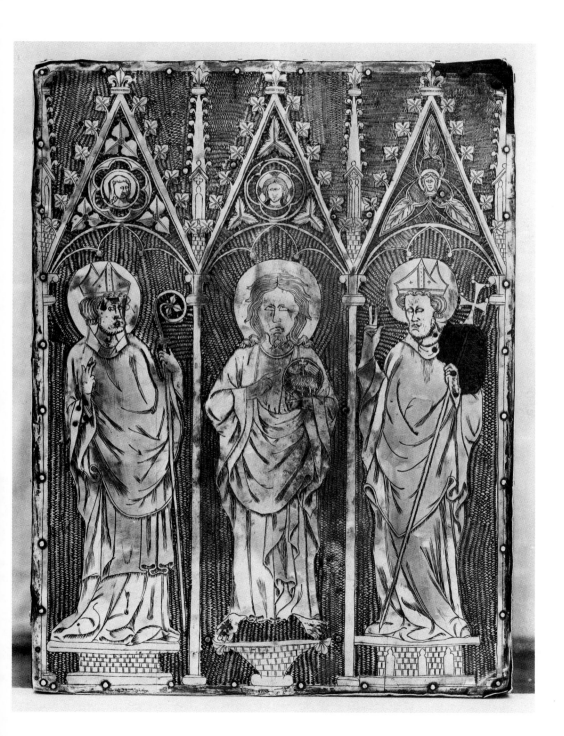

Figure 153.
Front Cover
of *Plenar
of Duke Otto
the Mild.*
Miniatures (tempera
and burnished gold on
parchment) and red jasper
squares set in gilt-silver
ornamented with gems
and pearls on a core of
oak, 13-15/16 x 10-1/4
inches (35.4 x 26 cm.).
Germany, Lower Saxony,
Brunswick, 1339. Berlin,
Staatlichen Museen
Preussischer Kulturbesitz,
Kunstgewerbe museum,
Inv. W32.

Another outstanding Gothic piece in the Guelph Treasure, and one which is clearly related by its goldsmith work to the reliquary in the shape of a book, is the brilliantly colored binding of the *Plenar of Otto the Mild* (Figure 153) given by this duke to the cathedral. The volume, composed of fifty-six folios with the text of various masses and including full-page miniatures (Figure 154), has been bound with a late thirteenth-century gaming board as main element of the cover; again an object of former days and this time of secular origin has been revitalized for a new purpose. The board consists of small gilt-silver square divisions inset with miniatures painted on vellum and seen beneath a rock-crystal plaque, with slabs of speckled jasper interspersed for coloristic effects. The miniatures framed by a row of tiny pearls represent courtly, knightly, or imaginary

122

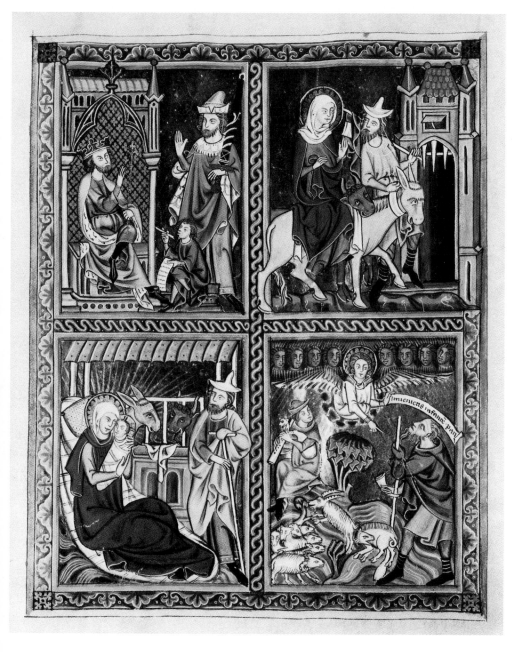

Figure 154.
*Emperor Issuing
the Edict
for the Census,
Journey to
Bethlehem,
Nativity;
Annunciation
to the Shepherds.*
Tempera and gold on
parchment, 13-15/16 x
10-1/4 inches (35.4 x 26
cm.). Germany, Lower
Saxony(?), ca. 1330.
*Plenar of Duke Otto the
Mild,* folio 4v.

scenes on a burnished gold ground. The extravagant binding of Otto the Mild's plenar bears an obvious relationship to such prototypes as the thirteenth-century Venetian *House Altar Diptych of King Andrew III of Hungary* (Figure 155) with its alternation of agate pieces and miniatures framed by small pearls under crystal. The conception of such works obviously stems from those rare, large golden Byzantine tablets or bindings, and their Western derivates, inset with multi-colored enamel plaques and roundels (Figure 59).

In Otto the Mild's plenar, the metal frame and its subdivisions are further enriched with pearls and stones. It has been suggested that these were the jewels of Agnes of Brandenburg as the volume was presented to the cathedral in 1339 by the duke immediately upon her death. Discreetly present in the middle

Figure 155. *House Altar Diptych of Andrew III of Hungary.* Tempera, gold, marble, jasper, and gems on a core of wood. Italy, Venice, 1290-96. Bern, Historisches Museum.

of this rich and variegated surface is the religious symbolism occupying five squares: a gold cross on jasper stone and circular symbols of the evangelists of chased gilt-metal on blue ground. These roundels are identical in shape to those on the cover of the *Plenar for Sundays* (Figure 147) of 1326 and to those on the gilt-silver altar cross (Figure 148) in Chicago. The decor of engraved ivy leaves on the silver sides of the plenar (Figure 156) is familiar to us from both the *Book-Shaped Reliquary* (Figure 149) and the *Plenar for Sundays* (Figure 147), while the back cover (Figure 157), a chased and nielloed sheet of partially gilded silver, is clearly in the same style as the reverse of the Cleveland shrine (Figure 151). Otto and Agnes kneel at either side of the blessing St. Blaise seated on a curule chair which rests on a platform bearing the names Otto and Agnes as well as their arms. In the arcature above the duke appears a praying woman; above Agnes of Bradenburg is a running dog about to grasp a pig, a mawkish reference to a miracle performed by

124

the saint who, at the entreaty of the woman, saved the life of her swine.

During Romanesque times, relics had been venerated while concealed within shrines. In the Gothic period, on the contrary, it became customary to make the actual relic visible to the faithful through apertures in reliquaries, the latter now becoming monstrances. An arm reliquary fashioned for a relic of St. George (Figure 158) — another commission related to the patronage of Otto the Mild — with the entire length of the inner side of the arm covered with open grill work (Figure 159), is a primary example of these new devotional preferences. On the back is the engraved figure of the knightly saint facing St. Blaise and carrying a shield with the arms of Otto the Mild's younger brother Albrecht of Brunswick-Göttingen, Bishop of Halberstadt from 1324 until 1357.[86]

By the fifteenth century metal reliquaries in the shape of parts of the human body were no longer in fashion. Although arm

Figures 156-157. *Plenar of Duke Otto the Mild:* side with clasps; back cover with *Enthroned St. Blaise Flanked by Duke Otto and Agnes of Brandenburg.* Gilt-silver with niello on a core of oak. Germany, Lower Saxony, Brunswick, 1339. Berlin, Staatlichen Museen Preussischer Kulturbesitz, Kunstgewerbemuseum, Inv. W32.

Figures 158-159. *Arm Reliquary of St. George.* Gilt-silver and gems on a core of cedar,
H. 21-3/4 inches (55.3 cm.). Germany, Lower Saxony, Brunswick, mid-fourteenth century.
Berlin, Staatlichen Museen Preussischer Kulturbesitz, Kunstgewerbemuseum, Inv. W33.

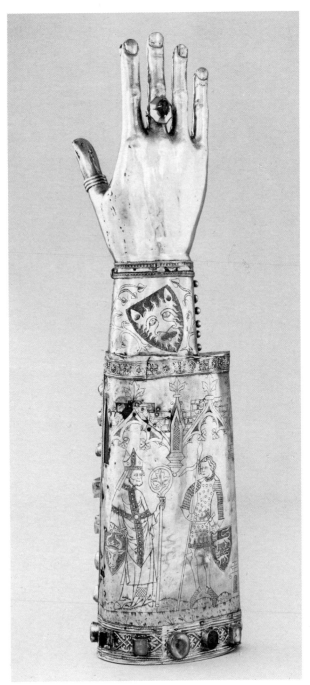
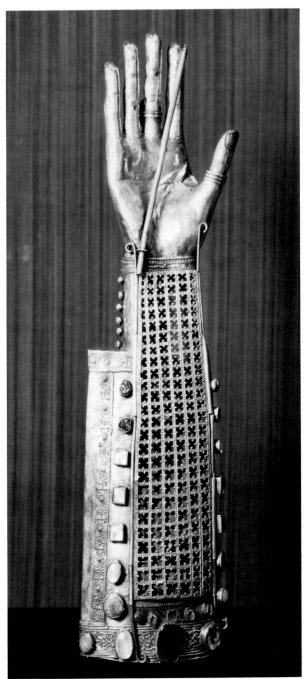

Figure 160. From left to right:
Church-Shaped Reliquary on a Foot. Gilt-copper and horn, H. 10-13/16 inches (27.5 cm.). Germany, Lower Saxony, fifteenth century. Chicago, The Art Institute of Chicago, The Lucy Maud Buckingham Medieval Collection, Gift of Kate S. Buckingham, Acc. 38.1956.

Arm Reliquary of One of the Thousand Saintly Warriors. Linden with polychromy and gilding, H. 21-3/16 inches (53.7 cm.). Germany, Lower Saxony, Brunswick, end fifteenth century. Berlin, Staatlichen Museen Preussischer Kulturbesitz, Kunstgewerbemuseum, Inv. W41.

Tower-Shaped Reliquary. Gilt-copper, H. 12-7/8 inches (32.7 cm.). Germany, Lower Saxony, second half fourteenth century. Whereabouts unknown.

reliquaries continued to be produced in Brunswick, it was only in the relatively inexpensive medium of carved and polychromed wood. One of the last of these modest reliquaries to enter the Guelph Treasure was fashioned for the arm of one of the Thousand Saintly Warriors (Figure 160). Concurrently, and actually beginning in the late years of the fourteenth century, it increasingly became the tendency to fashion monstrances that were more abstract in shape, either circular containers on a foot (Figure 148) or architectural structures (Figure 160) built to hold a translucent container in which the relic—invariably a bone, a tooth, or a piece of garment—could be seen. A series of such Gothic monstrances dating to the fourteenth and fifteenth centuries is in the Guelph Treasure, one of the latest in date being in Cleveland (Color Plate XXII). This highly decorative structure is made of gilt-silver in the shape of a Gothic church framed by an involved series of buttresses and crowned by a wide lantern centering on the narrow crystal cylinder containing a limb bone identified by a parchment as that of St. Sebastian. The relic of the healer saint par excellence had been acquired by Duke Henry the Peaceful in 1473, for the purpose of warding off the plague then taking a heavy toll in Lower Saxony. Made shortly afterwards, the monstrance is in fact specifically identified in the inventory of 1482 as the "monstrancia nova."[87]

The fifteenth century sought to mark the old church of St. Blaise with a stamp of "modernism." In the period 1469-1474, for example, the Romanesque north aisle was replaced by a double hall in the late Gothic style supported on columns with a spiral decoration and ogival ribs prominently applied on the vaulting. The Treasure was also added to without interruption. Several of the new objects, such as the *Veltheim Cross*, now in Chicago or the two small receptacles for carrying the host (*Agnus Dei capsulae*) (Figure 161) now in Berlin were, however, the gifts of the lesser gentry and wealthy burghers, rather than of the ruling house.[88]

Figure 161. *Lamb of God.* Silver, Diam. 1-15/16 inches (5 cm.). Germany, Lower Saxony, Brunswick(?), second half fifteenth century. Detail of *Agnus Dei Capsula* (receptacle for carrying the host). Berlin, Staatlichen Museen Preussischer Kulturbesitz, Kunstgewerbemuseum, Inv. W38.

CHAPTER V

Vicissitudes and Dispersal of the Treasure

From the sixteenth century onwards, the Treasure suffered countless tribulations. In 1528 the Brunswickers eagerly embraced the Reformation although the ducal house remained Catholic. Georg, brother of the reigning Duke Heinrich II was then dean of the foundation and tended to its property, but in 1540, during a series of bitter doctrinal conflicts, the town council, as it rose to further power, demanded the suppression of the foundation as a Catholic collegiate chapter. A new constitution leaning to Lutheran beliefs was evolved for St. Blaise, though Heinrich II did try in 1547 and 1558 — but to no avail — to re-establish the Catholic service. The relics, which in former days had been stored in chests in the sacristy when not displayed on altars or carried in processions, were now placed within the high altar itself. Despite this precaution, in 1574 twenty monstrances were stolen by night. To balance recorded losses such as this one, and others which remained unaccounted for, additions were made to the Treasure — in 1545 when the foundation of St. Cyriacus was abolished, for example, a great part of its treasury was transferred to St. Blaise. This explains the fact that several Medieval reliquaries which are included in the revised inventory of the year 1697 had not been mentioned in the 1482 document.[89]

Until the seventeenth century there is no indication that the Treasure was considered to be the property of the ruling house independent from the foundation church. When a member of the family, Duke Anton Ulrich, a famous art collector, took some of the objects from the Treasure in 1658 and again in 1661, giving one or more to his granddaughter Elizabeth Christina, wife of Prince Charles VI of Austria, he seems to have been the first to have crossed that thin and delicate boundary. His brother Rudolph August in fact even entered into negotiation with electorate representatives of Cologne and Hildesheim in 1663, with a view of selling the entire Treasure, but finally only the large collection of vestments owned by the cathedral was alienated.[90]

In 1670 the Brunswickers openly revolted against Duke Rudolph August in an attempt to unite with Prussia. The duke had to be swift; with the help of his cousins of the Lüneburg branch — the three brothers Georg Wilhelm von Celle, Johann Friedrich of Hanover, and Ernst August, bishop of Osnabrück — he forced the town to surrender. It was necessary for Rudolph August to provide indemnity to his allies. Johann Friedrich (Figure 162), who in 1651 had become a member of the Catholic church, demanded no less than the Guelph Treasure as booty. With the exception of the *Arm Reliquary of St. Blaise* (Figure 29) and an ivory hunting horn (Figure 65), the objects were relinquished and quickly removed to Hanover. There they were

128

Figure 162. Duke Johann Friedrich (1625-1679), who removed the Guelph Treasure from Brunswick to Hanover in 1651. Engraving, 17-11/16 x 15-3/4 inches (45 x 40 cm.), 1674. Robert Nanteuil, French (1623-1678), after a painting by Jean Michelin, French (1623-1695). Hanover, Historisches Museum am Hohen Ufer.

Figure 163. *Treasury of the Chapel in the Royal Castle of Hanover* (Leineschloss).
Clearly identifiable are several pieces from the Guelph Treasure. Pen and ink on paper from an album of drawings
by C. E. von Malortie, Oberhof of the royal court. Hanover, Niedersächsisches Hauptstaatsarchiv in Hannover,
Depositorium 93 B (Prinz von Hannover), Fach 61, nr. 2. The chapel was destroyed during the bombardments of 26 July 1943.

*Ansicht
der Reliquienkammer in Königlicher Schloß Capelle.*

Figure 164. King George V of Hanover and Queen Mary, attired for the ball. Photograph, ca. 1860.

deposited in the chapel of the sprawling Leineschloss, a seventeenth-century palace, which was still under construction.[91] When Johann Friedrich's brother, Ernst August, Protestant bishop of Osnabrück, succeeded as duke in 1679, he not only allowed the Treasure to remain in the court chapel, but also appointed to it a keeper of distinction, Gerhard Wolter Molanus (1633-1722), Protestant abbot of the Abbey of Loccum, who was also a professor of mathematics and theology. Later, in 1697, Molanus published an inventory in German of the Treasure under the Latin title of *Lipsanographia sive Thesaurus sanctarum Reliquiarium Electoralis Brunsvico-Luneburgicus.* It was slightly revised and translated into Latin and printed in 1713 and 1724 by another keeper, Johann Heinrich Jung. It is primarily a descriptive list of the numerous relics which the Treasure includes seen from the standpoint of a "cabinet de curiosité" rather than as a sacral treasure. In a letter of 1713 to the philosopher Gottfried Wilhelm Leibnitz, Kurfürstin Sophie, who presided over the intellectual life at the court of Hanover, questioned the veracity of the relics, suggesting in Volterian overtones gullibility on the part of Molanus.[92]

In the meantime, the dukes of the House of Brunswick-Lüneburg had been created electors of Hanover in 1692 by imperial decree. The Treasure remained in the court chapel (Figure 163) of Hanover until 1803 and was seen only by a very few. In that year, fearing an invasion by the Napoleonic armies, it was temporarily taken to England where the House of Hanover had ruled since 1714. In 1814 the title of elector of Hanover was raised to that of King by the Congress of Vienna. In 1861 King George V of Hanover (Figure 164), a cousin of Queen Victoria, founded the Guelph Museum in his capital. Its principal holdings were a picture gallery drawn from the Cumberland Collection, the Guelph Treasure, and a group of thirty-eight objects and some sixty manuscripts from Lüneburg, all dating from the eleventh to the sixteenth century and all of which were eventually dispersed among various Hanoverian institutions. While seeking to imbue his dynasty with an aura of grandeur, King George saw to the construction between 1857 and 1866 of the picturesque Welfen Schloss, or Palace of the Guelph, built in a Romanesque style with clear reminiscences of Brunswick's old Dankwarderode, on the outskirts of the Herrenhausen Gardens. He also purchased from the Cathedral of Prague the gospels of his most prestigious ancestor, Henry the Lion, a volume which had apparently been solicited by Emperor Charles IV when he visited Brunswick in the 1360s or 1370s.[93]

The new dreams of Guelph grandeur though were soon shattered. In 1867 Hanover, and with it the possessions of the House

Figure 165. The neo-Gothic Schloss Cumberland, Gmunden. A one-time repository for the Guelph Treasure.

of Brunswick-Lüneburg, were annexed by Prussia. George V was deposed. A settlement negotiated in September of that year called for financial compensation for the former ruling family and recognized the Guelph Museum as its private property. The dethroned king and his family went into exile retiring to the neo-Gothic castle of Cumberland at Gmunden in Austria (Figure 165). In that very year the Treasure, with the exception of a few unimportant pieces, was removed to Penzing Castle near Vienna.

In 1869 the former King George, now known as duke of Cumberland (an English title which had been his father's before ascending the Hanoverian throne in 1837), entrusted the Treasure to the Österreichisches Museum für Kunst und Industrie in Vienna. The following year restoration was carried out on some of the objects there by C. Haas and members of the Restaurischule des kaiserlich Belvederes.[94] Duke Ernst August I (Figure 166), son of the duke of Cumberland, commissioned from Father W. A. Neumann of the Cistercian order an extensive compilation of the Treasure, 300 copies of which were printed in 1891 in Vienna under the title *Der Reliquiarienschatz des Hauses Braunschweig-Lüneburg* and illustrated with 144 line drawings by F. W. Bader.[95] Four years earlier to commemorate the *modus vivendi* that the pope brought about between the Catholic church and the German state, the duke had presented Leo XIII with a startling, near duplicate copy (Figure 167) of the apostle arm reliquary in Cleveland (Color Plates XIV-XVIII) in which, according to a dedicatory inscription on the base plate, was incorporated a relic of St. Blaise.

131

Figure 166. Three Generations of the House of Brunswick-Lüneburg, ca. 1917. Seated: Duke Ernst August I. Standing behind, in the uniform of Colonel of the Totenkopf Regiment: Duke Ernst August II, who was to sell the Guelph Treasure. In the foreground, his two sons: at right, Prince Ernst August, now 71 and head of the House; on the left, his younger brother Prince Georg Wilhelm. Postcard sold at the time in the region of Hanover.

This skillfully executed object is now the property of the Church of Dardago, a small town in northern Italy.[96] In the 1890s the Guelph Treasure was removed to the ducal schloss in Gmunden, and in 1918 it is said to have been taken from there to Switzerland for safekeeping in a bank vault.

An icy barrier separated the House of Hanover, living in exile, and the Prussian imperial family and its government. Protracted negotiations concerning the so-called Guelph Fund — that is, the substantial sum assigned to the dethroned king of Hanover in 1866 by the Prussians — had never been concluded and were in fact eventually cancelled on the pretense that the former king had not officially abdicated. It was Duke Ernst August II (1887-1953) (Figure 166), who made headway from the return of the Brunswick-Lüneburgs to Germany. He became heir to the ducal title in 1911 when his elder brother died, and in 1913 ended the long controversy between the houses of Hohenzollern and Guelph by marrying Kaiser Wilhelm II's daughter Victoria Louise, making Blankenburg, a picturesque locality at the foot of the Harz Mountains, his main seat in Germany. Fully associating himself with the Prussian regime, he participated in World War I first as a colonel and then as a major-general of the Totenkopf, a well-known cavalry regiment instrumental in the invasion of Belgium and northern France.[97]

In the aftermath of the war, after the collapse of the imperial regime, the House of Brunswick-Lüneburg found itself in Germany without clear allies. Ernst August II, although reputed to be one of the wealthiest men in landed properties, was hard pressed to maintain the standards of his court: addressed as "His Royal Highness," he held to all the social prerogatives of the throne. In addition to his five children, the duke had several impoverished relatives and at least sixty major retainers for whom he had to provide. Resumed negotiations with the new government, the Weimar Republic, for the recovery of the Guelph Fund, led to a formal public vote in 1923 calling for the restitution of the private properties of the House of Brunswick-Lünebug, thereby laying the path for an eventual but still distant settlement. From 1921 onwards, every other year parts of the royal collection — mostly silver and paintings, and including such important items as Holbein's *Portrait of Prince Edward VI* (Washington, National Gallery) — were being sold through various agents. In the 1920s while negotiating for the Guelph Fund, Ernst August II indicated that he would probably sell the family's historically prized heirloom — the Guelph Treasure — which he unofficially valued at ten million dollars. In subsequent transactions with government officials, the duke bound himself to a clause promising not to sell the Guelph Treasure if the funds

Figure 167. *Copy of the Arm Reliquary of the Apostles in Cleveland.* Silver and enamel on a core of wood, H. 20-1/16 inches (51 cm.). Austria, Vienna(?), 1887. Dardago, Church.

were indeed made available. The wavering government, faced with a crumbling economy, proved unable to raise the required sum and could only make provisions for the duke to receive the Castle of Marienburg, some fifteen miles south of Hanover. By late 1928 rumors that negotiations for the sale of at least part of the Guelph Treasure, then still in a Swiss bank, were nearing conclusion caused a stir throughout Germany, particularly in Hanover. The provincial administrator of Hanover, Noske, who had been in direct contact with the duke, appealed to the German government, the Prussian Diet, and the Hanover municipal council to purchase the Treasure, reportedly at a special price then equivalent to $2,500,000. But this was to no avail. The Treasure was subsequently quietly sold to a syndicate of art dealers: Julius F. Goldschmidt of Berlin and Z. M. Hackenbroch and J. Rosenbaum of Frankfurt-am-Main. Both the price (anywhere from five to ten million dollars as reported by the press) and whatever restrictions the transaction might have carried remained a tightly kept secret.[98]

No efforts were spared at this point to publicize the collection's availability. A new publication, *Die Welfenschatz*, essentially a large catalogue describing the eighty-two items of the Treasure, was commissioned from Otto von Falke, Robert Schmidt, and Georg Swarzenski, a team of well-recognized art historians. The Treasure was put on public exhibit in 1930, first for six weeks during the summer in Frankfurt-am-Main at the prestigious Städelsche Kunstinstitut and then in Berlin at the Deutsche Gesellschaft, a private association, after the government, in a last-minute decision, opposed its being shown at the Arts and Craft Museum in order "not to facilitate action that might be conducive to the loss of the Treasure for Germany." Given the current economic conditions, however, the dealers met with little result in Germany. Though the Frankfurt and Berlin exhibits drew crowds, only a few items of secondary importance were purchased by private German collectors and a Swedish banker.[99]

During the Frankfurt showing one significant commitment was made, however, by an American. William M. Milliken (Figure 168), the new director and curator of decorative arts of The Cleveland Museum of Art, reserved six of the most important objects for purchase. He had come to view the exhibit and said he would present to his museum trustees for their approval the *Cumberland Medallion* (Color Plate IV), the "*Paten of St. Bernward*" in its monstrance (Front Cover, Color Plate XIII), the *Arm Reliquary of the Apostles* (Color Plates XIV-XVIII), the *Horn of St. Blaise* (Color Plate X), the *Book-Shaped Reliquary* with the Ottonian ivory (Back cover, Figures 17, 149,

Figure 168. William M. Milliken (1889-1978) in 1930.

151), and the Byzantine *Portable Altar in Tablet Form* (Figure 63). In early October at an accessions meeting in Cleveland, the Trustees headed by President John L. Severance and Vice-Presidents William G. Mather and Leonard C. Hanna, Jr., formally agreed to purchase the six reserved pieces, and the objects went on public view in the Museum's Rotunda before the month was over.

Cleveland's acquisitions were widely publicized. Indicative of the times, the main headlines and the copy distributed by the Associated Press emphasized the religious aspect of the purchase over its aesthetic value: "Fragment of True Cross in Cleveland Museum of Art," "Museum Buys Part of Cross," "Cleveland Museum Now Houses Fragment of True Cross of Calvary," "Portion of Cross for Art Museum," all focusing on the relic visible through rock crystals in the monstrance of the *"Paten of St. Bernward"* (Color Plate XIII). It was, in fact, the fourth fragment of the True Cross to reach America.[100]

In the fall of 1930, perhaps partially spurred on by Milliken's enthusiasm, the dealers brought the Treasure to the United States where all of the eighty-two pieces were exhibited. Cleveland's six objects were taken to New York by train by the four Trustees, John L. Severance, Francis F. Prentiss, William G. Mather, and Leonard C. Hanna, Jr., who were serving on the honorary committee of the New York exhibition along with J. P. Morgan, Randolph Hearst, Clarence H. MacKay, Michael Friedman, Philip Lehman, and Jules S. Bache. The well-attended exhibit was first shown from 30 November until the end of the year at the newly created Goldschmidt and Reinhardt Galleries at 730 Fifth Avenue at the corner of 57th Street. Proceeds of the admissions benefited the urbane Big Sisters Philanthropies, "concerned with the problems of adolescent girls." The opening day address was delivered by William Milliken. The most widely published item during the New York showing was the *Dome Reliquary* (Figure 122) estimated to be worth from $500,000 to $750,000 by the press.

The exhibit then traveled to Cleveland where, according to the Museum's president, it was the most significant event since the institution's founding in 1916. It was shown in four specially designed galleries from 10 January to 1 February 1931, bringing a recorded number of 74,894 visitors (Figure 169). "Culture has been put in competition with world series baseball," commented Robert Bordner in the *Cleveland Press* of 31 January 1931. Milliken, during the Cleveland showing, convinced the far from unwilling Museum Trustees to make a further commitment of purchasing the *Portable Altar of Countess Gertrude* (Color Plates V-IX) as well as the two ceremonial crosses (Color

Figure 169. Clevelanders queuing up at The Cleveland Museum of Art on 11 January 1931 to view the Guelph Treasure. In the middle ground at right are the dealers who brought the Treasure from Europe, from left to right: Saemy Rosenberg (hands in pocket), who was J. Rosenbaum's nephew and representative, Julius F. Goldschmidt (bald), and Z.M. Hackenbroch (dark hair and moustache, left hand in pocket).

Plates I-III). One cross was bought through the J. H. Wade Fund with a supplementary gift from Mrs. E. B. Greene, Mr. Wade's daughter. The altar and second cross were acquired through the John Huntington Art and Polytechnic Trust. One concession was made: the Byzantine *Portable Altar in Tablet Form* (Figure 63), which had been accessioned at the October 1930 meeting, was to be returned, but as it ranked far secondary in artistic importance relative to the Gertrude altar, the condition was clearly acceptable. Supportive, the dealers (Figure 169) as a gesture of good will and in "appreciation of the respect shown the relics and their reliquaries" (*Cleveland Press*, 10 January 1931) by the Cleveland public, offered the fifteenth-

Post photo.
**Armed guards and members of the Antiquarian society super-
intended the unpacking at the Art institute today of the famous
Guelph treasure, a $5,000,000 collection of reliquaries and other
objects of art, masterpieces of the medieval goldsmith's craft. From
left to right, Mrs. Joseph Medill Patterson, Mrs. Bruce Borland, Mrs.
Waller Borden and Mrs. Parmalee McFadden. The collection will
be exhibited in the McKinlock galleries from March 31 to April 20.**

Figure 170. Members of the Antiquarian Society of the Art
Institute of Chicago unpacking the Guelph Treasure. Chicago
Post, 28 March 1931.

century *Architectural Monstrance with a Relic of St. Sebastian*
(Color Plate XXII) which was gratefully accepted as it filled
another gap in the Museum's holdings. Cleveland's collection
of goldsmith works of the Middle Ages, if still limited in number,
by its quality now ranked among the major ones and placed
the Museum in the forefront of American institutions owning
Medieval objects.

With the exception of the nine pieces acquired by the
Cleveland Museum, the Treasure traveled to the Detroit Institute
of Arts where it was exhibited from 10 to 25 February, to the
Pennsylvania Museum of Art from 16 to 23 March, and then
to the Art Institute of Chicago from 31 March to 20 April to
the great delight of enterprising members of the Antiquarian
Society (Figure 170). Finally it traveled to the M. H. de Young
Memorial Museum, San Francisco, where the remaining forty-
two pieces were shown from 1 to 31 December. Other North
American collections acquired some of the objects but none
truly emulated Milliken. The Fogg Museum of Harvard Univer-
sity bought the Siculo-Arabic ivory *Casket in Tower Form*
(Figure 64). In Chicago the Antiquarian Society of the Art In-
stitute acquired the fourteenth-century gilt-silver *Altar Cross*
(Figure 148), Mrs. Lucy M. Buckingham bought three four-
teenth-fifteenth century reliquaries (Figure 160), Chauncy
McCormick, a long-standing museum trustee, purchased four
other pieces of the same period (Figure 148), with the under-
standing that those objects would eventually be given to the Art
Institute. Both the Pennsylvania Museum of Art, now the Phila-
delphia Museum of Art, and the Nelson Art Gallery in Kansas
City, then under construction, acquired two pieces: the *Arm
Reliquary of St. Babylas*, dated 1467, and an *Agnus Dei*, a reli-
quary cross and a monstrance, respectively.

After leaving San Francisco, the bulk of the Treasure was
returned to Europe via New York and was stored in Austria.
In May 1931 the Berlin correspondent of the *Art News Weekly*
reported that the duke of Brunswick-Lüneburg was attempt-
ing to sell outside of Germany an important picture from the
Anton Ulrich-Museum in Brunswick, an institution of which
the duke was part owner since it was another foundation of his
ancestors. The work was Vermeer's *Girl with the Wine Glass*
(also known as *The Coquette*) which had been declared an im-
portant national property. In order to circumvent the govern-
ment's ruling, Ernst August II first proposed to give some
Guelph Treasure pieces to the museum and subsequently to ex-
change the painting for the *Dome Reliquary* (Figure 122), add-
ing as well a cash payment of 800,000 marks to provide funds
for museum maintenance.[101] The response against letting the

136

Vermeer leave the museum was overwhelming and the scheme failed. The episode is enlightening as it clearly indicates that the duke still had personal control over the dispersion of the Guelph Treasure.

When the Weimar Republic collapsed in 1933, louder voices bewailed the loss of the Guelph Treasure. The writer Erich Muksam made himself the spokesman of widespread feelings when he denounced the sales as spoliations of the nation on the part of the ducal family for base monetary reasons. He generally proposed that the family give to the state the remaining objects. At the same time, the duke was still appealing to the high court for compensation. The new Socialist Party, however, though it sought the support of monarchists in a common fear of Communism, had other priorities. It was only two years later that the state made a specific effort to purchase the balance of the Guelph Treasure consisting of forty-four objects. The new regime for ideological reasons was keen on using Henry the Lion — the hero who envisioned a federated Germany — as a historical myth. The transaction was handled through the "Preussischer Regierung für die Berliner Museum" for the equivalent of $2,500,000. Prodded by Popitz, the minister of fine arts, Hermann Göring, the newly created commander in chief of the Luftwaffe whose well-known interest in art objects was to lead to excess, is reputed to have been behind the purchase. [102]

The tribulations of the Guelph Treasure had not quite ended, for one of the prizes of the collection, the *Gospels of Henry the Lion*, a manuscript which prior to World War II had been on the list of national treasures in Germany, was yet unaccounted for. Indeed it was not part of any of the protracted sales of 1930-35. Kept for a long time at Schloss Cumberland in Austria, just before the Anschluss it was secretly removed to Switzerland.

After World War II, the Prince of Hanover, as Duke Ernst August II wished to be called, sold Schloss Cumberland, having received from the German government the rolling fields of Calenberg at the foot of Marienburg Castle. Even before his death in 1951, however, the ducal family was again in financial need in order to maintain its status. Sales of parts of the ancestral heritage occurred approximately twice each decade. Among them were the famous royal library manuscripts and printed books including many incunabulae, the baroque silver service made for Friedrich Wilhelm Prince-Bishop of Hildesheim, and the important coin collection of Georg II. In 1983 the *Gospels of Henry the Lion* finally surfaced for sale and drew a record price at Sotheby's London. [103]

Time has left a deep scar in the history of the Cathedral of St. Blaise. After many vicissitudes, it was given over to the Lutheran denomination, the very confession that broke its entity. In the 1930s and early 1940s, it was desecrated when transformed into the "Umbau als Nationale Weiheistätte" (Hall of State Consecration), the site of ideological harangues by Hitler's henchmen. Concurrently, the family which considered this church its God-granted shrine, kept its treasury sealed not as a precious trust but as its own private property — an exception among princely houses in Western history — finally disposing of it for purely materialistic reasons. The objects were not only scattered but divested of their spiritual values. Had martyrs delivered themselves to the wild beasts to see their relics pass into eternal oblivion? Had the munificent donors and skillful artists of Romanesque and Gothic times proudly given and wrought the sacred vessels for naught? It is a palm granted by capricious history that in the end the sacral treasure of St. Blaise has achieved greater fame than most other church collections, its very tribulations and division having actually fanned the fire of its renown. In an age in which material values compete with cultural ones, and spiritual values are often threadbare, the Guelph Treasure appears not only as a magical zeitgeist of Medieval times, but also as an enduring reminder of the rich artistic accomplishments of Germany.

Cleveland's Guelph Treasure objects displayed in the Museum Rotunda.

APPENDIX I

Contents of the Guelph Treasure as Known in the Twentieth Century

The objects listed here are arranged chronologically and geographically. When their whereabouts are unknown, or objects have been purportedly destroyed, dimensions are given in order to facilitate eventual identification. With the exception of numbers 5, 10, and 26, all items were part of the protracted sale of 1930-35. If they did not enter an institution directly, their intermediary owners, when known, are listed. Dealers' names are given within brackets.

EIGHTH CENTURY

Germany

1 *Cumberland Medallion* (Color Plate IV). Cloisonné enamel and gold on copper. Weserraum, late eighth century. Not identifiable in the Inventory of 1482. CMA 30.504 (Otto von Falke, Robert Schmidt, and Georg Swarzenski. *Der Welfenschatz: Der Reliquienschatz des Braunschweiger Domes aus dem Besitze des herzoglichen Hauses Braunschweig-Lüneburg* [Frankfurt-am-Main: Frankfurter Verlags-Anstalt A.G., 1930], no. 2; hereafter cited in this Appendix as von Falke).

ELEVENTH CENTURY

Germany or Lotharingia

[See below no. 45] *Miracle at Cana* (Back Cover and Figures 17, 149). Ivory plaque. Circle of the Master of the Registrum Gregorii, Lotharingia (?), Liège (?), ca. 1020. CMA 30.741

Germany: Lower Saxony

2-3 *Ceremonial Cross of Count Liudolf Brunon* and *Ceremonial Cross of Countess Gertrude* (Color Plates I-III). Gold, cloisonné enamel, gems, pearls, and mother-of-pearl on a core of oak. Hildesheim, ca. 1038-1040. CMA 31.461, 31.55 (von Falke, nos. 3-4)

4 *Portable Altar of Countess Gertrude* (Color Plates V-IX, Figure 38). Red porphyry, gold, niello, cloisonné enamel, gems, and pearls on a core of oak. Hildesheim, ca. 1045. CMA 31.462 (von Falke, no. 5)

5 *Arm Reliquary of St. Blaise* (Figures 29-31). Silver, gilt-silver, cameo, sardonyx, gems, and pearls on a core of wood (the rings are fifteenth century). Hildesheim, ca. 1075. Brunswick, Herzog Anton Ulrich-Museum, Inv. MA60

6 *Portable Altar with Embossed Figures of Christ and the Apostles* (Figure 54). Marble, gilt-silver, and niello on a core of walnut. Brunswick(?), ca. 1075. Berlin, Staatlichen Museen Preussischer Kulturbesitz, Kunstgewerbemuseum, Inv. W2 (von Falke, no. 6)

7 *Arm Reliquary of St. Sigismund*. Silver, gilt-silver, silver-plated bronze, gems, and pearls on a core of wood. Hildesheim(?), end of eleventh century; the hand and orb are of the late thirteenth-early fourteenth century. Berlin, Inv. W18 (von Falke, no. 25)

8 *Portable Altar of Provost Adelvoldus*. Green porphyry, alabaster, silver, and niello on a core of wood. Brunswick(?), before 1100. Berlin, Inv. W8 (von Falke, no. 14)

Italy

9 *Guelph Cross* (Figure 57). Gold, gilt-silver, niello, cloisonné enamel, gems, and pearls. Milan, ca. 1045. Berlin, Inv. W1 (von Falke, no. 1)

10 *Hunting Horn* (Figure 65). Ivory. Sicily, Palermo(?). Brunswick, Inv. MA/L5

Syria

11 *Oval Flask*. Green glass, H. 9.5 cm., Diam. 6.3 cm. Eleventh-twelfth century. Purchased by an anonymous Cleveland collector in 1931. Present whereabouts unknown. (von Falke, no. 36)

TWELFTH CENTURY

Germany: Cologne

12 *Portable Altar of Eilbertus* (Figures 72-74). Gilt-copper, champlevé and cloisonné enamel, gold, niello, vernis brun, rock crystal, and parchment with tempera and gold on a core of oak. Eilbertus of Cologne, German, ca. 1150. Berlin, Inv. W11 (von Falke, no. 17)

13 *Dome Reliquary* (Figure 122). Gilt-copper, champlevé enamel, and walrus ivory on a core of oak. Ca. 1185. Berlin, Inv. W15 (von Falke, no. 22)

Germany: Lower Saxony

14 *Portable Altar with Embossed Figures of Christ, the Apostles, and the Evangelists* (Figure 56). Red porphyry, rock crystal, silver, and nielloed gilt-silver on a core of wood. Brunswick(?), early twelfth century. Berlin, Inv. W9 (von Falke, no. 15)

15 *Reliquary Casket with Champlevé Enamels of Sharp Colors* (Figure 78). Gilt-copper and champlevé enamel on a core of oak. Hildesheim(?), early twelfth century. Berlin, Inv. W16 (von Falke, no. 23)

16 *Reliquary Cross on a Base Formed by Three Lions*. Gilt-bronze and rock crystal. First half twelfth century. Not identifiable in the Inventory of 1482. Berlin, Inv. W10 (von Falke, no. 16)

17 *Portable Altar of the Four Cardinal Virtues* (Figures 82-83). Green porphyry, gilt-copper, champlevé and cloisonné enamel, gilt-bronze, and vernis brun on a core of oak. Hildesheim, ca. 1155. Berlin, Inv. W12 (von Falke, no. 18)

18 *St. Walpurgis Shrine* (Figures 84-85). Gilt-copper, silver, champlevé enamel, vernis brun, and wax on a core of oak. Hildesheim, ca. 1158. Berlin, Inv. W13 (von Falke, no. 20)

19 *Portable Altar with Abraham and Melchizedek* (Figure 89). Green porphyry, champlevé and cloisonné enamel, gilt-copper, vernis brun, on a core of oak. Hildesheim, ca. 1162. Not identifiable in the Inventory of 1482. Berlin, Inv. W14 (von Falke, no. 21)

20 *Casket with Enamel Plaque of St. Matthew.* Champlevé enamel and gilt-copper on a core of beech with an oak veneer. Hildesheim(?) or Cologne(?), ca. 1165. Robert von Hirsch Coll., Basel; [Sotheby's, London, 22 June 1978, lot 228]; [Rainer Zietz, London], Brunswick, Inv. MA352 (von Falke, no. 19)

21 *Arm Reliquary of St. Theodore* (Figure 101). Partially gilt-silver on a core of pear wood. Brunswick(?), shortly after 1173. Berlin, Inv. W20 (von Falke, no. 27)

22 *Arm Reliquary of St. Caesar.* Partially gilt-silver and gems on a core of pear wood. Brunswick(?), shortly after 1173; partially restored in the fourteenth century. Berlin, Inv. W21 (von Falke, no. 28)

23 *Arm Reliquary of St. Innocent* (Figures 102-103). Gilt-silver on a core of pear wood. Brunswick(?), shortly after 1173. Berlin, Inv. W19 (von Falke, no. 26)

24 *Arm Reliquary of St. Lawrence* (Figures 104-105). Partially gilt-silver, niello, and rock crystal on a core of cedar. Hildesheim(?), ca. 1175-1180. Berlin, Inv. W23 (von Falke, no. 31)

25 *Monstrance with "Paten of St. Bernward"* (Front Cover, Color Plate XIII, Figure 109). Paten: gilt-silver and niello; monstrance: gilt-silver and rock crystal. Paten: Hildesheim(?), ca. 1185; monstrance: Brunswick, end fourteenth century. CMA 30.505 (von Falke, no. 32)

26 *Gospels of Henry the Lion* (Figures 33, 126, 141). Ink, tempera, gold, and silver alloy on parchment, 226 folios. Herimann, German, Helmarshausen, 1185-88; binding: Prague, 1594. Not in the Inventory of 1482 since removed by Emperor Charles IV (1316-1378) from the Treasury of St. Blaise in the late fourteenth century and taken to Prague. Wolfenbüttel, Herzog August-Bibliothek

27 *Arm Reliquary of the Apostles* (Color Plates XIV-XVIII). Silver, gilt-silver, and champlevé enamel on a core of oak. Hildesheim(?), ca. 1190-1200. Not identifiable in the Inventory of 1482; perhaps given by Henry the Lion to the Monastery Church of St. Cyriacus, Brunswick. CMA 30.739 (von Falke, no. 30)

28 *Portable Altar in Tablet Form.* White marble set in an oak frame painted red. Probably twelfth century. Berlin, Inv. W28 (von Falke, no. 38)

Byzantium

29 *Icon of St. Demetri* (Figure 61). Gold and cloisonné enamel on a core of wood, reset at a later date in Germany with the addition of pearls and gems. Comnenian Period. Not identifiable in the Inventory of 1482. Berlin, Inv. W3 (von Falke, no. 7)

Italy

30 *Portable Altar in Tablet Form.* Rock crystal, gilt-silver, and tinted parchment on a wood frame. Italy(?), Byzantine-style. Not identifiable in the Inventory of 1482. Berlin, Inv. W5 (von Falke, no. 9)

31 *Horn of St. Blaise* (Color Plate X, Figure 66). Ivory. Sicily, Palermo(?). CMA 30.740 (von Falke, no. 10)

32 *Casket in Tower Form* (Figure 64). Ivory plaques mounted on a core of oak with gilt-bronze fittings. Sicily, Palermo(?). Cambridge, MA, Fogg Art Museum, Acc. 1931.52 (von Falke, no. 12)

Palestine

33 *Portable Altar in Tablet Form.* Limestone set in a cedar frame. Bethlehem(?). Berlin, Inv. W27 (von Falke, no. 37)

THIRTEENTH CENTURY

Germany: Lower Saxony

34 *Portable Altar in Tablet Form* (Figure 63). Agate and nielloed gilt-silver on a frame of wood. Ca. 1200, incorporating a twelfth-century Byzantine agate and silver frame. Not identifiable in the Inventory of 1482. Berlin, Inv. W4 (von Falke, no. 8)

35 *Chest Reliquary in the Shape of a Portable Altar.* Walnut with traces of polychromy, rock crystal, gilt-bronze, and copper. Lower Saxony(?), early thirteenth century. Berlin, Inv. W24 (von Falke, no. 33)

36-37 *Two Reliquary Caskets with Rounded Lids.* Gilt-copper, bronze, and horn. Lower Saxony(?), early thirteenth century. Berlin, Inv. W25-26 (von Falke, nos. 34-35)

38 *Chest Reliquary with Champlevé Enamels.* Champlevé enamel, gilt-copper, and silver on a core of wood. North Germany, Lower Saxony(?), mid-thirteenth century. Berlin, Inv. W17 (von Falke, no. 24)

39 *Bust Reliquary of St. Cosmas* (Figure 145). Partially gilt-silver, niello, and rock crystal on a core of oak. Brunswick(?), 1275-1300. Berlin, Inv. W29 (von Falke, no. 39)

Italy

40 *Truncated Pyramid Lid Casket with Partially Engraved Ivory Plaques.* Ivory and gilt-bronze on a core of oak. Sicily, Palermo(?). Berlin, Inv. W6 (von Falke, no. 11)

FOURTEENTH CENTURY

Germany: Lower Saxony

41 *Veltheim Cross*. Gilt-silver, enamel, and gems. Brunswick, ca. 1300. Chicago, The Art Institute of Chicago, Gift of Mrs. Chauncey McCormick, Acc. 62.92 (von Falke, no. 48)

42 *Relic Capsula with Engraved Scenes of the Annunciation and of the Crucifixion*. Gilt-silver. Brunswick, early fourteenth century. Philadelphia, Philadelphia Museum of Art, Gift of Charles D. Hart, Acc. 31-24-1 (von Falke, no. 45)

43 *Plenar for Sundays* (Figure 147). Ink on parchment, 110 folios; binding: partially gilt-silver on a core of oak. Tenth-century manuscript in a binding produced in Brunswick, 1326. Berlin, Inv. W31 (von Falke, no. 41)

44 *Altar Cross* (Figure 148). Partially gilt-silver on a core of wood. Brunswick, ca. 1326 (the foot is of a later date). Not identifiable in the Inventory of 1482. Chicago, Gift of the Antiquarian Society, Acc. 31.263 (von Falke, no. 50)

45 *Book-Shaped Reliquary with Ivory Plaque of the Miracle at Cana* (Back Cover, Figures 17, 149, and 151). Ivory plaque set within a frame of silver, gilt-silver, gems, and pearls on a core of wood. Ivory: Circle of the Master of the Registrum Gregorii, Lotharingia(?), Liège(?), ca. 1020; frame: Brunswick, ca. 1340. CMA 30.741 (von Falke, no. 43)

46 *Bust Reliquary of St. Blaise* (Figure 152). Gilt-silver, champlevé enamel, gems, rock crystal, and polychromy on a core of oak. Brunswick, ca. 1335. Berlin, Inv. W30 (von Falke, no. 40)

47 *Plenar of Duke Otto the Mild* (Figures 153-154, 156-157). Ink, tempera, and gold on parchment, 56 folios; binding, front cover: miniatures (tempera and burnished gold on parchment) and red jasper squares set in gilt-silver ornamented with gems and pearls on a core of oak; back cover and sides: gilt-silver with niello on a core of oak. Brunswick, manuscript of ca. 1330 in a binding produced in 1339. Berlin, Inv. W32 (von Falke, no. 42)

48 *Casket with Truncated Pyramid-Shaped Lid and Ornamented with Painted Shields*. Polychromed beech and linden. Brunswick(?), ca. 1340. Berlin, Inv. W34 (von Falke, no. 47)

49 *Miniature Folding Altar with Ivory Virgin and Child on a Stemmed Foot*. Gilt-silver, silver, and ivory. Altar: Germany, late thirteenth century; foot: Brunswick, first half fourteenth century. Berlin, Inv. W37 (von Falke, no. 55)

50 *Arm Reliquary of St. George* (Figures 158-159). Gilt-silver and gems on a core of cedar. Brunswick, mid-fourteenth century. Berlin, Inv. W33 (von Falke, no. 44)

51 *Arm Reliquary of St. Bartholomew*. Silver, gilt-silver, and gems on a core of wood. Probably Brunswick, mid-fourteenth century. Berlin, Inv. W22 (von Falke, no. 29)

52 *Reliquary Cross*. Gilt-silver and gems. Not identifiable in the Inventory of 1482. Kansas City, The Nelson-Atkins Museum of Art, Acc. 31.72 (von Falke, no. 68)

53 *Reliquary Monstrance with Ivory Plaques of the Annunciation and the Crucifixion*. Silver-plated copper, ivory, and horn. Ivories: Cologne, third quarter fourteenth century; monstrance: Brunswick(?), end fourteenth century. Berlin, Inv. W35 (von Falke, no. 51)

54 *Reliquary Monstrance with Three Turrets*. Silver, gilt-silver, and crystal. H. 21.7 cm. Second half fourteenth century. Purchased by Ludwig Roselius, Bremen, 1931. Reportedly destroyed in the bombardments of 1945. (von Falke, no. 49)

55 *Tower-Shaped Reliquary* (Figure 160). Gilt-copper. H. 32.7 cm. Second half fourteenth century. Not identifiable in the Inventory of 1482. Whereabouts unknown. (von Falke, no. 52)

56 *Monstrance with a Relic of St. Blaise*. Silver, gilt-silver, niello, enamel, and crystal. Brunswick(?), third quarter fourteenth century. Berlin, Inv. W44 (37, 22) (von Falke, no. 59)

57 *Reliquary Monstrance Crowned with a Dome*. Gilt-silver and crystal. Brunswick(?), late fourteenth century. Chicago, The Lucy Maud Buckingham Medieval Collection, Gift of Kate S. Buckingham, Acc. 38.1957 (von Falke, no. 61)

58 *Monstrance with Relics of SS. Anianus and Lawrence*. Silver and crystal. Late fourteenth century. Chicago, The Lucy Maud Buckingham Medieval Collection, Gift of Kate S. Buckingham, Acc. 38.1958 (von Falke, no. 72)

59 *Monstrance with a Tooth of John the Baptist in a Fadimidian Crystal Vessel*. Gilt-silver and crystal. Crystal: Egypt, tenth-eleventh century; monstrance: Lower Saxony, end fourteenth century. Chicago, Gift of Mrs. Chauncey McCormick, Acc. 62.91 (von Falke, no. 60)

60 *Beechwood Casket*. Painted red beechwood and iron. 17.8 x 13.5 x 13.8 cm. Germany(?), fourteenth-fifteenth century. Not identifiable in the Inventory of 1482. Whereabouts unknown. (von Falke, no. 76)

Spain

61 *Octagonal Leather Casket*. Leather, lead nails, and iron on a core of beech. Not identifiable in the Inventory of 1482. Berlin, Inv. W7 (von Falke, no. 13)

FIFTEENTH CENTURY

Germany: Lower Saxony

62 *Reliquary Statuette of St. Blaise* (Figure 67). Linden with polychromy and gilding, and a silver crozier. Brunswick, ca. 1400. Berlin, Inv. W43 (von Falke, no. 82)

63 *Reliquary Cross*. Gilt-bronze. Ca. 1400. Not identifiable in the Inventory of 1482. Berlin, Inv. W36 (von Falke, no. 53)

64 *Reliquary Monstrance with a Finger of St. Valerius*. Gilt-copper, silver, and enamel. Hildesheim, ca. 1400. Not identifiable in the Inventory of 1482. Gustav Oberlander, Reading, PA, 1930; [Parke-Bernet Galleries, New York, 25 May 1939, lot 366]; [Herman Bear, London, 1959]; [Edward R. Lubin, New York, 1961]; Houston, The Museum of Fine Arts, Lawrence H. Favrot Bequest Fund, Acc. 70.16 (von Falke, no. 62)

65 *Corpus Christi Monstrance with a Relic of St. Blaise*. Gilt-silver and glass. Göteborg, Röhsska Konstlöjdmuseet, RKM 76-34 (von Falke, no. 63)

66 *Monstrance with a Finger of St. John the Baptist*. Gilt-silver and glass. Kansas City, Acc. 31.71 (von Falke, no. 64)

67 *Small Reliquary Cross*. Silver and glass. H. 8.4 cm.; W. 6.6 cm. Not identifiable in the Inventory of 1482. Purchased by Ludwig Roselius, Bremen, 1931. Reportedly destroyed in the bombardments of 1945. (von Falke, no. 66)

68 *Small Reliquary Cross*. Silver and gilt-silver. H. 8.3 cm.; W. 6.6 cm. Not identifiable in the Inventory of 1482. Purchased by Ludwig Roselius, Bremen, 1931. Reportedly destroyed in the bombardments of 1945. (von Falke, no. 67)

69 *Capsula with the Engraved Figure of St. Veronica and the Relics of SS. Blaise and Thomas of Canterbury*. Silver. Brunswick(?), second quarter fifteenth century. Not identifiable in the Inventory of 1482. Bremen, Focke-Museum (von Falke, no. 69)

70 *Reliquary Capsula Engraved with the Virgin Clothed with the Sun*. Silver and enamel. Mid-fifteenth century. Not identifiable in the Inventory of 1482. Bremen (von Falke, no. 70)

71 *Reliquary Capsula with a Mother-of-Pearl Relief of the Dead Christ at the Tomb and an Engraved Trinity*. Silver, gilt-silver, and mother-of-pearl. Brunswick(?), mid-fifteenth century. Not identifiable in the Inventory of 1482. Bremen (von Falke, no. 46)

72 *Reliquary Monstrance with Crucifixion Relief in Mother-of-Pearl*. Silver, gilt-silver, and mother-of-pearl. Second half fifteenth century. Gustav Oberlander, Reading, PA, 1930; [Parke-Bernet, Galleries, New York, 25 May 1939, lot 365]; [Herman Bear, London, 1959]; [Edward R. Lubin, New York, 1961]; [Munich, Weinmüller Auktion 91, cat. no. 99, 30 September-2 October 1964, p. 34, no. 356, pl. 29]; Brunswick, Inv. MA350 (von Falke, no. 57)

73 *Church-Shaped Reliquary on a Foot* (Figure 160). Gilt-copper and horn. Chicago, The Lucy Maud Buckingham Medieval Collection, Gift of Kate S. Buckingham, Acc. 38.1956 (von Falke, no. 54)

74 *Circular Monstrance with a Relic of St. Christine* (Figure 148). Silver, champlevé enamel, and crystal. Brunswick, second half fifteenth century. Not identifiable in the Inventory of 1482. Chicago, Gift of Mrs. Chauncey McCormick, Acc. 62.90 (von Falke, no. 56)

75 *Agnus Dei Capsula Engraved with the Lamb of God, the Virgin, and the Christ Child* (Figure 161). Silver. Brunswick(?), second half fifteenth century. Not clearly identifiable in the Inventory of 1482. Berlin, Inv. W38 (von Falke, no. 71)

76 *Pyx Mounted on a Foot*. Pyx: gilt-pewter on a core of wood; foot: gilt-copper. Pyx: France, fourteenth century; foot: Germany(?), fifteenth century. Chicago, Gift of Mrs. Chauncey McCormick, Acc. 62.93 (von Falke, no. 58)

77 *Ciborium-Shaped Reliquary Crowned with a Cross*. Gilt-copper. Göteborg, RKM 77-34 (von Falke, no. 74)

78 *Chalice-Shaped Reliquary Crowned by a Belfry Tower and Pinnacles*. Silver and crystal. H. 18.7 cm. Whereabouts unknown. (von Falke, no. 65)

79 *Arm Reliquary of St. Babylas*. Silver, gilt-silver, gems, and oak. Brunswick, 1467. Philadelphia, Acc. 51-12-1 (von Falke, no. 80)

80 *Arm Reliquary of Mary Magdalene*. Linden with polychromy and gilding. Brunswick, end fifteenth century. Not identifiable in the Inventory of 1482. Berlin, Inv. W40 (von Falke, no. 78)

81 *Arm Reliquary of One of the Thousand Saintly Warriors* (Figure 160). Linden with polychromy and gilding. Brunswick, end fifteenth century. Not identifiable in the Inventory of 1482. Berlin, Inv. W41 (von Falke, no. 79)

82 *Architectural Monstrance with a Relic of St. Sebastian* (Color Plate XXII). Gilt-silver and crystal. Brunswick, ca. 1475. CMA 31.65 (von Falke, no. 65)

83 *Large Reliquary Cross on a Foot*. Silver, gilt-silver, champlevé enamel, gems, coral, pearls, and gilt-copper on a core of wood. Brunswick, 1483. Included in the 1483 copy of the 1482 Inventory. Berlin, Inv. W42 (von Falke, no. 81)

84 *Mazer Reliquary*. Oak with polychromy. H. (with lid) 25 cm.; Diam. 10.5 cm. Brunswick, fifteenth century. [Paul Capton, New York, 1930]. Present whereabouts unknown. (von Falke, no. 75)

85 *Round Box and Lid with Relics*. Maple. Late Gothic. Not identifiable in the Inventory of 1482. Berlin, Inv. W39 (von Falke, no. 77)

APPENDIX II

Present Whereabouts of the Guelph Treasure

Berlin: Staatlichen Museen Preussischer Kulturbesitz, Kunst-gewerbemuseum, nos. 6-9, 12-19, 21-24, 28-30, 33-40, 43, 46-51, 53, 56, 61-63, 75, 80-81, 83, 85

Bremen: Focke-Museum, nos. 69-71

Brunswick: Herzog Anton Ulrich-Museum, nos. 5, 10, 20, 72

Cambridge, MA: Fogg Art Museum, no. 32

Chicago: The Art Institute of Chicago, nos. 41, 44, 57-59, 73-74, 76

Cleveland: The Cleveland Museum of Art, nos. 1-4, 25, 27, 31, 45, 82

Göteborg: Röhsska Konstlöjdmuseet, nos. 65, 77

Houston: The Museum of Fine Arts, no. 64

Kansas City: The Nelson-Atkins Museum of Art, nos. 52, 66

Philadelphia: Philadelphia Museum of Art, nos. 42, 79

Wolfenbüttel: Herzog August-Bibliothek, no. 26

Whereabouts unknown: nos. 11, 55, 60, 69-72, 78, 84

Purportedly destroyed in 1945: nos. 54, 67-68

Frequently Cited Literature

Elbern, Victor H., and Hans Reuther. *Der Hildesheimer Domschatz*. Hildesheim: Verlagbuchhandlung August Lax, 1969.

Falke, Otto von, and Heinrich Frauberger. *Deutsche Schmelzarbeiten des Mittelalters*. Frankfurt-am-Main: Joseph Baer & Co., 1904.

Falke, Otto von, Robert Schmidt, and Georg Swarzenski. *Der Welfenschatz:Der Reliquienschatz des Braunschweiger Domes aus dem Besitze des herzoglichen Hauses Braunschweig-Lüneburg*. Frankfurt-am-Main: Frankfurter Verlags-Anstalt A.G., 1930.

Goldschmidt, Adolph. *Die Elfenbeinskulpturen*. 4 vols. Berlin: Bruno Cassirer, 1914-1933. I (1914) and II (1918): *Aus der Zeit der karolingischen und sächsischen Kaiser, VIII-XI Jahrhunderts*. IV (1926): *Aus der romanischen Zeit XI-XIII Jahrhundert*.

Kötzsche, Dietrich. *Der Welfenschatz im Berliner Kunstgewerbemuseum*. Berlin: Staatliche Museen Preussischer Kulturbesitz, 1973.

Kunst und Kultur im Weserraum 800-1600. Exhib. cat. Corvey. Münster in Westfalen: Bernard Korzus, Landesmuseum für Kunst und Kulturgeschichte, 1966.

Lasko, Peter. *Ars Sacra 800-1200*, Pelican History of Art. Harmondsworth: Penguin Books, 1972.

Milliken, William M. "The Acquisition of Six Objects from the Guelph Treasure for the Cleveland Museum of Art." *The Bulletin of The Cleveland Museum of Art*, XVII (1930), 161-177.

Molanus, Gerard W. *Lipsanographia sive Thesaurus sanctarum Reliquiarum Electoralis Brunsvico-Luneburgicus*. Hanover: Nicolaum Försterum, 1697. Also published in 1713 and 1724, ed. Johann H. Jung.

Neumann, Wilhelm A. *Der Reliquienschatz des Hauses Braunschweig-Lüneburg*. Vienna: Alfred Hölder, 1891.

Rhein und Maas: Kunst und Kultur 800-1400. Exhib. cat., Cologne, Kunsthalle. Cologne: Schnütgen-Museum, 1972.

Swarzenski, Georg. "Aus dem Kunstkreis Heinrichs des Löwen." *Städel-Jahrbuch*, VII-VIII (1932), 241-397.

Swarzenski, Hanns. *Monuments of Romanesque Art: The Art of Church Treasures in North-Western Europe*. London: Faber and Faber, 1954.

Die Zeit der Staufer. Exhib. cat., 2 vols. Stuttgart: Württembergisches Landesmuseum, 1977.

Notes to the Text

INTRODUCTION

1. For a brief description and the present whereabouts of the eighty-five objects, see the Appendices. The inventory of the Treasury of St. Blaise written in 1482 consists of a sheaf of parchment, 22.6 x 16.3 cm., paginated 3 to 32, and kept at the Niedersächsisches Staatsarchiv in Wolfenbüttel (Register *VII B Hs 166)*. Also relevant for the study of the Treasure are the following inventories similarly housed in the Niedersächsisches Staatsarchiv: 1542 (Register *11 Alt Blas. 713*, 22 folios), 1574 (Register *95 Alt Blas. 4),* and 1663-1671 (Register *11 Alt Blas. 720*, folios 3-23, 82-87).

2. Otto von Falke, Robert Schmidt, and Georg Swarzenski, *The Guelph Treasure: The Sacred Relics of Brunswick Cathedral Formerly in the Possession of the Ducal House of Brunswick-Lüneburg*, trans. Silvia M. Welsh (Frankfurt-am-Main: Frankfurter Verlag-Anstalt A.G., 1930), limited edition of 75 copies. An abridged version, *The Guelph Treasure, Catalogue of the Exhibition*, was printed privately in connection with the showing of the Treasure at the Goldschmidt and Reinhardt Galleries in New York and at six American museums in 1930-31.

CHAPTER I
Dawn of German Art: Images of Salvation and Power

3. Flavius Philostratus, *Icones Philostrati* (Florence: Philippi Iuntia, 1517), Book I, 28. For German goldsmith works of the Middle Ages, see among other works von Falke and Frauberger, *Deutsche Schmelzarbeiten*; Fraucke Steenbock, *Der kirchliche Prachteinband im frühen Mittelalter, von der Anfängen bis zum Beginn der Gotik* (Berlin: Deutscher Verlag für Kunstwissenschaft, 1965); Lasko, *Ars Sacra*.

4. CMA 30.504 *Cumberland Medallion* (with bust of Christ). Cloisonné enamel and gold on copper, Diam. 1-15/16 inches (5 cm.); thickness 3/16 inch (.5 cm.). Germany, Weserraum, late eighth century. Purchase from the J. H. Wade Fund. Ex collection: House of Brunswick-Lüneburg; [Goldschmidt Galleries, New York]. Not recorded in the 1482 inventory of the St. Blaise Cathedral Treasury, nor in Molanus, *Lipsanographia* of 1697-1724. The medallion may well have been part of the decoration of a reliquary and would therefore not have been mentioned individually in the inventories or in the early literature where the descriptive emphasis is placed on the relic itself.

Exhibitions: Vienna, 1869: Österreichisches Museum für Kunst und Industrie; Frankfurt-am-Main, 1930: Städelsche Kunstinstitut; Berlin, 1930: *Deutsche Gesellschaft* (for the two 1930 exhibits in Germany, see p. 31, no. 2, of the catalogue *Der Welfenschatz* [printed privately] which is an abridged version of sixty-eight pages and twenty-four plates of von Falke, Schmidt, and G. Swarzenski, *Welfenschatz*); New York, 1930: Goldschmidt and Reinhardt Galleries, The Guelph Treasure, p. 36, no. 2; pl. 3 (the *Cumberland Medallion* traveled with this exhibition to The Cleveland Museum of Art, 10 January-1 February 1931); Cleveland, 1936: The Cleveland Museum of Art, The Twentieth Anniversary Exhibition of the Cleveland Museum of Art—The Official Art Exhibit of the Great Lakes Exposition, p. 15, no. 5; Baltimore, 1947: The Baltimore Museum of Art, Early Christian and Byzantine Art, p. 108, no. 522, pl. LXIX; Aachen, 1965: Rathaus and Kreuzgang des Domes, Karl der Grosse: Werk und Wirkung, p. 100, no. 125 (Düsseldorf: Verlag L. Schwann, 1965, entry by K. Weidemann).

Selected publications: Neumann, *Reliquienschatz*, pp. 314-316, no. 78; Émile Molinier, *L'Émaillerie* (Paris: Librairie Hachette, 1891), pp. 92-93, 95; Marc Rosenberg, "Erster Zellenschmelz Nördlich der Alpen," *Jahrbuch der königlich preussischen Kunstsammlungen,* XXXIX (1918), 7-18; idem, *Geschichte der Goldschmiedekunst auf technischer Grundlage*, 6 vols. (Frankfurt-am-Main: Joseph Baer & Co., 1921-25), III (1921): *Zellenschmelz*, 77; IV (1922): *Zellenschmelz*, 6; Willy Burger, *Abendländische Schmelzarbeiten*, XXXIII (Berlin: Richard Carl Schmidt & Co., 1930), 41-42; von Falke, Schmidt, and G. Swarzenski, *Welfenschatz*, pp. 26-27; p. 100, no. 2; pl. 5; Milliken, "Acquisition of Six Objects," pp. 174-176; José Pijoán, *Summa artis, historia general del arte*, 25 vols. (Madrid: Espasa-Calpe, S.A., 1931-1977), VIII (1942): *Arte bárbaro y prerrománico desde el siglo IV hasta el año 1000*, 160-161; William M. Milliken, "The Guelph Treasure in Cleveland," *American-German Review*, XXII (1955-56), 10; Karl Dinklage has announced a forthcoming publication. *Die merovingischen, karolingischen und ottonischen Emails Europas*, which is to include a study of the *Cumberland Medallion*.

5. Rosenberg, *Geschichte der Goldschmiedekunst*, III, 59; *Zweitausend Jahre Glasveredelung*, exhib. cat. (Darmstadt: Hessisches Landesmuseum, 1935), p. 60, no. 342; Karl Dinklage, "Karolingischer Schmuck aus dem Speyer-und Wormsgau," *Pfälzer Heimat*, VI (1955), 41-42. See also Hayo Vierck, "Mittel-und westeuropäische Einwirkungen auf die Sachkultur von Haithabu/Schleswig," in *Archäologische und naturwissenschaftliche Untersuchungen an Siedlungen im deutschen Küstengebiet* (Weinheim: Acta humaniora der Verlag Chemie GmbH, 1984), II: *Handelsplätze des frühen und hohen Mittelalters*, 366-422; Günther Haseloff, *Der Tassilokelch* (Munich: C.H. Beck'sche verlagsbuchhandlung, 1951); *Karl der Grosse*, pp. 360-365, and p. 366, no. 548; pl. 105 (entry by H. Elbern); Lasko, *Ars Sacra*, pp. 8, 10, figs. 1, 10.

6. H. Swarzenski, *Monuments*, p. 49, no. 63, fig. 142; pl. 63; Marian Campbell, *An Introduction to Medieval Enamels* (London: Victoria and Albert Museum [Her Majesty's Stationery Office], 1983), p. 16.

7. For the image of the ruler in Germany, see Percy E. Schramm, *Die deutschen Kaiser und Könige in Bildern ihrer Zeit 751-1190* (Munich: Prestel Verlag, 1983). The classic study on reliquaries and the most complete listing of them was published by Joseph Braun, *Die Reliquiare des christlichen Kultes und Ihre Entwicklung* (Freiburg-im-Breisgau: Herder & Co., 1940).

8. CMA 51.445 *Pendant: Virgin and Child*, steatite (soapstone) relief: 2-1/16 x 1-9/16 inches (5.2 x 4 cm.). Byzantium, tenth century. Frame engraved with Bull, symbol of St. Luke, on reverse: gilt-silver with pearls, 2-5/8 x 2-1/16 inches (6.7 x 5.2 cm.). Germany, Aachen, mid-fourteenth century. Purchase from the J. H. Wade Fund. Ex collections: Treasury at Aachen until 1804; Empress Josephine of France; Eugène de Beauharnais; Daguerre, Paris; César de Hauke, Paris. Exhibitions: Cleveland, 1963: The Cleveland Museum of Art, Gothic Art 1360-1440 (cat. CMA *Bulletin*, L [1963], 208, no. 54); Aachen, 1965: Karl der Grosse, pp. 494-495, no. 674 (entry by Ernst G. Grimme). Selected publications: Ernst G. Grimme, "Die 'Lukasmadona' und das 'Brustkreuz Karls des Grossen,' " in *Miscellanea Pro Arte Hermann Schnitzler zur Vollendung des 60. Lebensjahres am 13. Januar 1965*, ed. Peter Bloch and Joseph Hoster (Düsseldorf: Verlag L. Schwann, 1965), pp. 48-53; pl. XLIV, figs. 1-2; idem, "Der Aachener Domschatz," *Aachener Kunstblätter*, XLII (1972), 48-50, no. 33; pl. 35; Ioli Kalavrezou-Maxeiner,

"Byzantine Steatite Icons," in *Byzantina Vindobonensia*, XV (Vienna: Verlag der Österreichischen Akademie der Wissenschaften, 1984), in press.

For Theophanu and the impact of her arrival in Germany, see Hans Wentzel, "Das byzantinische Erbe der ottonischen Kaiser Hypothesen über den Brautschatz der Theophano," *Aachener Kunstblätter*, XL (1971), 15-39; *Die Heiratsurkunde der Kaiserin Theophanu 972 April 14, Rom*, exhib. cat., Wolfenbüttel: Niedersächsichen Staatsarchivs (Göttingen: Vanderbroeck & Ruprecht, 1972).

9. John G. Hawthorne and Cyril Stanley Smith, eds. and trans., *On Divers Arts: The Treatise of Theophilus* (Chicago: The University of Chicago Press, 1963), pp. 79-80. See also the more cursory translation of C. R. Dodwell in Theophilus, *The Various Arts* (London: Thomas Nelson and Sons Ltd., 1961), p. 64.

10. On the patronage of Egbert, see Franz Rademacher, "Der Trierer Egbertschrein," in *Trierer Zeitschrift*, XI (1936), 144-166; Franz Ronig, "Egbert, Erzbischof von Trier (977-993) — Zum Jahrtausend seines Regierungsantritts," in *Festschrift 100 Jahre Rheinisches Landesmuseum Trier* (Mainz: Verlag Philipp von Zabern, 1984), pp. 347-365. See also C. R. Dodwell and D. H. Turner, *Reichenau Reconsidered, a Re-Assessment of the Place of Reichenau in Ottonian Art*, Warburg Institute Surveys II (London: University of London, 1965).

11. CMA 30.741 *Book-Shaped Reliquary*, ivory plaque set within a frame of gilt-silver, gems, and pearls on a core of wood, Frame: 12-3/8 x 9-1/2 x 2-11/16 inches (31.4 x 24.2 x 6.8 cm.). Germany, Lower Saxony, Brunswick, ca. 1340. Ivory plaque: *Miracle at Cana*, 7 x 5-1/2 inches (17.8 x 14.3 cm.). Circle of the Master of the Registrum Gregorii, Lotharingia(?), Liège(?), ca. 1020. Gift of the John Huntington Art and Polytechnic Trust. Ex collection: Treasury, Cathedral of St. Blaise, Brunswick (when inventoried in 1482 as if an actual book: "In secundo plenario iacent quatuor ewangelica scripta in quatuor foliis. Item ibidem habentur reliquie de XI mulibus virginum et de quatuor aliis sanctis"; although the presence of relics as well as the fourteenth-century metalwork on the four small sides clearly indicate that the object was a reliquary since ca. 1340); House of Brunswick-Lüneburg; [Goldschmidt Galleries, New York].

Exhibitions: Vienna, 1869: Österreichisches Museum für Kunst und Industrie; Frankfurt-am-Main, 1930: Städelsche Kunstinstitut; Berlin, 1930: Deutsche Gesellschaft (for the two 1930 exhibits in Germany, see Der Welfenschatz, pp. 54-55, no. 43; pl. 22); New York, 1930: Goldschmidt and Reinhardt Galleries, The Guelph Treasure, pp. 54-55, no. 43; pl. 22 (the *Book-Shaped Reliquary* traveled with this exhibition to The Cleveland Museum of Art, 10 January-1 February 1931); Cleveland, 1936: The Cleveland Museum of Art, Twentieth Anniversary Exhibition, p. 36, no. 7.

Selected publications: Molanus, *Lipsanographia*, no. XVIII; Neumann, *Reliquienschatz*, pp. 17, 21, and 232-239, no. 37; Goldschmidt, *Elfenbeinskulpturen*, I, 29, no. 47; pl. XXII; von Falke, Schmidt, and G. Swarzenski, *Welfenschatz*, pp. 46-47, 173-175, no. 43; pls. 6, 82-83; Milliken, "Acquisition of Six Objects," pp. 172-173, 176-177; idem, "The Guelph Treasure," *The American Magazine of Art*, XXII (1931), 163-172; Alfred M. Frankfurter, "The Guelph Treasure: Its Importance to America," *Antiquarian*, XV (1930), 63-67; H. Swarzenski, *Monuments*, p. 39, no. 14; fig. 33; Milliken, "The Guelph Treasure in Cleveland" (1955-56), pp. 2, 8, 10; Hanns Swarzenski, "The Role of Copies in the Formation of the Styles of the Eleventh Century," in *Romanesque and Gothic Art*, Studies in Western Art, Acts of the Twentieth International Congress of the History of Art (Princeton: Princeton University Press, 1963), I, 7-18; Anton von Euw, "Elfenbeinarbeiten des 9. bis 12. Jahrhunderts," *Rhein und Maas: Kunst und Kultur 800-1400*, II: *Berichte, Beiträge und Forschungen zum Themenkreis der Austellung und des Katalogs* (Cologne: Schnütgen-Museum, 1973), pp. 377, fig. 1; 379; James Murphy, "Ottonian or Romanesque? Two

Ivory Carvings from Liège," *Athanori* (Florida State University, Tallahassee), I (1981), 13-18.

12. Goldschmidt, *Elfenbeinskulpturen*, I, 29, no. 47; pl. XXII. For Paris, Bibliothèque nationale, ms. lat. 17969 (191 folios, 26.5 x 21.4 cm., text area approx. 17.5 x 12.7 cm., 23 lines per page, bound within oak flaps 26.7 x 21.5 cm.), see Suzanne Gevaert, *Étude sur les miniatures mosanes prégothiques: quatre manuscrits mosans de la Bibliothèque nationale, à Paris* (Brussels, 1942), pp. 5-14, figs. 1-5; *Art mosan et arts anciens du pays de Liège*, exhib. cat. Liège (Liège: Éditions de l'a.s.b.l. le grand liége, 1951), pp. 161-162, no. 62. The Cleveland ivory, it can be assumed, was readily available in Brunswick in the fourteenth century when incorporated in the *Book-Shaped Reliquary* produced there. The House of Brunswick-Lüneburg and its ancestors, for all we know, had limited contact with France; it would seem to be a happenstance indeed that the ivory originally graced the cover of the Corbie manuscript which is now in Paris and had assumedly been in France throughout the centuries (when the Revolution broke out at the end of the eighteenth century, the volume was in the library of the Benedictine "Couvent des Feuillants" in Paris). See Léopold Delisle, *Inventaire des manuscrits latins de Notre-Dame et d'autres fonds* (Paris, 1871), p. 75.

13. Goldschmidt, *Elfenbeinskulpturen*, II, 49, nos. 161-162, pl. XLVI; Murphy, "Ottonian or Romanesque," pp. 15-18.

14. Carl Nordenfalk, "Der Meister des Registrum Gregorii," *Münchner Jahrbuch der bildenden Kunst*, I (1950), 61-77; C. R. Dodwell, *Painting in Europe 800 to 1200*, Pelican History of Art (Harmondsworth: Penguin Books, 1971), pp. 53-63.

15. For the Tongeren plaque and that of Bishop Notger's *Gospels* (Liège, Musée Curtius), see *Rhein und Maas*, p. 220, no. F8; see also p. 221, no. F9 (entries by Anton von Euw); Lasko, *Ars Sacra*, pp. 163-166, figs. 170, 172. For the plaque representing Bishop Sigebert, see Goldschmidt, *Elfenbeinskulpturen*, II, 44, no. 145; pl. XLI; *Kunst und Kultur im Weserraum*, p. 522, no. 209, fig. 175.

16. Lasko, *Ars Sacra*, p. 120, fig. 115.

17. Francis J. Tschan, *St. Bernward of Hildesheim: His Life and Times*, 3 vols. (Notre Dame, IN: University of Notre Dame Press, 1942-1952), II (1951), 80; Elbern and Reuther, *Hildesheimer Domschatz*, pp. 18-19, no. 5. Other amphoras also held to have been part of the Cana miracle are in St.-Denis, Paris, Tournus, Angers, Bobbio, Venice, Bamberg, Cologne, Quedlinburg, and Reichenau, all differing in size and material.

CHAPTER II
Commissions and Acquisitions of the Brunons in Eleventh-Century Brunswick

18. The inscription reads in translation: "I Gertrude died in the peace of the Lord on the 12th day of August" (date according to Julian calendar; 21 July 1077 according to present-day Gregorian calendar). On this epitaph, see Philipp J. Rethmeyer, *Antiquitates ecclesiasticae...Der berühmten Stadt Braunschweig Kirchenhistorie*, I (Brunswick, 1707), p. 59; L. C. Bethmann, "Das Grab der Gräfin Gerdrud in der Burgkirche," *Braunschweigerisches Magazin*, XVI (21 April 1860), 133-136. An essential tool for the study of the Collegiate Church of St. Blaise is Ernst Döll, *Die Kollegiatestifte St. Blasius und St. Cyriacus zu Braunschweig*, Braunschweiger Werkstücke, Veröfflichungen aus Archiv, Bibliothek und Museum der Stadt (Brunswick: Waiserhaus-Buchdreicherei und Verlag, 1967).

19. The thirteen rings, crudely attached, are not part of the original conception; they date to the fifteenth century. On this reliquary see Rethmeyer, *Antiquitates ecclesiasticae*, I, 102 (who considered it to be the gift of Henry the Lion's mother); Neumann, *Reliquienschatz*, pp. 27, 32, 39, 322-323, 331, 349; von Falke, Schmidt, and G. Swarzenski,

Welfenschatz, p. 20; Ars Sacra: Kunst des Frühen Mittelalters, exhib. cat. (Munich: Staatsbibliothek, 1950), p. 89, no. 173; H. Swarzenski, Monuments, p. 42, no. 27, fig. 66.

20. CMA 31.461, 31.55 Ceremonial Cross of Count Liudolf Brunon and Ceremonial Cross of Countess Gertrude, gold, cloisonné enamel, gems, pearls, and mother-of-pearl on a core of oak; both crosses: 9-1/2 x 8-1/2 inches (24.2 x 21.6 cm.). Germany, Lower Saxony, Hildesheim; Cross of Count Liudolf: 1038 or shortly thereafter; Cross of Countess Gertrude: ca. 1040. Cross of Count Liudolf: Gift of the John Huntington Art and Polytechnic Trust; Cross of Countess Gertrude: Purchase from the J. H. Wade Fund with addition of Gift from Mrs. E. B. Greene.

Ex collections: Treasury, Cathedral of St. Blaise, Brunswick (Inventory of 1482: "Item, II cruce preciose que portantur cum vexillis optimis in festivitatibus quas contulit gertrudis cometista"); House of Brunswick-Lüneburg; [Goldschmidt Galleries, New York]. Exhibitions: Vienna, 1869: Österreichisches Museum für Kunst und Industrie; Frankfurt-am-Main, 1930: Städelsche Kunstinstitut; Berlin, 1930: Deutsche Gesellschaft (for the two 1930 exhibits in Germany, see Der Welfenschatz, pp. 31-32, nos. 3-4, pl. 4; New York, 1930: Goldschmidt and Reinhardt Galleries, The Guelph Treasure, pp. 31-32, nos. 3-4, pl. 4 (the Cross of Count Liudolf and the Cross of Countess Gertrude traveled with this exhibition to The Cleveland Museum of Art, 10 January-1 February 1931); Cleveland, 1936: The Cleveland Museum of Art, Twentieth Anniversary Exhibition, pp. 13-14, nos. 2-3, pl. I.

Selected publications: Molanus, Lipsanographia, nos. V-VI, pls. 3-4; Christian Ludwig Scheid, Origines Guelficae, 3 vols. (Hanover: Sumptibus orphanotrophei morigensis, 1750-1752), III (1752), pls. IX-X; P. Deckers and J. C. Baum, Welfenschatz Abbildung (Reliquiarienschatz des Hauses Braunschweig-Lüneburg), Chromolitos (Cologne: Weber and Deckers [ca. 1860-1866]), pl. II (2nd series); Neumann, Reliquienschatz, pp. 93-103, nos. 2-3; Rosenberg, Geschichte der Goldschmiedekunst, III, 64; von Falke, Schmidt, and G. Swarzenski, Welfenschatz, pp. 14, 39-40, and 101-104, nos. 3-4; pls. 7-10; William M. Milliken, "The Gertrudis Altar and Two Crosses," CMA Bulletin, XVIII (1931), 23-26, 34; idem, "Guelph Treasure" (1931), pp. 162-173; idem, "The Guelph Treasure in Cleveland" (1955-56), pp. 5-6; Louis Grodecki, Florentine Mütherich, Jean Taralon, and Francis Wormald, Le Siècle de l'An Mil (Paris: Gallimard, 1973), p. 264 (where confusion occurs between the inscription on the Liudolf Cross and on the Portable Altar of Countess Gertrude); Martin Gosebruch, "Die Braunschweiger Gertrudiswerkstatt – zur spätottonischen Goldschmiedekunst in Sachsen," Niederdeutsche Beitrage zur Kunstgeschichte, XVIII (1979), 21-28.

21. Theophilus, The Various Arts, trans. Dodwell, pp. 99-102.

22. CMA 31.462 Portable Altar of Countess Gertrude, red porphyry, nielloed gold, cloisonné enamel, gems, and pearls on a core of oak (close examination of the filigree work negates Lasko's suggestion [Ars Sacra, p. 286, n. 12] that it was originally backed by Drahtemail [wire enamel]), 4 x 10-1/2 x 8 inches (10.2 x 26.7 x 20.3 cm.). Germany, Lower Saxony, Hildesheim, ca. 1045. Gift of the John Huntington Art and Polytechnic Trust.

Ex collections: Treasury, Cathedral of St. Blaise, Brunswick (Inventory of 1482: "In uno precioso scrineo habens superius lapidem fusci coloris marmoreum et in circumferenciis multas imagines sanctorum deauratus super quo in festivitatibus solet poni caput sancti blasii," a list of the relics it contains follows); House of Brunswick-Lüneburg; [Goldschmidt Galleries, New York]. Exhibitions: Vienna, 1869: Österreichisches Museum für Kunst und Industrie; Frankfurt-am-Main, 1930: Städelsche Kunstinstitut; Berlin, 1930: Deutsche Gesellschaft (for the two 1930 exhibits in Germany, see Der Welfenschatz, p. 33, no. 5, pls. 5-6); New York, 1930: Goldschmidt and Reinhardt Galleries, The Guelph Treasure, p. 33, no. 5; pls. 5-6 (the Portable Altar of Countess

Gertrude traveled with this exhibition to The Cleveland Museum of Art, 10 January-1 February 1931); Cleveland, 1936: The Cleveland Museum of Art, Twentieth Anniversary Exhibition, p. 13, no. 1; pl. I.

Selected publications: Molanus, Lipsanographia, no. XI; Neumann, Reliquienschatz, pp. 129-135, no. 13; von Falke and Frauberger, Deutsche Schmelzarbeiten, pp. 4, 11, 107-108, 111; Rosenberg, Geschichte der Goldschmiedekunst, III, 64, fig. 70; von Falke, Schmidt, and G. Swarzenski, Welfenschatz, pp. 14, 42-45, and 105-106, no. 5; pls. 11-14; Milliken, "The Gertrudis Altar and Two Crosses," pp. 23-26, 31-33; Milliken, "Guelph Treasure" (1931), pp. 163-164; H. Swarzenski, Monuments, p. 44, no. 36; fig. 85; Milliken, "The Guelph Treasure in Cleveland" (1955-56), pp. 5-6, 10; Erika Dinkler-von Schubert, Der Schrein der Hl. Elizabeth zu Marburg (Marburg: Verlag des Kunstgeschichtlichen Seminars der Universität Marburg an der Lahn, 1964), pp. 57-60, pl. 25, fig. 73; Stanley Ferber, "Aspects of the Development of Ottonian Respoussé [sic] Gold Work," Gesta, I-II (1964), 16-17, 19; Florentine Mütherich, "Der Watterbacher Tragaltar," Münchner Jahrbuch der bildenden Kunst, 3rd ser., XV (1964), 60-61; Tilmann Buddensieg, "Beiträge zur ottonischen Kunst in Niedersachsen," in Miscellanea Pro Arte Hermann Schnitzler zur Vollendung des 60. Lebensjahres am 13. Januar 1965, eds. Peter Bloch and Joseph Hoster (Düsseldorf: Verlag L. Schwann, 1965), pp. 72-73; pl. LVII, figs. 16-18; Lasko, Ars Sacra, pp. 135-136, 138, 289, fig. 140; Grodecki, Mütherich, Taralon, and Wormald, Siècle de l'An Mil, p. 276 and fig. 280; Gosebruch, "Braunschweiger Gertrudiswerkstatt," 26-27, 29, figs. 10-14.

23. S. Lowenfeld, Epistolae pontificum romanorum ineditae (Leipzig: Veit et Comp., 1885), p. 65; Bibliotheca sanctorum, 12 vols. + index (Rome: Istituto Giovanni XXIII, 1961-1970), I (1961), cols. 233-235; Butler's Lives of the Saints, ed. Herbert Thurston and Donald Attwater, 4 vols. (Westminster, MD: Christian Classics, 1980 edition), IV, 572-573. For a discussion of equivalent vs. formal canonization, see The Catholic Encyclopedia, 15 vols. + suppl. + index (New York: The Encyclopedia Press, Inc., 1913-14), II (1913), 365-366 ("Beatification and Canonization" entry by Camillus Beccari). I wish to thank Dr. Adelaide L. Bennett of the Index of Christian Art for calling my attention to this reference.

24. For Bernward's patronage, see particularly Tschann, St. Bernward of Hildesheim, vols. II-III, passim; Rudolf Wesenberg, Bernwardinisch Plastik (Berlin: Deutscher Verein für Kunstwissenschaft, 1955); idem, "Curvatura Erkanbaldi Abbatis: Bestimmung und Datierung der silbernen Krümme im Domschatz zu Hildesheim," in Karolingische und ottonische Kunst: Werden, Wesen, Wirkung, Forschnungen zur Kunstgeschichte und christlichen Archäologie 3 (Wiesbaden: Franz Steiner Verlag, 1957), pp. 373-381; Elbern and Reuther, Hildesheimer Domschatz, passim; Lasko, Ars Sacra, pp. 111-123, figs. 106-108, 111-114.

25. For the Hildesheim Madonna, see Wesenberg, Bernwardinisch Plastik, pp. 59-62; Elbern and Reuther, Hildesheimer Domschatz, pp. 73-74, no. 82, figs. 40-41 (illustrating other fragments of the goldsmith work); Lasko, Ars Sacra, p. 122, fig. 120. For the Madonna of Essen Cathedral dating of ca. 1000, see, among others, H. Swarzenski, Monuments, p. 45, no. 39, figs. 89-91; Hermann Schnitzler, Rheinische Schatzkammer, 2 vols. (Düsseldorf: Verlag L. Schwann, 1957), I, 31, no. 39, pls. 130-133; Lasko, p. 104, fig. 97.

26. The Bernward Cross was first restored in the twelfth century (back and ends of obverse) and again more thoroughly in the nineteenth century with the inclusion of new gems. For the late dating proposed by Hermann Schnitzler, see his "Das sogennante grosse Bernwardkreuz," in Karolingische und ottonische Kunst: Werden, Wesen, Wirkung, Forschungen zur Kunstgeschichte und christlichen Archäologie 3 (Wiesbaden: Franz Steiner Verlag, 1957), pp. 382-394. For the rebuttal of Martin Gosebruch with a dating (ca. 1040) which in turn seems to us much too early, see his "Braunschweiger Gertrudiswerkstatt," pp.

1-24, where he further suggests that there was a goldsmith workshop right in Brunswick, a much debatable question.

27. Hiltrud Westermann-Angerhausen, *Die Goldschmiedearbeiten der Trierer Egbertwerkstatt*, Trier Zeitschrift für Geschichte und Kunst des Trierer Landes und seiner Nachbargebiete XXXVI (Trier: Spee-Verlag, 1973); Peter Metz, *The Golden Gospels of Echternach – Codex Aureus Epternacensis* (London: Thames and Hudson, 1957); Lasko, *Ars Sacra*, pp. 95-99; figs. 89-92; Frauke Steenbock, "Ein fürstliches Geschenk," in *Studien zum europäischen Kunsthandwerk, Festschrift Yvonne Hackenbroch*, ed. Jorg Rasmussen (Munich: Klinkhardt & Biermann, 1983), pp. 25-33. For the Victoria and Albert Museum plaques, see Campbell, *Introduction to Medieval Enamels*, p. 13.

28. H. Swarzenski, *Monuments*, p. 43, no. 33, p. 44, no. 36, figs. 80, 84; Schnitzler, *Rheinische Schatzkammer*, I, 32-33, nos. 42-46; pls. 136-156; *Rhein und Maas*, pp. 189-191, nos. D2-3 (entries by Kötzsche); Lasko, *Ars Sacra*, pp. 99-106, 136, figs. 93-94, 96, 139, 141.

29. H. Swarzenski, *Monuments*, p. 45, nos. 41-42; figs. 92-93, 95, 99, 101; Géza de Francovich, "Arte carolingia ed ottoniana in Lombardia," *Romanisches Jahrbuch für Kunstgeschichte*, VI (1942-44), 184-219; Tilmann Buddenseig, "Die baseler Altartafel Heinrichs II," *Wallraf-Richartz-Jahrbuch*, XIX (1957), 133-192; Lasko, *Ars Sacra*, pp. 129-130, fig. 130; Tschan, *St. Bernward of Hildesheim*, II, 78. In this context, cf. also the *Arnulf Ciborium* of 887/96(?) (Munich, Residenz, Treasury) and the *Golden Altar Frontal* of the Palace Chapel at Aachen of ca. 1020 (for which see H. Swarzenski, *Monuments*, p. 38, no. 8, figs. 14-16, and Lasko, pp. 126-128, 130-131, figs. 58A-B, 132).

30. For Otto I and Magdeburg, see Robert Holtzmann, "Otto der Grosse und Magdeburg," in *Aufsätze zur deutschen Geschichte des Mitelelberaums* (Darmstadt, 1962), pp. 1-33. For the *Codex Wittekindeus* in the Berlin Staatsbibliothek, see particularly Johann Carl Conrad Ölrichs, *Entwurf einer Geschichte der königlichen Bibliothek zu Berlin* (Berlin, 1752), p. 56. For other reliquaries, see also the inventory of 1049 in G. Wenz and Berent Schwineköper, *Das Erzbistum Magdeburg* (Berlin, 1972), I, part 1, p. 238.

31. The cathedral was heavily damaged by a series of fires in 1008, 1049, and 1208. See H. Kunze, "Der Dom des Ottos des Grossen in Magdeburg," *Geschichtsblättern für Stadt und Land Magdeburg*, LXV (1930), 1-72; Walther Greischel, *Der Magdeburger Dom* (Berlin-Zurich: Atlantis-Verlag, 1939); Friedrich Oswald, Leo Schaefer, and Hans Rudolf Sennhauser, eds., *Verromanische Kirchenbauten, Katolog der Denkmaler bis zum Ausgang der Ottonen* (Munich: Prestel-Verlag, 1966), II, 190-191 (entry by Oswald); Ernst Schubert, *Der Magdeburger Dom* (Vienna, Cologne, 1974). For relationships with Lombardy, see de Francovich, "Arte carolingia ed ottoniana," pp. 116-157.

32. For Bernward's bronze column, see H. Swarzenski, *Monuments*, p. 47, nos. 52-52; figs. 117-120; Wesenberg, *Bernwardinisch Plastik*, pp. 117-150, figs. 256-313. For the display of the altar in the fifteenth century, see the Inventory of 1482 quoted above in note 22.

33. See Appendix, nos. 6, 8; Kötzsche, *Welfenschatz*, p. 67, nos. 7-8 (with bibliography), figs. 8-9. On Adelvoldus, see Döll, *Kollegiatstifte St. Blasius*, pp. 31-32, 139.

34. *Kunst und Kultur im Weserraum*, pp. 569-570, no. 248, figs. 210-212; Lasko, *Ars Sacra*, pp. 156-157, figs. 161-162. Also attributed to Roger is another portable altar (repr. in Lasko, fig. 163) and the binding of a gospel book (for which see our fig. 137). Roger of Helmarshausen may also be the author – using the Greek pseudonym of Theophilus – of the already mentioned treatise *The Various Arts (De Diversis Artibus)*. Indeed, in what seems to be the earliest manuscript that survives of this treatise, the heading states "Theophilius qui est Rugerius" (Theophilus who is Roger). Theophilus, a knowledgeable monk, was unequivocally also a practicing craftsman. His invaluable compendium on artistic techniques offers instruction on painting and glassworking, and mostly on the large variety of processes used in gold-smith work and bronze casting. It in fact describes, if often too succinctly, the methods used in the making of most objects in the Guelph Treasure, from the refining of gold and silver to the designing of chalices, patens, censers, altar-frontals, bookcovers, and reliquaries (see the standard Latin/English translation by Dodwell and the more recent edition by Hawthorne and Smith).

35. For the *Guelph Cross*, see Appendix, no. 9; von Falke, Schmidt, and G. Swarzenski, *Welfenschatz*, pp. 97-99, no. 1; pls. 1-4; Kötzsche, *Welfenschatz*, pp. 55, no. 1; figs. 1-2; Peter Springer, *Kreuzfüsse, Ikonographie und Typologie eines hochmittelalterlicher Gerätes* (Berlin: Deutscher Verlag für Kunstwissenschaft, 1981), pp. 59-64, no. 1; figs. K1-K10. For the patronage of Aribert of Milan, see de Francovich, "Arte carolingia ed ottoniana," pp. 223-241; Rossana Bossaglia and Mia Cinotti, with contributions by Ernesto Brivio and Mario Mirabella Roberti, *Tesoro e museo del Duomo*, 2 vols. (Milan: Electa Editrice, 1978), I, 55-58, nos. 10a-b, 11; Lasko, *Ars Sacra*, p. 86, fig. 76.

36. Yvonne Hackenbroch, *Italienisches Email des frühen Mittelalters*, Arts Docta, II (Basel/Leipzig: Holbein Verlag, 1938), pp. 49-55, figs. 24-45; Angelo Lipinski, "Sizilianische Goldschmiedekunst im Zeitalter der Normannen und Staufer," *Das Münster*, X (1957), 166-172; Springer, *Kreuzfüsse*, pp. 64-67, no. 2; figs. K11-K16.

CHAPTER III
Henry the Lion and the Arts
of Twelfth-Century Lower Saxony

37. The two major accounts of Henry the Lion's life used here are: the recension of Arnold von Lübeck's *Chronica Slavorum (Chronicle of the Slavs)* and that of Helmold von Bosau's *Chronica Slavorum*, both by J. M. Lappenberg, and published (separately) as school editions by George H. Pertz in *Scriptores Rerum Germanicarum* (Hanover: Impensis Bibliopolii Hahniani, 1868). For a transcription of all major documents relating to the rule of Henry the Lion, see Karl Jordan, *Die Urkunden Heinrichs des Löwen Herzogs von Sachsen und Bayern*, Monumenta Germaniae Historica 500-1500, I (Leipzig: Verlag Karl W. Hiersemann, 1941). For Henry's treatment of the Slavs, see Edouard Jordan, *Histoire du Moyen Age*, IV¹: *L'Allemagne et l'Italie aux XIIe et XIIIe siècles* (Paris: Presses Universitaires de France, 1939), pp. 126-128; Winifred Bauman, *Die Sage von Heinrich dem Löwen bei den Slaven* (Munich: Verlag Otto Sagner, 1975). The only English work on Henry the Lion's life is the brief sketch of Austin L. Pole, *Henry the Lion*, the Lothian Historical Essay for 1912 (Oxford: B. H. Blackwell 1912). Among works in German, still very useful for its documentation and perceptiveness is Martin Philippson, *Heinrich der Löwe Herzog von Bayern und Sachsen*, 2nd. ed. (Leipzig: Dsfar Leiner, 1918). Of the several studies published in recent years, I have consulted Paul Barz, *Heinrich der Löwe. Eine Welfe bewegt die Geschichte* (Bonn: Keil Verlag, 1977); Karl Jordan, *Heinrich der Löwe. Eine Biographie* (Munich: Verlag C. H. Beck, 1979); idem, "Die Stadtpolitik Heinrichs des Löwen," in *Brunswiek 1031 – Braunschweig 1981*, Festschrift zur Ausstellung, ed. Matthias Puhle (Brunswick: Städtisches Museum, 1981), pp. 97-103. The ancient Castle of Dankwarderode built by Henry the Lion was repeatedly damaged by fire, rebuilt and enlarged, particularly so in 1887, when it was uniformly restored in a neo-Romanesque mode including paintings in troubadour style by Quensen. It has undergone yet another restoration in the early 1980s.

38. Arnold von Lübeck, *Chronica Slavorum*, ed. Pertz, p. 30; Einar Joranson, "The Palestine Pilgrimage of Henry the Lion," in *Medieval and Historiographical Essays in Honor of James Westfall Thompson*, ed. James L. Cate (Chicago: The University of Chicago Press, 1938), pp. 146-225.

39. For the *Icon of St. Demetri*, see Klaus Wessel, *Byzantine Enamels from the 5th to the 13th Century* (Shannon: Irish University Press, 1969), pp. 174-176; Kötzsche, *Welfenschatz*, p. 65, no. 2 (with bibliography), fig. 3. For the icon in Venice, see André Grabar in *Il Tesoro di San Marco*, trans. and ed. R. Hahnloser (Florence: Sansoni, 1965), pp. 23-25, no. 16, pls. XVI-XVIII; idem, *Les Revêtements en or et en argent des icônes byzantines du Moyen Age*, Bibliothèque de l'Institut héllénique d'études byzantines et post-byzantines de Venise VII (Venice, 1975).

40. See Appendix, nos. 33-34; von Falke, Schmidt, and G. Swarzenski, *Welfenschatz*, p. 111, no. 9, and pl. 19; p. 162, no. 37; Kötzsche, *Welfenschatz*, p. 66, no. 4, pp. 75-76, no. 26 (with bibliography), figs. 5, 52, resp. For the duke's sojourn in the Holy Land, see Arnold von Lübeck, *Chronica Slavorum*, pp. 21-22.

41. For a survey of ivories with a similar origin, see Perry B. Cott, *Siculo-Arabic Ivories*, Princeton Monographs in Art and Archaeology: Folio Series, III (Princeton: Princeton University, 1939). For the Cambridge *Pyx*, see *Eucharistic Vessels of the Middle Ages*, exhib. cat. (Cambridge, MA: Busch-Reisinger Museum, 1975), pp. 71-72, no. 7 (entry by Sheila R. Connally). For the box in Berlin, see Appendix, no. 40; Kötzsche, *Welfenschatz*, p. 66, no. 5 (with further bibliography), fig. 7. For the *oliphant* in Brunswick, see Otto von Falke, "Elfenbeinhörner, I: Ägypten und Italien," *Pantheon*, IV (1929), 517.

CMA 30.740 *Horn of St. Blaise*, ivory, L. 19-½ inches (49 cm.), Widest Diam. 4-11/16 inches (12 cm.). Sicily, Palermo (?), twelfth century. Gift of the John Huntington Art and Polytechnic Trust. Ex collections: Treasury, Cathedral of St. Blaise, Brunswick (Inventory of 1482: "unum cornu de elephante auro argento et preciosis lapidibus circumductum et contextum. Est vocatur Cornu sancti Blasii"); House of Brunswick-Lünebrug; [Goldschmidt Galleries, New York]. Exhibitions: Vienna, 1869: Österreichisches Museum für Kunst und Industrie; Frankfurt-am-Main, 1930: Städelsche Kunstinstitut; Berlin, 1930: Deutsche Gesellschaft (for the two 1930 exhibits in Germany, see Der Welfenschatz, p. 36, no. 10, pl. 9; New York, 1930: Goldschmidt and Reinhardt Galleries, The Guelph Treasure, p. 36, no. 10, pl. 9 (the *Horn of St. Blaise* traveled with this exhibition to The Cleveland Museum of Art, 10 January-1 February 1931); Cleveland, 1936: The Cleveland Museum of Art, Twentieth Anniversary Exhibition, pp. 15-16, no. 6; Baltimore, 1947: The Baltimore Museum of Art, Early Christian and Byzantine Art, p. 48, no. 150; pl. XXIV. Selected publications: Molanus, *Lipsanographia*, no. XXXIV; Rethmeyer, *Antiquatates ecclesiasticae*, I, 103-104; Neumann, *Reliquienschatz*, pp. 318-321, no. 80; von Falke, Schmidt, and G. Swarzenski, *Welfenschatz*, pp. 51, 112, no. 10; pls. 20, 93; Milliken, "Aquisition of Six Objects from The Guelph Treasury," pp. 168-169, 174; idem, "The Guelph Treasure in Cleveland" (1955-56), pp. 6, 10.

42. For the so-called hunting horn of Charlemagne in the Treasury of Aachen, see *Karl der Grosse*, pp. 499-500, no. 679; Grimme, "Der Aachener Domschatz," pp. 17-18, no. 11, pls. 8-9.

43. The classic study on Henry the Lion's patronage (G. Swarzenski, "Kunstkreis" of 1932, pp. 241-397) has been criticized for the author's fascination with pairing the creation of works of art and historical motivation, and for proposing that Brunswick was the major artistic center of Saxony under Henry the Lion.

44. On the relationship of miniature painting and enameling, see Elisabeth Klemm, *Ein romanischer Miniaturenzyklus aus dem Maasgebiet*, Wiener Kunstgeschichtliche Forschungen, II (Vienna: Verlag Adolf Holzhausens NFG, 1973). For the *Head Reliquary of Pope Alexander*, see H. Swarzenski, *Monuments*, p. 67, no. 163; figs. 359-361; *Rhein und Maas*, p. 250, no. G11 (entry by Kötzsche); *Zeit der Staufer*, I, 404-406, no. 542 (entry by Kötzsche); II, pl. 333. On *Disk Reliquary*, CMA 26.428, repr. Figure 69, see also *Arts of the Middle Ages*, exhib. cat. (Boston: Museum of Fine Arts, 1940), p. 71, no. 244; pl. XXVII.

45. For the shrine in Siegburg, see *Rhein und Maas*, p. 273, no. H11 (entry by Kötzsche); Lasko, *Ars Sacra*, p. 214, fig. 240.

CMA 49.430 *Judgment and Martyrdom of St. Lawrence*, champlevé enamel and gilt-copper plaque, 3-3/4 x 8-3/16 inches (9.5 x 20.8 cm.). Inscribed: ECCE EI MILES SVFAT LAVRENTIVUS IGNES + S-CS LAVRENTIVS. Germany, Rhine Valley, Cologne (?), ca. 1185. Purchase from the J. H. Wade Fund. Ex collections: Basilewsky, Paris; The Hermitage, Leningrad; [The Brummer Gallery, Inc., New York]. Exhibitions: Boston, 1940: Museum of Fine Arts, Arts of the Middle Ages 1000-1400, p. 74, no. 255, pl. XXX, fig. 255. Publication: William M. Milliken, "New Accessions of Champlevé Enamel,' CMA *Bulletin*, XXXVI (1949), 166-170. For other Colognese productions, see *Rhein und Maas*, pp. 269-279, nos. H7-18 (entries by Kötzsche).

46. Von Falke and Frauberger, *Deutsche Schmelzarbeiten*, pp. 21-46. An origin in Saxony, with an attribution to the Weland Workshop, for these Apostle plaques, as proposed by G. Swarzenski, "Kunstkreis," pp. 244-246, which has been adhered to since in the literature (see, for example, Irmgard Woldergin, *Mittelalters: Bronze, Email, Elfenbein, Kestner-Museums,* [Hanover: Ferdinand Stuttmann, 1966], p. 58, no. 57; pl. 160), is in our opinion not convincing. The drawing and the execution of these trapezoidal plaques are markedly different from the *Reliquary of Henry II* (Figure 94), bearing a closer similarity to Rhenish examples strongly influenced by Mosan models. For the relationship between Mosan and Colognese enamelers, see Dietrich Kötzsche, "Zum Stand der Forschung der Goldschmiedekunst des 12. Jahrhunderts im Rhein-Maas-Gebiet," in *Rhein und Maas: Kunst und Kultur 800-1400*, vol. II: *Berichte, Beiträge und Forschungen zum Themenkreis der Ausstellung und Katalogs* (Cologne: Schnütgen-Museum, 1973), pp. 191-236. For Nicholas of Verdun, see H. Swarzenski, *Monuments*, p. 82, no. 218; figs. 513-516.

47. Otto von Falke, "Hildesheimer Goldschmiedewerke des 12. Jahrhunderts im Welfenschatz." *Pantheon*, V (1930), 266-274; G. Swarzenski, "Kunstkreis," p. 242. It has been suggested by Lasko (*Ars Sacra*, pp. 200-201) that the portable altar by Eilbertus might well have been acquired by Henry the Lion's father, Henry the Proud, in connection with a partial reconstruction and refurbishing in 1137 of the by then century-old Brunon foundation, but such an early dating would make the chronology of related plaques rather unintelligible both in the Mosan Region as well as in Germany.

48. On the casting of the Lion of Brunswick, see *Zeitschrift des Harz Vereins für Geschichte*, 1870, p. 307; Karl Jordan and Martin Gosebruch, *800 Jahre Braunschweiger Burglöwe 1166-1966*, Braunschweiger Werkstüke, Reihe A, Veröffentlichungen aus dem Stadtarchiv und der Stadtbibliothek (Brunswick: Waisenhaus Buchdruckerei und Verlag, 1967). For the *Krodo Altar*, see Lasko, *Ars Sacra*, p. 137, fig. 145.

49. For the *St. Godehard Shrine*, see *Kunst und Kultur im Weserraum*, pp. 582-584, no. 264; fig. 227; Lasko, *Ars Sacra*, pp. 197-198, figs. 213-214. For the early series of caskets with enamels of sharp colors, see Paul Nörlund, "An Early Group of Enamelled Reliquaries, its Dating and Provenance," *Acta Archaeologica* (Copenhagen), IV (1933), 1-32; Otto von Falke, "Die Inkunabeln der romanischen Kupferschmelz-Kunst," *Pantheon*, XVII (1936), 166-169, proposing the Danish origin, but cf. von Falke and Frauberger, *Deutsche Schmelzarbeiten*, pp. 105-115, and Lasko, *Ars Sacra*, pp. 175-176, fig. 185; Kötzsche, *Welfenschatz*, p. 73, no. 17, figs. 37-38; Springer, *Kreuzfüsse*, pp. 97-102, nos. 10-12; figs. K94-K113. There is also a casket of this type in the collections of the Metropolitan Museum of Art, Gift of J. P. Morgan (Acc. 17.190.401), and for which see *Treasures from the Cloisters and the Metropolitan Museum of Art*, exhib. cat., Los Angeles-Chicago (Los Angeles County Museum of Art, 1969), p. 88, no. 39. There is still another example in the British Museum. For the casket in the Hildesheim Treasury, see Elbern and Reuther, *Hildesheimer Domschatz*, pp. 33-34, no. 21, fig. 18B.

CMA 49.16 *Reliquary Casket with Champlevé Enamels of Sharp Colors*, gilt-copper and champlevé enamel on a core of wood, 3-5/8 x 9-3/16 x 5-5/16 inches (9.3 x 23.3 x 13.4 cm.). Germany, Lower Saxony, Hildesheim (?), early twelfth century. Purchase from the J. H. Wade Fund. Ex collections: Debruge Dumenil; Soltykoff; George Attenborough; Paul Shuvalov; The Hermitage, Leningrad; Baron Thyssen-Bornemisza, Schloss Rohoncz, Lugano; [Adolph Loewi, Los Angeles]. Publications: William M. Milliken, "A Danish Champlevé Enamel," CMA *Bulletin*, XXXVI (1949), 98, 101-103. Erich Meyer's opinion ("Die Hildesheimer Rogerwerkstatt," *Pantheon*, XXXII [1944], 1-11) that Helmarshausen had had a strong influence on Hildesheim remains unsubstantiated.

50. Elbern and Reuther, *Hildesheimer Domschatz*, pp. 42-43, no. 30, fig. 26; *Zeit der Staufer*, I, 444, no. 574 (entry by Kötzsche); II, pls. 381-382; Lasko, *Ars Sacra*, pp. 201-202, fig. 218. The splendid painted ceiling of St. Michael of Hildesheim produced shortly after the fire of 1186, which is dominated by an elaborate *Tree of Jesse*, also includes a series of standing prophets in rectangular frames or in medallions (best repr. in Johannes Sommer, *Das Deckenbild der Michaeliskirche zu Hildesheim* [Hildesheim: Verlag Gebrüder Gerstendberg, 1966]). It is essential to note in these compositions, steeped in twelfth-century formulas, that the ground behind the standing prophets is composed of concentric colored rectangles, the inner one being blue and the exterior one green, and that between the two colors there is a thin gold line reminiscent of the division between champlevé enamel fields in a fashion directly echoing the series of plaques described here and attributed to Hildesheim workshops.

51. See Appendix, nos. 17-18; Lasko, *Ars Sacra*, pp. 202-204, fig. 216; Kötzsche, *Welfenschatz*, pp. 70-71, no. 13, p. 73, no. 16 (with bibliography), figs. 19-22, 33-36.

52. John H. Pollen, *Ancient and Modern Gold and Silver Smiths' Work in the South Kensington Museum* (London: George E. Eyre and William Spottiswoode, 1878), pp. 8-9; V. C. Habicht, *Niedersächsische Kunst in England*, Schriftenreihe der Wirtschaftswissenschaftl. Gesellschaft zum Studium Niedersächsischen (Hanover: Edler & Krische, 1930), pp. 31-34; Lasko, *Ars Sacra*, p. 301, n. 8.

53. For the Ratmann and Tegernsee volumes, see Elbern and Reuther, *Hildesheimer Domschatz*, p. 50, no. 37, pl. 30; Lasko, *Ars Sacra*, pp. 202-204, figs. 220, 223; *Schatzkunst Trier*, ed. Franz J. Ronig, exhib. cat., Trier, Cathedral (Trier: Spee-Verlag, 1984), pp. 129-130, no. 68 (entry by F. Ronig). For the *Portable Altar of Abraham and Melchizedek*, see Appendix, no. 19; Lasko, p. 202; Kötzsche, *Welfenschatz*, p. 71, no. 14 (with bibliography), figs. 23-24.

54. For the casket with an enamel plaque of St. Matthew, see Appendix no. 20 and sales cat. Sotheby Parke Bernet & Co., London, 22 June 1978, *The Robert von Hirsch Collection*, II, lot 228, and the following exhibition catalogues: O. Homburger, *Kunst des frühen Mittelalters* (Bern, 1949), no. 433; Dietrich Kötzsche, *Meister Werke aus der Sammlung von Hirsch Erworben fuer deutschen Museen* (Bonn-Bad Godesberg: Wissenschaftszentrum, 1979), pp. 31-34. For the Crucifixion plaques in Paris and Trier, see H. Swarzenski, *Monuments*, p. 75, no. 193; fig. 439; Schnitzler, *Rheinische Schatzkammer*, p. 14, no. 3; pl. 9; *Zeit der Staufer*, I, 446-447 (entry by Kötzsche), no. 576; II, 383; Lasko, *Ars Sacra*, pp. 202-203, figs. 221-222. In connection with these plaques see also the champlevé enamel casket of the same period and bearing a nearly similar scene of the Crucifixion on its lid in the Victoria and Albert Museum, Inv. 4524-1858 (repr. in Campbell, *Introduction to Medieval Enamels*, p. 24, fig. 17).

CMA 49.431 *Pyx*, champlevé and cloisonné enamel and gilt-copper on a core of wood, 2-1/8 x 8-3/8 x 3-5/8 inches (5.4 x 21.3 x 9.2 cm.). Germany, Lower Saxony, Hildesheim (?). Purchase from the J. H. Wade Fund. Ex collections: George Eumorfopoulos, London; Joseph Brummer, New York; [R. Stora & Co., Paris]. Selected publications: Herbert

Read, "The Eumorfopoulos Collection: Western Objects – I," *Apollo*, III (1926), 187-188; von Falke, "Hildesheimer Goldschmiedewerke," pp. 272-273, where given as in South Kensington Museum; Milliken, "New Accessions of Champlevé Enamel," pp. 166-170; Kötzsche, "Zum Stand der Forschung des Goldschmiedekunst," pp. 211, 213, 268; Philippe Verdier, "The Cleveland Portable Altar from Hildesheim," CMA *Bulletin*, LXI (1974), 339-342. Examined in the Cleveland Museum laboratory by Frederick Hollendonner, the back of the champlevé plaque indeed has areas of cuprite – that reddish cuprous oxide which cannot be induced and which builds up on copper and bronze before the appearance of verdigris – as would form on an object at least one hundred years old. This oxidation is somewhat less detectable on the decorative cloisonné elements flanking the sides of the pyx.

55. On the *Stavelot Portable Altar*, see *Rhein und Maas*, p. 252. no. G13 (entry by Kötzsche); pl. facing p. 261; *Zeit der Staufer*, I, 409-410, no. 544 (entry by Kötzsche), II, pl. 336; Lasko, *Ars Sacra*, pp. 191-192, fig. 205.

56. For the *Reliquary of Henry II*, see *Zeit der Staufer*, I, 445-446, no. 575 (entry by Kötsche), II, pl. 380, Lasko, *Ars Sacra*, pp. 204-205, fig. 224.

CMA 50.574-.577 *Four Plaques with Seated Prophets: Isaiah, Elisha, Obadiah, and Hosea*, champlevé enamel, niello, gilt-copper each marked on the back with an incised letter; CMA 50.574 (marked Ö): 3-1/2 x 2-3/8 inches (8.9 x 6 cm.); CMA 50.575 (marked P.k), 50.577 (marked S): 3-1/2 x 2-1/4 inches (8.9 x 5.7 cm.); CMA 50.576 (marked D): 3-1/2 x 2-5/16 inches (8.9 x 5.8 cm.). Weland Workshop, Germany, Lower Saxony, Hildesheim, ca. 1185. Purchase from the J. H. Wade Fund. Ex collections: Albin Chalandon, Lyon; Frédéric Spitzer, Paris; [Rosenberg and Stiebel, Inc., New York]. Exhibition: New York, 1970: The Metropolitan Museum of Art, The Year 1200, I, 177-179, no. 183. Selected publications: Léon Palustre, et al., *La Collection Spitzer: Antiquité, Moyen-Age – Renaissance* (Paris: Librairie centrale des Beaux-Arts, 1890), p. 99, no. 9 (CMA 50.574); William M. Milliken, "Four Champlevé Enamel Plaques," CMA *Bulletin*, XXXVIII (1951), 70, 72-74; H. Swarzenski, *Monuments*, pp. 75-76, no. 194, fig. 440; Verdier, "The Cleveland Portable Altar from Hildesheim," pp. 341-342.

57. G. Swarzenski, "Kunstkreis," pp. 346-347. See also the earlier von Falke and Frauberger, *Deutsche Schmelzarbeiten*, pp. 105-115.

58. H. Swarzenski, *Monuments*, p. 76, no. 194; figs. 443-445; Lasko, *Ars Sacra*, p. 239, fig. 283; C. M. Kauffmann, *Romanesque Manuscripts 1066-1190* (London: Harvey Miller, 1975), pp. 10, 112, no. 86; *English Romanesque Art 1066-1200*, exhib. cat. (London: Hayward Gallery; Weidenfeld and Nicolson, 1984), pp. 273-275, no. 290a-f (entry by Neil Stratford).

59. For these arm reliquaries, see Appendix, nos. 21-23; Lasko, *Ars Sacra*, p. 205; Kötzsche, *Welfenschatz*, pp. 74-75, nos. 19-22 (with bibliography), figs. 41-48.

60. The second chalice in Tremessen Abbey, now Gniezno (Poland), may have been a gift from Henry the Lion to the Polish King Boleslaw IV (1146-1172), who ordered the construction of this foundation. The decorative spirals of the chalice inlaid in niello and the engraved figures reserved in gilt-silver clearly follow the scheme of the *Berthold Chalice*, with greater emphasis, however, on architectural elements. The central field of the paten for the *Tremessen Chalice* is occupied with the depiction of Christ on the cross surrounded by the representations of Church and Synagogue as on the series of "Hildesheim" enamel plaques (Figures 90-92). For these chalices, see Heinrich Klapsia, "Der Bertoldus-Kelch aus dem Kloster Wilten," *Jahrbuch der Kunsthistorischen Sammlungen in Wien*, XII (1938), 7-34; H. Swarzenski, *Monuments*, pp. 74-75, nos. 191-192, figs. 434-437; Johannes Sommer, "Der Niellokelch von Iber: Ein unbekanntes Meisterwerk der Hildesheimer Goldschmiededekunst des späten 12. Jahrhunderts," *Zeitschrift für Kunstwissen-*

schaft, XI (1957), 109-136; Lasko, *Ars Sacra,* pp. 205-207, figs. 225, 228; Piotr Skubiszewski, "Eine Gruppe romanischer Goldschmiedearbeiten in Polen (Trzemeszno, Czerwińsk)," *Jahrbuch der Berliner Museen,* XXII (1980), 35-90.

61. CMA 30.505 *Monstrance with the "Paten of St. Bernward."* Paten: gilt-silver and niello, Diam. 5-5/16 inches (13.4 cm.). St. Oswald Reliquary Workshop. Germany, Lower Saxony, Hildesheim(?), ca. 1185. Monstrance: gilt-silver, rock crystal with eight relics of SS. Nicholas, Auctore, Silvester, Servacio, John Chrisotemos, Alexis, Lawrence, and Godehard, wrapped in silk, and two slivers of the True Cross surrounded by parchment with the inscription: DE SIGILLO DOMINI, H. 13-1/2 inches (34.4 cm.). Germany, Lower Saxony, Brunswick, end of fourteenth century. Purchase from the J. H. Wade Fund with Additional Gift from Mrs. R. Henry Norweb. The paten is inscribed: + EST. CORPVS. IN. SE. PANIS. QVI. FRANGITVR. IN. ME: VIVET. IN ETERNVM. QVI. BENE. SVMIT. EVM. (outer rim); + HVC. SPECTATE. VIRI. SIC. VOS MORIENDO. REDEMI. Ex collections: Treasury, Cathedral of St. Blaise, Brunswick (Inventory of 1482 quoted in text); House of Brunswick-Lüneburg; [Goldschmidt Galleries, New York].

Exhibitions: Vienna, 1869: Österreichisches Museum für Kunst und Industrie; Frankfurt-am-Main, 1930: Städelsche Kunstinstitut; Berlin, 1930: Deutsche Gesellschaft (for the two 1930 exhibits in Germany, see *Der Welfenschatz,* pp. 48-49, no. 32, pl. 18); New York, 1930: Goldschmidt and Reinhardt Galleries, The Guelph Treasure, pp. 48-49, no. 32, pl. 18 (the *Monstrance with the "Paten of St. Bernward"* traveled with this exhibition to The Cleveland Museum of Art, 10 January-1 February 1931); Cleveland, 1936: The Cleveland Museum of Art, Twentieth Anniversary Exhibition, pp. 16-17, no. 8; Stuttgart, 1977: Württembergisches Landesmuseum, Zeit der Staufer, I, 447-448, no. 577 (entry by Kötzsche); II, pl. 384.

Selected publications: Molanus, *Lipsanographia,* no. XV; Deckers and Baum, *Welfenschatz Abbildung,* pl. VI (2nd series); Neumann, *Reliquienschatz,* pp. 47, 294-297, no. 65; von Falke, Schmidt, and G. Swarzenski, *Welfenschatz,* pp. 91-92, and 156-157, no. 32; frontispiece, and pls. 70-71; Frankfurter, "Guelph Treasure," p. 62; Milliken, "Acquisition of Six Objects from the Guelph Treasure," pp. 161, 167-168; von Falke, "Hildesheimer Goldschmiedewerk," p. 274; Milliken, "Guelph Treasure" (1931), pp. 169-170; Helmuth Th. Bossert, *Geschichte des Kunstgewerbes alter Zeiten und Völker in Verbindung mit zahlreichen Fachgelehrten Herausgegeben* (Berlin: Verlag Ernst Wasmuth A.G., 1932), V, 289; G. Swarzenski, "Kunstkreis," pp. 370-372; Tschan, *St. Bernward of Hildesheim,* II (1951), 115-122; III (1952), pl. 100; H. Swarzenski, *Monuments,* p. 79, no. 208; fig. 482; Milliken, "The Guelph Treasure in Cleveland" (1955-56), pp. 7, 10; Sommer, "Die Niellokelch von Iber," pp. 109-136; Florens Deuchler, ed., *The Year 1200,* II: *A Background Survey Published in Conjunction with the Centennial Exhibition at the Metropolitan Museum of Art* (New York: The Metropolitan Museum of Art, 1970), 95, 97; Lasko, *Ars Sacra,* pp. 203-208, 215; fig. 230.

62. Around the year 1286 (according to Stephen Beissel, *Der Aachenfahrt: Verehrung der Aachen Heiligtümer seit den Tagen Karls des Grossen bis in unsere Zeit* [Freiburg-im-Bresgau: Herder, 1902]), Pope Honorius III issued a bull of remission to pilgrims who visited the Cathedral of Hildesheim on the feast day of St. Oswald, this date providing only a terminus post quem for the presence of the reliquary in Hildesheim. A gilt-silver chalice ornamented with gems and its paten, both clearly dating of ca. 1400, now in the Hildesheim Cathedral Treasury are likewise referred to by an old tradition as "the chalice and paten of St. Bernward" (for these, see Elbern and Reuther, *Hildesheimer Domschatz,* pp. 25-27, no. 14; pls. 10-11). Conceivably, the Cleveland Paten may have come to the Guelph Treasure from Hildesheim after one of Henry the Lion's descendants, Heinrich III, became bishop of Hildesheim in 1331 (see Neumann, *Reliquienschatz,* p. 297).

63. For the clasps and seal, see H. Swarzenski, *Monuments,* p. 79, nos. 208-209, figs. 484-485, 487; J. Giddes, "The Twelfth-Century Metalwork at Durham Cathedral," *The British Archeological Association Conference Transactions,* III (1977) (London: The British Archaeological Association, 1980), pp. 142-145; pl. XXID; *English Romanesque Art 1066-1200,* p. 281, no. 301 (entry by N. Stratford); p. 314, no. 360 (entry not signed). For the Troyes casket, see H. Swarzenski, *Monuments,* p. 77, no. 197; fig. 454; *English Romanesque Art 1066-1200,* pp. 267-268, no. 283 (entry by N. Stratford). See also the gilt-bronze casket with the figures of Grammar, Rhetoric, and Music in champlevé enamel dating to ca. 1170, in the Victoria and Albert Museum repr. in Lasko, *Ars Sacra,* fig. 280.

64. CMA 30.739 *Arm Reliquary of the Apostles,* silver, gilt-silver, and champlevé enamel on a core of oak, H. 20 inches (51 cm.). Germany, Lower Saxony, Hildesheim(?), ca. 1195. Gift of the John Huntington Art and Polytechnic Trust. Ex collections: Treasury, Cathedral of St. Blaise, Brunswick; House of Brunswick-Lüneburg; [Goldschmidt Galleries, New York].

Exhibitions: Vienna, 1869: Österreichisches Museum für Kunst und Industrie; Frankfurt-am-Main, 1930: Städelsche Kunstinstitut; Berlin, 1930: Deutsche Gesellschaft (for the two 1930 exhibits in Germany, see *Der Welfenschatz,* pp. 47-48, no. 30; New York, 1930: Goldschmidt and Reinhardt Galleries, The Guelph Treasure, pp. 47-48, no. 30 (the *Arm Reliquary* traveled with this exhibition to The Cleveland Museum of Art, 10 January-1 February 1931); Cleveland, 1936: The Cleveland Museum of Art, Twentieth Anniversary Exhibition, pp. 14-15, no. 4; New York, 1970: Metropolitan Museum of Art, The Year 1200, A Centennial Exhibition at the Metropolitan Museum of Art, pp. 104-105, no. 110; Stuttgart, 1977: Württembergisches Landesmuseum, Zeit der Staufer, I, 448-449, no. 578; II, pl. 387; Miami, 1984: Center for the Fine Arts, In Quest of Excellence, p. 72.

Selected publications: Molanus, *Lipsanographia,* no. XXVII; Deckers and Baum, *Welfenschatz Abbildung,* pl. VIII (2nd series); Neumann, *Reliquienschatz,* pp. 268-269, no. 47; von Falke, Schmidt, and G. Swarzenski, *Welfenschatz,* pp. 76-77, and 153, no. 30, pls. 65-66; Frankfurter, "Guelph Treasure," repr. 66; Milliken, "Acquisition of Six Objects from the Guelph Treasure," pp. 162, 165-167, 183; von Falke, "Hildesheimer Goldschmiedewerke," p. 274; Milliken, "Guelph Treasure" (1931), pp. 168, 171; G. Swarzenski, "Kunstkreis," pp. 326-327, 329-331, 333-334, 338, 380-381; H. Swarzenski, *Monuments,* p. 80, no. 212; figs. 496-498; Heinz Leitermann, *Deutsche Goldschmidt-Kunst* (Stuttgart: W. Kohlhammer Verlag, 1954), p. 143; pl. 19; Milliken, "The Guelph Treasure in Cleveland" (1955-56), pp. 6, 10; Willibald Sauerländer, "Exhibition Review of 'The Year 1200' " in *Art Bulletin,* LIII (1971), 515-516; Lasko, *Ars Sacra,* pp. 205-206, fig. 226; François Avril, Xavier Barral I Altet, and Danielle Gaborit-Chopin, *Le Temps des Croisades* (Paris: Gallimard, 1982), pp. 268-269.

65. Von Falke, Schmidt, and G. Swarzenski, *Welfenschatz,* p. 153. For St. Cyriacus, see Döll, *Kollegiatstifte St. Blasius,* pp. 45-56.

66. For the record of Henry the Lion's gift of the cross, see K. Janicke, ed., *Urkundenbuch des Hochstifts Hildesheim und seiner Bischöfe,* Publicationen aus den kaiserlich Preussischer Staatsarchiven, LVI (1896), 342, no. 359. For the relationship of metalwork and monumental sculpture in Saxony, see Adolph Goldschmidt, "Die Stilentwickelung der romanischen Skulptur in Sachsen," *Jahrbuch der preussischen Kunstsammlungen,* XXI (1900), 225-241; Sauerländer, "Exhibition Review 'The Year 1200,' " pp. 515-516; idem, "Spätsfausche Skulpturen in Sachsen und Thüringen," *Zeitschrift für Kunstgeschichte,* XLI (1978), 181-216.

67. G. Swarzenski, "Kunstkreis," pp. 354-355; H. Swarzenski, *Monuments,* p. 77, no. 199; figs. 462-463; Martin Gosebruch, *Der Braunschweiger Dom und seine Bildwerke,* Blauen Bucher Series

(Königstein in Taunus: Karl Robert Langewiesche Nachfolger, 1980), pp. 65-75.

68. CMA 44.320 *Altar Cross,* gilt-bronze, H. (with base): 17-1/16 inches (43.3 cm.); W. (base): 6-1/8 inches (15.5 cm.); H. (cross only): 11-3/4 inches (29.8 cm.); W. (cross only): 8-7/8 inches (22.5 cm.). Germany, Lower Saxony, Hildesheim, ca. 1175-1190. Purchase from the J. H. Wade Fund. Ex collections: Private collection, Strasbourg; Paul Cassirer, Berlin; [Adolph Loewi, Los Angeles]. Exhibitions: Buffalo, 1964: Albright-Knox Art Gallery, Religious Art, no. 36; Ithaca, 1968: Andrew Dickson White Museum of Art, Cornell University, no. 43. Publications: Robert Calkins, *A Medieval Treasury: An Exhibition of Medieval Art from the Third to the Sixteenth Century,* exhib. cat. (Ithaca: Andrew Dickson White Museum of Art, Cornell University, 1968), pp. 130-131, no. 43; Springer, *Kreuzfüsse,* pp. 134-136, no. 24; figs. K194-196. For the Bernward cross, see Elbern and Reuther, *Hildesheimer Domschatz,* pp. 19-20, no. 6; pls. 4-5. For the two later crosses, see ibid., pp. 28-29, 79, nos. 17, 92 resp.; pls. 12-13, 45 resp.; *Zeit der Staufer,* I, 516-517, no. 686 (entry by P. Bloch), II, pl. 487; Springer, pp. 148-152, no. 28; figs. K244-254; pp. 162-164, no. 37; figs. K280-K284. See also Peter Bloch, "Romanische Bronzekruzifixe vom Typus des Bernward-Kruzifixus," *Aachner Kunstblätter,* XLVII (1976-77), 81-110.

69. CMA 26.555 *Perfume* or *Incense Burner,* gilt-bronze, 7-1/8 x 5 inches (18.1 x 12.7 cm.). Germany, Lower Saxony, Hildesheim, second half twelfth century. Purchase from the J. H. Wade Fund. Ex collections: Bouvier, Amiens; Frédéric Spitzer, Paris; [Arnold Seligmann Rey & Co., Paris]. Selected publications: Palustre, *Collection Spitzer,* p. 101, no. 15; *Catalogue des objets d'art et de haute curiosité, Antiques, du Moyen-Age et de la Renaissance composant l'importante et précieuse Collection Spitzer,* sales cat. (Paris, 17 April-16 June 1893), I, 40, no. 226, where referred to as a censer or hand warmer; William M. Milliken, "Two Medieval Objects from the Rhineland in the J. H. Wade Collection," CMA *Bulletin,* XIV (1927), 56-57, 62-63; Hans Reuther, "Ein architektonisches Räucherstandgefäss im Cleveland Museum of Art," in *Kaleidoskop, Eine Festschrift für Fritz Baumgart zum 75. Geburtstag,* intro. by Friedrich Mielke (Berlin: Gebr. Mann Verlag, 1977), pp. 24-34; Springer, *Kreuzfüsse,* pp. 145-148, figs. K222-243. There is another but very mediocre version of this object at the British Museum (Acc. 80-6-14-15) and another still more remote in quality in the Städtische Kunstsammlung, Maximilianmuseum of Augsburg.

70. Grabar in *Tesoro di San Marco,* no. 109; pls. LXXVIII-LXXX; *Venezia e Bisanzio,* exhib. cat. (Venice: Palazzo ducale, 1974), intro. by S. Bettini, no. 44; Etienne Coche de la Ferté, *L'Art de Byzance* (Paris, 1981), fig. 580; Willmuth Arenhövel, *Der Hezilo-Radleuchter im Dom zu Hildesheim; Beiträge zur Hildesheimer Kunst des 11. Jahrhunderts unter besonderer Berücksichtigung der Ornamentik* (Berlin: Gebr. Mann Verlag, 1975).

71. H. Swarzenski, *Monuments,* pp. 80-81, no. 213; figs. 500-502; Lasko, *Ars Sacra,* p. 222, fig. 256; Kötzsche, *Welfenschatz,* pp. 71-73, no. 15 (with bibliography), pls. VII-VIII, figs. 25-32.

72. For the *Shrine of St. Aetherius,* see von Falke and Frauberger, *Deutsche Schmelzarbeiten,* p. 39, pl. 43; Lasko, *Ars Sacra,* p. 220, fig. 251.

73. Proposed by Lasko (*Ars Sacra,* pp. 221-222, fig. 255). For the London reliquary, see Pollen, *Ancient and Modern Gold and Silver Smiths' Work,* pp. 4-7. For the *Shrine of St. Marinus,* see *Rhein und Maas,* p. 279, no. H18; Lasko, pp. 220-221, fig. 252.

74. CMA 27.29 *Portable Altar,* porphyry, walrus ivory, champlevé enamel, and gilt-copper on a core of wood, 5-1/8 x 10-9/16 x 6-5/8 inches (12.7 x 26.5 x 17 cm.). Germany, Cologne, ca. 1200-1220. Purchase from the J. H. Wade Fund. Ex collections: Sir Francis Cook, Windsor; [M. and R. Stora, Paris]; [Durlacher Brothers, New York]. Exhibitions: Boston, 1940: Museum of Fine Arts, Arts of the Middle Ages 1000-1400,

p. 72, no. 250. Selected publications: Goldschmidt, *Elfenbeinskulpturen,* IV, 58, no. 302a-d; pl. LXXVI; Milliken, "Two Medieval Objects from the Rhineland," pp. 56-58, 60-61. For other Colognese walrus ivory productions of the period, see *Zeit der Staufer,* I, 491-492, nos. 634-635; II, pls. 438-439.

75. Reiner Haussherr, "Zur Datierung des Helmarshausener Evangeliars Heinrichs des Löwen," *Zeitschrift des deutschen Vereins für Kunstwissenschaft,* XXXIV (1980), 3-15; Martin Gosebruch, "'Labor est Herimanni' Zum Evangeliar Heinrichs des Löwen," *Abhandlungen der Braunschweigischen Wissenschaftlichen Gesellschaft,* XXXV (1983), 135-161; Anton von Euw and Joachim M. Plotzek, *Die Handschriften der Sammlung Ludwig,* I (Cologne: Schnütgen-Museum der Stadt Köln, 1979), 153-158, no. II 3, figs. 49-55. See also London, Sotheby Parke Bernet & Co., sales cat., *The Gospels of Henry the Lion* (with description and detailed analysis of the ms. by Christopher de Hamel), 6 December 1983, lot no. 50 (separate volume of 77 pages, including many repr.).

76. For a partial repr. of Theophanu's document, see *Heiratsurkunde der Kaiserin Theophanu,* p. 85, and text pp. 34-39, no. 28. For the *Double Leaf from a Roman Gradual,* CMA 33.466 — a palimpsest once on the inside flap of ms. 142/124/67 of the Trier Cathedral Treasury — see William M. Milliken, "Manuscript Leaf from the Time of Duke Henry the Lion," CMA *Bulletin,* XXI (1934), 37; P. Petrus Siffrin, "Eine Schwesterhandschrift des Graduale von Monza: Reste zu Berlin, Cleveland und Trier," *Ephemerides Liturgicae,* LXIV (1950), 53-80; C. U. Faye and W. H. Bond, *Supplement to the Census of Medieval and Renaissance Manuscripts in the United States and Canada* (New York: The Bibliographical Society of America, 1962), pp. 427-428.

77. Summary list of manuscripts of the Helmarshausen School, arranged chronologically:

Gospels, 171 folios, 31.5 x 22.5 cm. Ca. 1120. Trier, Cathedral, Treasury, ms. 137.

Gospels, 173 folios, 31.4 x 23 cm. Ca. 1125. Trier, Cathedral, Treasury, ms. 138.

Gospels (Figure 129), 168 folios, 22.8 x 16.8 cm. Ca. 1130. Malibu, The J. Paul Getty Museum, Ludwig ms. II.2.

Gospels (Figure 130), 166 folios, 32.7 x 23.9 cm. Early twelfth century. Trier, Cathedral, Treasury, ms. 139/110/68.

Gospels, 158 folios, 23.3 x 16.2 cm. Ca. 1140. Copenhagen, Kongelige Bibliotek, ms. Thott 21.4°

Gospels of Lund Cathedral (Figure 132), 177 folios, 24.9 x 17 cm. Ca. 1150. Uppsala, Universitätsbibliothek, Cod. C. 83.

Compendium from Corvey Abbey, 73 folios, 22.5 x 15 cm. Mid-twelfth century. Münster, Staatsarchiv, ms. 1.132.

Helmarshausen's Register of Benefactors, 14 folios, 20 x 13.9 cm. Mid-twelfth century. Marburg, Staatsarchiv, Kop. 238.

Lippoldsberg Gospels, 147 folios, 28.5 x 21 cm. Ca. 1155-1165. Formerly Kassel, Murhardsche Bibliothek der Stadt, ms. 2° Theol. 59; lost in 1945.

Compendium from Abdinghof Abbey, 139 folios, 24.5 x 15.7 cm. Ca. 1160. Trier, Cathedral, Treasury, ms. 62.

Hersfeld Sacramentary, 158 folios, 28.5 x 20.5 cm. Ca. 1165. Kassel, Murhardsche Bibliothek der Stadt, ms. 2° Theol. 58.

Liber Vitae, Pontifical from Corvey Abbey, 191 folios, 28.5 x 23 cm. Ca. 1168. Münster, Staatsarchiv, ms. 1.133.

So-called *Psalter of Henry the Lion,* 11 folios, 20.9 x 13 cm. Ca. 1170. London, British Library, Lansdowne ms. 381.

Sacramentary, 2 folios, 18.3 x 13.1 cm. Ca. 1170. Hanover, Kestner Museum, no. 3969, a-b.

Gospels, 174 folios, 32 x 22.4 cm. Ca. 1175. Gnesen, Domkapitel, ms. 2.

Psalter (of Matilda Plantagenet?), 125 folios, 11.4 x 6.5 cm. Ca. 1188. Baltimore, Walters Art Gallery, ms. W10.

Gospels of Henry the Lion, 226 folios, 34.2 x 25.5 cm. Ca. 1185-1188. Wolfenbüttel, Herzog August-Bibliothek.

Gospels, 195 folios, 35 x 24.5 cm. (and one detached folio now CMA 33.445). Ca. 1190. Trier, Cathedral, Treasury, ms. 142/124/67.

Helmstedt Gospels (Figure 133), 177 folios, 32.8 x 22.4 cm. Dated 1194. Wolfenbüttel, Herzog August-Bibliothek, Cod. Guelph. 65 Helmst.

Most inclusive among studies devoted to the Helmarshausen scriptorium are G. Swarzenski, "Kunstkreis," pp. 254-278; Franz Jansen, *Die Helmarshausener Buchmalerei zur Zeit Heinrichs des Löwen* (Hildesheim-Leipzig: A. Lax, 1933); Ekkehard Krüger, *Die Schreib- und Malwerkstatt der Abtei Helmarshausen bis in die Zeit Heinrichs des Löwen,* 3 vols., Quellen und Forschungen zur Hessischen Geschichte, XXI (Darmstadt and Marburg: Hessischen Historischen Kommission Darmstadt und der Historischen Kommission für Hessen und Waldeck, 1972).

78. Folio 177v. of the *Helmstedt Gospels* bears the following inscription: ANNO INCARNATIONIS DŃ MILLESIMOCENTESIMONONACIMO QVARTO CONSCRIPTVS EST CODEX ISTE, DŌ GRĀS. For the influence of Byzantium see Hans Belting, "Zwischen Gotik und Byzanz, Gedanken zur Geschichte der sächsischen Buchmalerei im 13. Jahrhundert," *Zeitschrift für Kunstgeschichte,* XLI (1978), 217-257; Jacqueline Lafontaine-Dosogne, "Le Problème des influences byzantines dans la peinture, principalement la miniature, de la Germanie médiévale," *Scriptorium,* XXIV (1970), 95-101; Franziska C. Lambert, *Byzantinische und westliche Einflüsse in ihrer Bedeutung für die sächsische Plastik und Malerei im 12. Jahrhundert* (Berlin, 1926). For Berlin graec. qu. 66, see exhib. cat. *Ars Sacra,* pp. 123-126, no. 280. For late twelfth- and thirteenth-century Byzantine adaptations in Saxony, see also Hugo Buchtal, *The "Musterbuch" of Wolfenbüttel and Its Position in the Art of the Thirteenth Century,* Byzantina Vindobonensia XII (Vienna: Österreichischen Akademie der Wissenschaften, 1979). For the Helmarshausen gospels dated 1194, see references cited above in note 77 and *Kunst und Kultur im Weserraum,* pp. 509-510, no. 195; *Zeit der Staufer,* I, 585-587, no. 756 (entry by R. Haussherr), pls. 549-550.

79. G. Swarzenski, "Kunstkreis," pp. 254-255; Adolph Goldschmidt, "A German Psalter of the Twelfth Century Written in Helmarshausen," *The Journal of the Walters Art Gallery,* I (1938), 18-23; Dodwell, *Painting in Europe,* pp. 164-165; *Kunst und Kultur im Weserraum,* pp. 495-496, no. 184, pp. 502-503, no. 191; figs. 185-186; *Zeit der Staufer,* I, 584-585, no. 755 (entry by R. Haussherr); II, pls. 547-548; Gosebruch, " 'Labor est Herimanni,' " pp. 139, 158-159.

80. *Kunst und Kultur im Weserraum,* pp. 491-492, no. 180, fig. 179; pp. 506-508, no. 193, figs. 187-189, 193b-c, 231; Krüger, *Schreib-und Malwerkstatt,* II, 915-926; Lasko, *Ars Sacra,* p. 159, fig. 168; *Schatzkunst Trier,* pp. 126-127, no. 65. Several manuscripts of the Helmarshausen School came to the Cathedral of Trier through the legacy in 1823 of Canon Edmund von Kesselstatt, who had inherited them in 1814 from his brother, Count Christoph, who in turn had acquired them from the Cathedral Chapter of Paderborn where he had been dean (see Franz Jansen, "Der Paderborner Domdechant Graf Christoph von Kesselstatt und seine Handschriften-sammlung," in *Sankt Liborius sein Dom und sein Bistum. Zum 1100jährigen Jubiläum der Reliquienübertragung,* ed. P. Simon (Paderborn, 1936), pp. 355-368.

81. CMA 33.445 *Leaf Excised from a Gospel Book* (now Trier, Domsbibliothek ms. 142) with two scenes on the recto: in the upper register, *Solomon(?), Sponsa, Justice, and Truth,* and in the lower register, the *Nativity;* on the verso, *St. Matthew,* tempera, gold, and silver on parchment, 13-9/16 x 9-1/4 inches (34.4 x 23.6 cm.). Herimann and Byzantinizing Master, German, Helmarshausen, ca. 1190. Purchase from the J. H. Wade Fund. Ex collections: Cathedral of Paderborn(?); Convent of Kemnade, Westphalia (1777); Count von

Kesselstadt; Private Collection, Westphalia (until 1933); [Saemy Rosenberg, New York].

Exhibitions: Boston, 1940: Museum of Fine Arts, Arts of the Middle Ages, 1000-1400, p. 8, no. 22; pl. XIX; Cincinnati, 1949: The Taft Museum, Medieval Art Exhibition from XII to XV Centuries; Winnipeg, 1952: The Winnipeg Art Gallery; Exhibition of Medieval Art; Cleveland, 1959: The Cleveland Museum of Art, The Helmarshausen Latin Gospels; Berkeley, 1963: University Art Gallery, University of California at Berkeley, Pages from Medieval and Renaissance Illuminated Manuscripts from the Xth to the Early XVIth Centuries, p. 12, no. 4; Corvey, 1966: Kunst und Kultur im Weserraum 800-1600, p. 508, no. 194.

Selected publications: G. Swarzenski, "Kunstkreis," pp. 277-278; Jansen, *Helmarshausen Buchmalerei,* pp. 118-119; pl. 29; Milliken, "Manuscript Leaf from the Time of Duke Henry the Lion," pp. 33-39; Faye and Bond, *Supplement to the Census,* pp. 426-427; Franz Ronig, "Ein Fehlendes Blatt der Handschrift NR. 142/124 des Trierer Domschatzes," *Archiv für mittelrheinische Kirchengeschichte,* XIII (1961), 404-412; Dinkler-von Schubert, *Schrein der Hl. Elizabeth,* pp. 14-15; Gertrud Schiller, *Ikonographie der christlichen Kunst* (Gütersloh: Gütersloh Verlaghaus, 1966), I, 83-84, fig. 173; Larry Ayres, "Collaborative Enterprise in Romanesque Manuscript Illuminations and the Artists of the Winchester Bible," in *Medieval Art and Architecture at Winchester Cathedral,* The British Archaeological Association, Conference Transactions VI, 1980 (Leeds: British Archaeological Association, 1983), p. 25, fig. VIIIb.

82. Krüger, *Schreib-und Malwerkstatt,* I, 313-315, 356-358; II, 915-926. For what follows, see G. Swarzenski, "Kunstkreis," pp. 262-278; Belting, "Zwischen Gotik und Byzanz," pp. 230-231.

83. CMA 72.167 *Lion Aquamanile,* brass, 10-1/2 x 11-7/8 x 5-7/8 inches (26.7 x 30.2 x 15 cm.). Germany, Lower Saxony, Brunswick(?), early thirteenth century. Gift of Mrs. Chester D. Tripp in honor of Chester D. Tripp. Ex collections: Josephus Jitta, Heiloo (1919-1966); Hermann Schwartz, Mönchengladbach-Hardt (1966-1972). Selected publications: William D. Wixom, "A Lion Aquamanile in Cleveland," in *Intuition und Kunstwissenschaft: Festschrift für Hanns Swarzenski zum 70. Geburtstag am 30. August 1972* (Berlin: Gebr. Mann Verlag, 1973), pp. 253-260; revised and reprinted as "A Lion Aquamanile," CMA *Bulletin,* LXI (1974), 260-268 (the traditional blanket hypothesis here reiterated, i.e., that such Saxon aquamanilia were cast in Hildesheim, remains unsubstantiated). For the later history of the Rammelsberg mine, see Helen Boyce, *The Mines of the Upper Harz from 1514 to 1589* (Ph.D. Diss., University of Chicago, 1917; Menasha, WI: Collegiate Press, George Banta Publishing Co., 1920).

CHAPTER IV
A Time of Steady Growth

84. For the will of Otto IV dated 18 May 1218 which ambiguously states: "Omnes reliquias, quas pater noster habuit et nos habemus...praeter unum brachium, quod uxori nostrae repraesentatibur," see *Cosmodium (Chronicon Universale),* ed. H. Meibrom in *Rerum Germanicarum,* I (Helmstedt, 1688), Part 3, p. 148; Neumann, *Reliquienschatz,* p. 28; von Falke, Schmidt, and G. Swarzenski, *Welfenschatz,* pp. 15-16. For the coronation mantle of Otto, see Marie Schuette and S. Müller-Christensen, *Das Stickereiwerk* (Tübingen, 1963), p. 30, nos. 86-90; Bodo Hedergott, *Kunst des Mittelalters Herzog Anton Ulrich-Museum* (Brunswick: Herzog Anton Ulrich-Museum, 1981), pp. 10-11, nos. 14-15, pls. 14-15. For the tomb of Henry and Matilda, see particularly *Zeit der Staufer,* I, 325-327, no. 447 (entry by W. Sauerländer); II, pl. 248; Georgia S. Wright, review of Frank N. Steigerwald's *Das Grabmal*

Heinrichs des Löwen und Mathildes im Dom zu Braunschweig (Brunswick, 1972) in *Art Bulletin,* LVII (1975), 128-130 with earlier literature.

85. See above note 11 with inventory. According to Neumann, *Reliquienschatz,* p. 235, when the reliquary was opened in 1887, it held a single parchment leaf, considered to date to the fourteenth century, which included an excerpt from the Good Friday liturgy. When opened again in May 1984, it was empty. Quite noticeable was the fact that the entire wooden core had been replaced, probably in 1887.

86. For the various items in the Guelph Treasure which are related to Otto the Mild's patronage, see Appendix, nos. 43-51, and Kötzsche, *Welfenschatz,* pp. 76-79, nos. 29-33, 36 (with bibliography), figs. 54-62, 67.

87. CMA 31.65 *Architectural Monstrance with a Relic of St. Sebastian,* gilt-silver and crystal, H. 18-1/8 inches (47 cm.). Germany, Lower Saxony, Brunswick, ca. 1475. Gift of Julius F. Goldschmidt, Z. M. Hackenbroch, and J. Rosenbaum in Memory of the Exhibition of the Guelph Treasure Held in The Cleveland Museum of Art from 10 January to 1 February 1931. Ex collections: Treasury, Cathedral of St. Blaise, Brunswick (Inventory of 1482: "Item, una magna monstrancia nova cum relique S. Sebastiani martiris"); House of Brunswick-Lüneburg; [Goldschmidt Galleries, New York].

Exhibitions: Vienna, 1869: Österreichisches Museum für Kunst und Industrie; Frankfurt-am-Main, 1930: Städelsche Kunstinstitut; Berlin, 1930: Deutsche Gesellschaft (for the two 1930 exhibits in Germany, see Der Welfenschatz, p. 63, no. 65; New York, 1930: Goldschmidt and Reinhardt Galleries, The Guelph Treasure, p. 63, no. 65 (the *Architectural Monstrance with a Relic of St. Sebastian* traveled with this exhibition to The Cleveland Museum of Art, 10 January-1 February 1931); Cleveland, 1936: The Cleveland Museum of Art, Twentieth Anniversary Exhibition, p. 17, no. 9.

Selected publications: Molanus, *Lipsanographia,* no. LV; Neumann, *Reliquienschatz,* pp. 279-281, no. 55; von Falke, Schmidt, and G. Swarzenski, *Welfenschatz,* pp. 93, 200, no. 65; pl. 100; Milliken, "The Guelph Treasure in Cleveland" (1955-56), pp. 9-10. For a survey of the activity of goldsmiths in Brunswick from the fifteenth century onwards, see Gerd Spies, "Braunschweiger Goldschmiede," in *Brunswiek 1031-Braunschweig 1981,* Festschrift zur Ausstellung, ed. Matthias Puhle (Brunswick: Statdisches Museum, 1981), pp. 275-337.

88. Appendix, nos. 41, 69, 75; von Falke, Schmidt, and G. Swarzenski, *Welfenschatz,* pp. 179, 181, 204, nos. 46, 48, 69; repr. pls. 86, 88, 102, respectively.

CHAPTER V
Vicissitudes and Dispersal of the Treasure

89. For a brief synopsis of Saxony during the Reformation and subsequent periods, including family trees of the Brunswick-Lüneberg family, see Georg Schnath et al., *Geschichte des Landes Niedersachsen* (Würzburg: Verlag Ploetz, 1973), pp. 24-30. For the Cathedral of St. Blaise in the sixteenth century, see particularly von Falke, Schmidt, and G. Swarzenski, *Welfenschatz,* pp. 18-19.

90. Von Falke, Schmidt, and G. Swarzenski, *Welfenschatz,* p. 19. See the list compiled by Döll, *Kollegiatstifte St. Blasius,* pp. 171-182.

91. For the palace chapel at Hanover, see Georg Schnath and Helmut Plath, *Das Leineschloss. Kloster. Furstensitz. Landtagsgebäude* (Hanover: Hahnsahe Buchhandlung, 1972), pp. 9-28, 33, 40-42.

92. Molanus had an important collection of coins subsequently purchased by King George II in 1745. He was also a well-known bibliophile whose library is now part of the Niedersächsische Landesbibliothek in Hanover. For Sophie, Leibnitz, and the Court of Hanover, see Alheidis

von Rohr, *Sophie Kurfürstin von Hannover 1630-1714,* Begleitheft zur Ausstellung, exhib. cat. (Hanover: Historisches Museum am Hohen Ufer, 1980); Edouard Bodermann, "Leibnizens Briefwechsel mit dem Herzoge Anton Ulrich von Braunschweig-Wolfenbüttel," in *Zeitschrift des historischen Vereins für Niedersachsen* (Hanover, 1888), pp. 236-238.

93. Udo von Alvensleben, *Herrenhausen die Sommerresidenz der Welfen* (Berlin: Deutscher Kunstverlag, 1939); J. H. Miller, *Das königliche Welfen-Museum zu Hannover im Jahre 1863* (Hanover: Hahn'sche Hofbuchhandlung, 1864). The 1863 collection was partially regrouped in the exhibition Welfenschatz, Schatz der goldenen Tafel, Lüneburger Ratssilber, Hildesheimer Silberfund (Hanover, Kestner-Museum, 1956-57). The purchase of the *Gospels of Henry the Lion* from Prague by V. Klopp and S. Culemann on order of George V is hinted at in Register *36 Alt. 158,* consisting of correspondence of 1860-1890 exchanged with W. A. Neumann, at the Niedersächsisches Staatsarchiv. The actual records of the transaction are in the Archives of Hanover but cannot be consulted without the express permission of H.R.H. Duke Ernst August III.

94. Neumann, *Reliquienschatz,* p. 41.

95. Paul Zimmerman, *Ernst August, Herzog von Cumberland, Herzog zu Branschweig und Lüneburg* (Hanover: Helwingsche Verlagsbuchhandlung, 1929); Helmut Plath, "Zur Geschichte des Welfenschatzes — Ein Briefwechsel," *Niederdeutsche Beiträge zur Kunstgeschichte,* X (1971), 289-294.

96. On the replica of the *Apostle Arm Reliquary* in Dardago (near Pordenone) bearing the following inscription on its base plate: LEONI XIII PONT. MAX. / HOC ECTYPON ANTIQUI / RELIQUIARII / ATQUE RELIQUIAM S. BLASII / EP. et M. / OFFERT ERNESTUS AUGUSTUS / CUMBRIAE DUX BRUNSVIGAE / ET LUNEBURGI / MDCCCLXXXVII, see Giovanni Mariacher, *Orificeria sacra del Friuli occidentale sec. XI-XIX,* exhib. cat. (Pordenone, 1976), p. 77, no. 111 (where suggested to be a Venetian work of the fourteenth century), and pl. 111.

97. Fr. von Sobbe, *Geschichte des Braunschweigischen Infanterie Regiments nr. 92 in Welkriege 1914-1918* (Berlin: Verlag Tradition Wilhelm Roef, 1929); Manfred R. W. Garzmann, "Zur Geschichte der Garrison Braunschweig," in *Brunswiek 1031-Braunschweig 1981,* Festschrift zur Ausstellung, ed. Matthias Puhle (Brunswick: Städtisches Museum, 1981).

98. Frank E. Washburn Freund, "'The Guelph Treasure' of Ecclesiastical Art," *International Studio,* XCI (1928), 56-57; "The Great Guelph Treasure Destined to Go to America?," *The Illustrated London News,* 12 January 1929, p. 45; "Guelph Treasure Sold by Duke of Brunswick," *Art News,* 18 January 1930, pp. 1, 12-14. See also the New York *Tribune,* 18 October 1930, and Frankfurter, "Guelph Treasure," pp. 62-67.

99. Review by Fink in *Niedersächsiches Jahrbuch für Landesgeschichte,* VIII (1931), 242-246; Göran Axel-Nilsson, "Zwei Reliquiarien aus dem Welfenschatz im Röhsska Konstslöjdmuseet," *Röhsska Konstslöjd Museet* (Göteborg, Arstryck), 1958, pp. 39-67.

100. Among others, September 1930: *Art Digest,* pp. 5-6; 13 October: (Cleveland) *Press,* (Columbus) *Citizen;* 14 October: (Philadelphia) *Times;* 22 October: (Hartford City, IN) *News;* 24 October: (Denver) *Post,* (St. Paul) *News,* (Kearney, NB) *Hub,* (Grand Rapids) *Press,* (Baltimore) *Evening Sun;* 30 October: (Oklahoma City) *News.* See also Francis H. Taylor, "Notes on the Guelph Treasure," *Parnassus,* December 1930, pp. 24-25. Those relics of the True Cross already in the United States were at the Sacred Heart Church of the University of Notre-Dame, South Bend, IN; Chapel of the Foreign Mission, Catholic University, Washington, DC; Cathedral of the Holy Cross, Boston. Needless to say, the purchase was also proudly heralded by William Milliken ("The Acquisition of Six Objects from the Guelph Treasure").

101. For a German account of the episode, see Friedrich Winkler, "Der Tauschhandel der Museen und der Braunschweiger Vermeer," *Pantheon,* v (1930), 488-489. For the background on co-ownership of the Museum collection by the duke, see August Fink, *Geschichte des Herzog-Anton-Ulrich-Museums in Braunschweig* (Brunswick: ACO Verlag, 1967), pp. 114-129.

102. For the politics and controversies surrounding the sale of the Guelph Treasure within Germany, see Ernst Grohne, "Zur Discussion über den Welfenschatz," *Niedersachsen,* XXXVII (1932), 30-31. For reports of the sale to Berlin, see for example, *Art News,* 17 August 1935, p. 11. The documents relating to the sale are now in East Germany, perhaps in East Berlin. Queries as to their whereabouts were not answered and request for permission to examine them was not granted. The Ländes (federal state) of Brunswick had been the first to join the Nationalsozialistische Deutsche Arbeitpartei (of which Nazi is the abbreviation), and the venerable Cathedral of St. Blaise was transformed into the "Umbau als Nationale Weihestätte," or Hall of State Consecration where ideological speeches were delivered. On 24 June 1935 in connection with an official visit by Chancellor Adolf Hitler, the tombs of Henry the Lion and Matilda were opened with the expectation that this would support the racial criteria of the regime. But the exhumation was a sore disappointment, Henry's remains clearly showing him as a small, lame, and dark-haired man, in shocking contrast to the fair recumbent figure on his tomb. The chancellor, it is reported, was no less disappointed in the fact that Matilda proved to have been taller than was her consort (Dietrich Kuessner, *Geschichte der Braunschweigischen Landeskirche 1930-1947 im Überblick* [Büddenstedt: Pfarramt Offleben, 1981]). The fate of the three dealers associated with the sale of the Guelph Treasure is as follows: Z. M. Hackenbroch returned to Germany and died in Frankfurt before the beginning of the war; J. Rosenbaum moved to Amsterdam, where he died during the 1940s, while his nephew Saemy Rosenberg remained in America and with Eric Stiebel opened the firm of Rosenberg and Stiebel Inc. in New York; Julius Goldschmidt established himself in London as a dealer in Renaissance bronzes and died there in the early 1950s.

103. For glimpses of the ducal collections, see "The Connoisseur Diary – Treasure from Germany," *The Connoisseur,* CXXVIII (1951), 190; John F. Hayward, "Brunswick Arms and Armour in the Tower of London," *Burlington Magazine,* XCIV (1952), 232-234, and Oliver Millar, "The Brunswick Art Treasures at the Victoria and Albert Museum: The Pictures," ibid., 266-268; Sotheby Parke Bernet, Geneva, sales cat., 12 November 1980. On the sale of the *Gospels,* see Werner Knopp, "Die Heimholung des Evangeliars, Ablauf-Echo-Argumente," *Das Evangeliar Heinrichs des Löwen,* ed. Hansgeorg Loebel (Hanover: Niedersächsischen Landeszentrale für politische Bildung, 1984), pp. 81-94; London *Sunday Times,* 15 January 1984; Georg Himmelheber, "Der Ankauf des Evangeliars im Spiegel der Tagespresse," *Museumskunde,* XLIX (1984), 27-33; Christopher de Hamel, "The Gospel Book of Henry the Lion," *Art at Auction – The Year at Sotheby's 1983-84* (London: Sotheby Publication, 1984), pp. 158-165.

Acknowledgements

For their cordial assistance, I would like to express my thanks, in Berlin, to Dr. Dietrich Kötzsche, curator at the Kunstgewerbe Museum; in Bremen, to Mrs. Gursch and Mrs. Stocker of the Roselius-Haus; in Brunswick, to Prof. Martin Gosebruch of the Lehrstuhl für Kunstgeschichte, and to Dr. Johanna Lessmann, and Dr. Reinhold Wex, curators at the Herzog Anton Ulrich-Museum; in Dardago, to Don Giovanni Perin; in Essen, to Monsignor Martin Pischel of the Bishopry; in Hanover, to Dr. U. Gehrig, director of the Kestner Museum, and to Dr. Alheidis von Rohr, curator at the Historisches Museum am Hohen Ufer; in Hildesheim, to Mr. Michael Brandt, curator at the Diocesan Museum; in Kansas City, to the late Mr. Joseph Kuntz, curator at The Nelson-Atkins Museum of Art; in Kassel, to Mrs. Grimm, of the Muhardesche Bibliothek der Stadt; in London, to Mr. Neil Stratford, keeper at the British Museum; in Munich, to Dr. Karl Dachs, and Ms. Lisotte Renner of the Bayerisches Staatsbibliothek, and to Dr. Peter Vignau of the Zentralinstitut für Kunstgeschichte; in New York, to Mr. Edward R. Lubin, and to Mr. Eric Stiebel of Rosenberg and Stiebel, Inc.; in Paris, to Mr. Amaury Lefebure, curator at the Louvre; in Philadelphia, to Mr. Donald J. LaRocca, curatorial assistant at the Philadelphia Museum of Art; in Trier, to Prof. Franz Ronig, curator of the Cathedral Treasury; in Vienna, to Dr. Helmut Trnek, curator at the Kunsthistorisches Museum; in Wolfenbüttel, Dr. Meier of the Niedersächsisches Staatsarchiv and Dr. Wilhelm Milde of the Herzog August-Bibliothek. I owe particular words of appreciation to my wife for her help, and I thank Mr. Stephen Fliegel for his patience in typing my manuscript.

Photograph Credits

Index

The first number(s) refer to pages. References to Appendix I appear as pages followed by numbers (e.g. 139 no. 8); endnotes, referred to as n., nn., appear on pages 145-155; Roman numbers refer to Color Plates, while numbers in *italics* indicate black-and-white Figures.

Aachen: Palace Chapel, 20; Treasury, 8, 20; ivory hunting horn, 60
Abdinghof Abbey, 103, n. 77
Adelaide, St., empress, 37, 39, 40, 47, VIII, *39B*
Adelvoldus, deacon of St. Blaise, 49, 139 no. 8
Agnes of Brandenburg, 117, 123, 124, *146, 157*
Albrecht, bishop of Halberstadt, 124, *158*
Albrecht the Great, 116
Anton Ulrich, duke of Brunswick-Wolfenbüttel, 128
Aribert, archbishop of Milan, 52, 54
Azelin, bishop of Hildesheim, 40

Baltimore, Walters Art Gallery, psalter, 106, n. 77, *134*
Bamberg, Cathedral, 16, 40, 115; enamel apostle plaques, 67
Berlin, Staatlichen Museen Preussischer Kulturbesitz, 137; Kunstgewerbemuseum:
—Agnus Dei capsula, 127, 142 no. 75, *161*
—arm reliquaries of: St. Bartholomew, 141 no. 51; St. Caesar, 82, 83, 140 no. 22; St. George, 124, 141 no. 50, *158-159*; St. Innocent, 82, 83, 87, 140 no. 23, *102-103*; St. Lawrence, 82, 84, 88, 117, 140 no. 24, *104-105*; St. Mary Magdalene, 142 no. 80; St. Sigismund, 139 no. 7; St. Theodore, 82, 83, 87, 140 no. 21, *101*; Saintly Warrior, 127, 142 no. 81, *160*
—bust reliquaries of: St. Blaise, 47, 120, 141 no. 46, *152*; St. Cosmas, 116-117, 140 no. 39, *145*
—caskets: ivory, 59, 140 no. 40, n. 41; leather, 141 no. 61; with painted shields, 141 no. 48; with sharp-colored enamels, 68, 74, 139 no. 15, *78*
—dome reliquary, 96, 98, 101, 134, 136, 139 no. 13, *122*
—Enger burse reliquary, 120, *150*
—Guelph Cross, 52, 54, 139 no. 9, *57*
—icon of St. Demetri, 56, 140 no. 29, *61*
—miniature folding altar, 141 no. 49
—monstrances: with ivory plaques, 141 no. 53; with a relic of St. Blaise, 141 no. 56
—perfume or incense burner, 94, *120*
—plenars: for Sundays, 117-118, 120, 124, 141 no. 43, *147*; of Otto the Mild, 122-124, 141 no. 47, *153-154, 156-157*
—portable altars: in tablet form: from Byzantium, 56, 59, 88, 134-135, 140 no. 34, *63*; from Italy, 140 no. 30; from Palestine, 59, 140 no. 33; German, 140 no. 28; of Eilbertus, 65, 67, 73, 139 no. 12, n. 47, *72-74*; of Four Cardinal Virtues, 73-74, 78, 79, 87, 140 no. 17, *82-83*; of Provost Adelvoldus, 47, 139 no. 8; with Abraham and Melchizedek, 75, 79, 140 no. 19, *89*; with Christ and Apostles, 47, 139 no. 6, *54*; with Christ, Apostles, and Evangelists, 49, 139 no. 14, *56*
—reliquary chests: in the form of a portable altar, 140 no. 35; with enamels, 140 no. 38; with rounded lids, 140 nos. 36-37
—reliquary crosses: gilt bronze, 142 no. 63; silver, 142 no. 83; with three lions, 139 no. 16
—round box with relics, 142 no. 85
—St. Walpurgis Shrine, 73-74, 78, 79, 82, 140 no. 18, *84-85*
—statuette of St. Blaise, 60, 142 no. 62, *67*

Berlin, Staatlichen Museen Preussischer Kulturbesitz, Kupferstichkabinetts, Mosan psaltar, 63, 73, *71*
Berlin, Staatsbibliothek Preussischer Kulturbesitz, Codex Wittekindeus, 47, n. 30; gospels, 82, 103, *131*
Bern, Historisches Museum, diptych of Andrew III of Hungary, 123, *155*
Bernward, St., bishop of Hildesheim, 20, 21, 28, 40-41, 47, 86, 87, 96, *80*
Berthold III, count of Andechs, 85
Braunweiler, Abbey of SS. Nicholas and Medard, 101, *125*
Bremen
—Focke-Museum, capsulae, 127, 142 nos. 69-71;
—Formerly Roselius-Haus: monstrance with three turrets, 141 no. 54, reliquary crosses, 142 nos. 67-68
Bruno of Brunswick, 29, *27*
Brunon, House of, 7, 29, 47, 49
Brunswick, 7, 29, 39, 40, 49, 55, 56, 62, 67, 81, 101, 117, 131, n. 12, *Frontispiece, 1, 27*
—Cathedral of St. Blaise, 7, 29, 47, 49, 52, 55, 56, 83, 85, 87, 88, 109, 115, 116, 117, 122, 128, 137, 140, nn. 47, 102, *Frontispiece, 1-2*; altar of the Virgin, 88, 101, *115*; candelabrum, 88, 94, *2, 116*; mural paintings, 7, 115, *2*; sculptures of Otto the Mild and Agnes of Brandenburg, 117, *146*; tomb of Henry and Matilda, 7, 55, 115, n. 102, *3*
—Dankwarderode Castle, 7, 29, 47, 49, 55, 68, 115, 130, n. 37, *Frontispiece, 1*
—Herzog Anton Ulrich-Museum, 136; arm reliquary of St. Blaise, 30, 40, 41, 82, 83, 128, 139 no. 5, n. 19, *29-31*; casket with enamel plaque of St. Matthew, 78, 140 no. 20; coronation mantle of Otto IV, 115, *144*; epitaph of Countess Gertrude, 29, n. 18, *28*; ivory hunting horn, 59, 128, 139 no. 10, *65*; monstrance with mother-of-pearl Crucifixion, 142 no. 72
—Lion of bronze, 7, 55, 68, 114, *Frontispiece, 4*
—Monastery of St. Cyriacus, 87, 128, 140
—Monastery of St. Giles, 30, 55, 83, *32*
—Stadtbibliothek, *Cronecken der Sassen*, 29, 30, 60, *27, 32, 68*
—workshops of, 67, 87, 88, 94, 114, 117, 127, 139, 140, 141, 142, nn. 26, 43, 61, 83, 87
Brunswick-Lüneburg, House of, 7, 114, 116, 128, 130, 131, 132, n. 12
Brussels, Musées royaux d'art et d'histoire: head reliquary of Pope Alexander, 65; Lower Saxony enamel reliquary, 78; portable altar from Stavelot, 78, *93*
Byzantinizing Master, 112-114, n. 81, XXIII-XXIV, *133, 138-140, 142*
Byzantium, 56, 140, n. 8, see also Constantinople

Cambridge, St. John's College, commentary on the Apocalypse, 81, *98*
Cambridge, MA, Fogg Art Museum, ivory casket, 59, 136, 140 no. 32, *64*
Charlemagne, emperor, 13, 14, 20
Charles IV, emperor, 131, 140
Chicago, Art Institute of Chicago, 136, *170*; church-shaped reliquary, 127, 136, 142 no. 73, *160*; gilt-silver altar cross, 118, 124, 136, 141 no. 44, *148*; monstrances: crowned with a dome, 136, 141 no. 57; of SS. Anianus and Lawrence, 136, 141 no. 58; with relic of St. Christine, 127, 136 no. 74, *148*; with tooth of John the Baptist, 136, 141 no. 59; pyx on a foot, 136, 142 no. 76; Veltheim cross, 127, 136, 141 no. 41

Cleveland, The Cleveland Museum of Art, 133-134, 136, 138, *169*; altar cross, 94, n. 68, XIX; Apostles arm reliquary, 82, 87-88, 131, 133-134, 136, 140 no. 27, nn. 64, 96, XIV-XVIII, *111*; book-shaped reliquary, 22, 118, 120, 124, 133-134, 136, 140 no. 45, nn. 11-12, 85, *Back Cover*, *149*, *151*; Byzantine gospels, 35, *35*; casket with sharp-colored enamels, 68, 74, n. 49, XI; crosses of: Countess Gertrude, 30, 33, 35-36, 40, 41, 43-44, 45, 47, 117, 134-135, 136, 139 no. 3, n. 20, II, III B; Count Liudolf, 30, 33, 35-36, 40, 41, 43, 45, 47, 117, 134-135, 136, 139 no. 2, n. 20, I, III A, *34*; Cumberland medallion, 13, 14, 133-134, 136, 139 no. 1, n. 4, IV; double leaf from a Roman gradual (palimpsest from Trier ms. 142), 101, n. 76, *127*; enamel prophet plaques, 79, 81, 82, n. 56, XII A-D; horn of St. Blaise, 59-60, 133-134, 136, 140 no. 31, n. 41, X, *66*; ivory Miracle at Cana, 21-22, 25, 28, 43, 118, 120, 133-134, 139, nn. 11-12, *Back Cover*, *17*, *149*; leaf from a gospel book (Trier ms. 142), 110-114, n. 81, XXIII-XXIV; lion aquamanile, 114, n. 83, XXI; monstrances with: "paten of St. Bernward," 84, 85-86, 87, 133-134, 136, 140 no. 25, n. 61, *Front Cover*, XIII, *109*; relic of St. Sebastian, 127, 135-136, 142 no. 82, n. 87, XXII; Mosan Virgin and Child disk reliquary, 63, 73, *69*; perfume or incense burner, 94, n. 69, XX; portable altars: of Countess Gertrude, 30, 36-37, 39-40, 41, 43, 47, 67, 74, 117, 134-135, 136, 139 no. 4, n. 22, V-IX, *38-39*; with walrus ivory, 101, n. 74, *124*; pyx with Crucifixion, 78, n. 54, XII F, *92*; St. Lawrence enamel plaque, 67, 75, 78, n. 45, XII E; Virgin and Child steatite pendant, 20, n. 8, *14*
Cologne, 40, 96, 98, 101, 128; Cathedral, Gero crucifix, 45; Church of St. Pantaleon, shrine of St. Maurinus, 98; Church of St. Ursula, shrine of St. Aetherius, 98; Schnütgen-Museum, enamel prophet plaque, 79, 81, 82, *95*; workshops, 25, 40, 65, 67, 75, 78, 79, 81, 96, 98, 101, 139, 140, nn. 45, 74
Constantinople, 16, 20, 55, 56, 83. *See also* Byzantium
Copenhagen, Kongelige Bibliotek, gospels, n. 77
Corvey, 103, n. 77
Cunigonde, St., empress, 47, 81, *94*

Dankward of Brunswick, 29, *27*
Dardago, Church, copy of Cleveland Apostle arm reliquary, 131-132, n. 96, *167*
Darmstadt, Hessisches Landesmuseum, enamel roundel, 13, *6*
Dijon, Musée des Beaux-Arts, enamel prophet plaque, 79, 81, 82, *96*
Durham, Cathedral, Puiset Bible, 87, *110*
Düsseldorf, Kunstmuseum, enamel prophet plaque, 79, 81, 82, *97*

Echternach, Abbey, 13, 20, 28; gospels of, 13, *5*
Egbert I, count of Brunswick, margrave of Meissen, 30
Egbert II, margrave of Meissen, 30, 49
Egbert, archbishop of Trier, 20, 21, 28, 43, *16*
Egypt, 141
Eilbertus of Cologne, 65, 67, 73, 74, 78, 81, 139, *72-74*
Engelhardus, archbishop of Magdeburg, 47
England, 62, 81, 87, 106, 115-116, 130
Épernay, Bibliothèque municipale, Ebbo Gospels, 82, *100*
Ernst August I, duke of Cumberland, Brunswick, and Lüneburg, 131, *166*
Ernst August II, duke of Cumberland, Brunswick, and Lüneburg, 132, 136-137, n. 96, *166*
Ernst August III, duke of Cumberland, Brunswick, and Lüneburg, n. 93, *166*
Ernst August, bishop of Osnabrück, 128, 130
Essen, 45, 54; Cathedral, Treasury, crosses: of Abbess Matilda (first), 36, 44-45, 54, *37*; (second), 44-45, *48*; of Abbess Theophanu, 44, 45, 47, 54, *46*; gospel book of Abbess Theophanu, 44, 47, *47*

Florence, Museo nazionale, ivory of Marys at the sepulchre, 25, *20*
Framegaud, 22, 25
Frederick I (Barbarossa), emperor, 55, 62
Frederick II, emperor, 115
Fulda, 25, 103

Gandersheim, 40
George V, king of Hanover, 130-131, 132, n. 93, *164*
Gernrode, St. Cyriacus, Mary Magdalene(?), 44, *45*
Gertrude, countess of Brunswick, 29-30, 36, 40, 41, 43, 47, III B. For crosses and portable altar of, *see* Cleveland, The Cleveland Museum of Art
Gertrude, duchess of Bavaria and Saxony, 49, n. 19, *33*
Gertrude, queen of Denmark, 55, 106, *134*
Gertrude of Brunswick, margravine of Northeim, 30, 39, 40, 49, *32*
Ghibellines, 7
Gmunden, Schloss Cumberland, 131, 132, 137, *165*
Gnesen, Domkapitel, gospels, 103, n. 77
Gniezno, Cathedral Treasury, chalice from Tremessen, 84, 85, n. 60
Godehard, St., bishop of Hildesheim, 28, 29, 40, 86. For shrine of, *see* Hildesheim, Cathedral
Goslar, 62, 67-68, 88, 114, 115; Museum, Krodo altar, 68
Göteborg, Röhsska Konstlöjdmuseet: ciborium-shaped reliquary, 142 no. 77; monstrance with relic of St. Blaise, 142 no. 65
Gregorius Master and Workshop, 67, 98, *75*
Guelph, 7; Fund, 132; House of, 49, 52, 116; Treasure, 7-8, 13, 29-30, 36, 55, 56, 62, 114, 115, 116, 117, 127, 130, 131, 132-133, 139-143 (Appendices I and II); dispersal of, 8, 128, 133-134, 136-137, n. 102
Guelph V of Bavaria, 52

Halberstadt, 39
— Cathedral Museum, Codex 3, 114
— Liebfrauenkirche, 88, *114*
Hanover
— Kestner-Museum, enamel apostle plaque, 67, 74, *76*; sacramentary, n. 77
— Leinschloss, 128, 130, *163*
— Niedersächsisches Hauptstaatsarchiv in Hannover, drawing of Leineschloss Treasury, 130, *163*
— Welfen Schloss, 130
Heinrich II, duke of Brunswick, 128
Heinrich III, bishop of Hildesheim, n. 62
Heinrich von Werl, bishop of Paderborn, 49, 103.
Helena, St., empress, 39, VIII
Helmarshausen, Abbey, 21, 49, 101, *128*; metalwork from, 49, 101, 103-104, n. 49, *55*, *136-137*; manuscripts from, 101, 103-104, 106, 109, 140, nn. 77, 81, XXIII-XIV, *33*, *126*, *129-130*, *132-135*, *138-142*
Helmstedt, Abbey, 103, n. 77
Henry Count Palatine, 115
Henry (the Proud), duke of Bavaria and Saxony, 49, 52, 55, n. 47, *33*
Henry (the Peaceful), duke of Brunswick, 127
Henry (the Lion), duke of Saxony and Bavaria, 7, 49, 55, 62, 81, 83, 85, 115, 116, 137, nn. 37, 102, *3*, *33*, *126*, *135*; trip to Palestine and Constantinople, 55-56, 59, 83, 96; patronage of, 55, 62, 67, 81, 82, 84, 85, 87, 96, 106, 109, 114, 117, nn. 43, 60; for Gospels of, *see* Wolfenbüttel, Herzog August-Bibliothek; for tomb of, *see* Brunswick, Cathedral of St. Blaise; other objects connected with the duke, 83, 85, 87, 98, 106, 140, n. 77, *101-103*
Henry II, emperor, 40, 47, 81, *94*
Henry II (Plantagenet), king of England, 55, 62, 115, *33*
Herimann of Helmarshausen, 101, 112, 114, 140, n. 81, XXIII-XXIV, *33*, *126*, *138-141*

Hersfeld, Abbey, 103, n. 77
Hezilo, bishop of Hildesheim, 40
Hildesheim, 39, 44, 47, 67, 68, 74, 128
—Abbey of St. Michael, 28, 40, 75, n. 50
—Cathedral: column, bronze, 40, 47, *53*; corona, 96; doors, bronze, 21, 28, 30, 40, 111, *15, 24-25*; shrine of St. Godehard, 68, 74, 103, *79*
—Cathedral Treasury, 8; altar crosses: from St. Michael, 94, *118*; silver, of St. Bernward, 94, *117*; with pyx, 94, *119*; amphora from Cana, 28, 37, *26*; casket with sharp-colored enamels, 68, 74, *77*; chalice and paten of St. Bernward, n. 62; enamel plaques from antependium, 70, 73, *81*; gold Madonna, 41, *40-41*; gospels of St. Bernward, 21, 70, *80*; great cross of St. Bernward, 41, n. 26, *42*; Ratmann Sacramentary, 74-75, *87*; reliquary cross of Henry the Lion, 88, *112*; reliquary of St. Oswald, 84-85, 87, n. 62, *106-107*
—Church of St. Godehard, 75, 79, 88, *113*
—workshops of, 40-41, 47, 65, 67-68, 70, 73-75, 78-79, 81-82, 84-87, 88, 94, 139, 140, 142, nn. 20, 22, 49, 50, 54, 56, 60, 61, 64, 68, 69
Houston, Museum of Fine Arts, monstrance with finger of St. Valerius, 142 no. 64

Italy, 54, 55, 62, 132, 139, 140

Johann Friedrich of Hanover, 128, 130, *162*
John Lackland, king of England, 55, 115

Kansas City, Nelson-Atkins Museum of Art: monstrance with finger of John the Baptist, 136, 142 no. 66; reliquary cross, 136, 141 no. 52
Kassel, Murhardsche Bibliothek der Stadt, Lippoldsberg Gospels and Hersfeld Sacramentary, n. 77
Kremsmünster, Abbey, Tassilo Chalice, 14

Leningrad, Hermitage, enamel prophet plaque, 79, 81, 82
Liège, 25-26, 28, 65, 139, 141, n. 11
Lincoln, Cathedral, matrix for seal, 87
Lippoldsberg, Abbey, 103, n. 77
Liudolf, count of Brunswick, 29, 40, 43. For cross of, *see* Cleveland, The Cleveland Museum of Art
London
—British Library: Floreffe Bible, 63, *70*; psalter, 106, n. 77, *135*
—British Museum: casket with sharp-colored enamels, n. 49; enamel apostle plaques, 67; ivory Miracle at Cana, 22, *18*
—Victoria and Albert Museum: casket with enamel Crucifixion, n. 54; dome reliquary, 98, 101, *123*; enamel plaque with symbol of St. John, 43, *44*; English enamel with St. Paul, 81, *99*; ivory Crucifixion, 25; portable altar in tablet form, 74, *86*; reliquary cross, 14, *10*
Lower Saxony, 7, 29, 49, 55, 127, *Map*; workshops of, 65, 67-68, 70, 73, 87, 88, 139-140, 141, 142
Lübeck, 55
Lund, 103, n. 77

Magdeburg, 40, 47, 88, n. 31; Cathedral, sculpture of, 47, *52*
Mainz Cathedral, 14
Malibu, J. Paul Getty Museum, gospels, 103, n. 77, *129*
Manuel Comnenus, emperor, 55-56, 62
Marburg, Staatsarchiv, Helmarshausen Register, n. 77
Master of the Registrum Gregorii, 26, 28, 43, 139, 141, n. 11, *21-22*
Matilda, abbess of Essen, 20, 36, 44, 54, *37*
Matilda, countess of Tuscany, 49, 52
Matilda (Plantagenet), duchess of Saxony and Bavaria, 7, 33, 55, 85, 93, 101, 106, 115, n. 102, *3, 33, 126, 134-135*
Metz, 22, 25, 28
Meuse Valley, 25, 49, 62-63, 65, 67, 68, 78, 106

Milan, 47, 52, 139:
—Cathedral Museum: cross of archbishop Aribert, 52, 54, 58; gospels of archbishop Aribert, 52, 54, 123, *59*
—Sant'Ambrogio, *paliotto*, 47, *50*
Milliken, William M., 133, 134, 136, *168*
Minden, Cathedral, Treasury, reliquary of St. Peter, 35, *36*
Monza, Cathedral, Treasury, cross of Berengar I, 47, *49*
Munich, Bayerisches Staatsbibliothek, Codex Aureus of St. Emmeram, 16, *12*
Münster, Staatsarchiv, compendium and liber vitae from Corvey Abbey, n. 77

Nancy, Cathedral, Treasury, gospels of St. Gozelin, 13, *7*
New York, Metropolitan Museum of Art: casket with sharp-colored enamels, n. 49; English enamel with St. Paul, 81, *99*
Nicholas of Verdun, 67
Nuremberg, Germanisches Nationalmuseum, Codex Aureus, 43, *43*

Otto I, emperor, 20, 39, 47
Otto II, emperor, 20, *11*
Otto III, emperor, 20, 28
Otto IV, emperor, 55, 56, 115, n. 84; coronation mantle of, 115, *144*
Otto the Child, 116
Otto the Mild, 117, 118, 120, 123, 124, *146, 157*; patronage of, 117, 120, 124, n. 86; for his plenar, *see* Berlin, Kunstgewerbemuseum

Paderborn, Diocesan Museum: portable altars: of Heinrich von Werl, 49, 67, 101, 103, *55*; of SS. Felix, Blaise, and Sebaste, n. 34.
Palestine, 55, 59, 140
Paris
—Bibliothèque nationale: Echternach Gospels, 13, *5*; Framegaud Gospels, 22, 25, n. 12, *19*
—Musée de Cluny: Crucifixion plaque, 78-79, *90*; golden altar frontal from Basel Cathedral, 47, *51*; ivory of Otto II and Theophanu crowned, 16, 55, *11*
—Musée du Louvre, reliquary of Henry II, 79, 81, 82, *94*
Philadelphia, Philadelphia Museum of Art, 136; arm reliquary of St. Babylas, 136, 142 no. 79; relic capsula, 136, 141 no. 42
Prague, Cathedral, 130, 140, n. 93

Quedlinburg, 40, 44

Regensburg, 20
Reichenau, Abbey, 40
Reims, 21, 22, 43, 82
Richard I (the Lionheart), king of England, 55
Richenza, empress, 49
Roger of Helmarshausen, 49, 101, 103, 109, n. 34, *55, 137*. See also Theophilus of Helmarshausen
Rudolph August, duke of Brunswick-Wolfenbüttel, 128

St. Gall, 40
St. Oswald Reliquary Workshop, 84-87
Saxony. *See* Lower Saxony
Sicily, 59-60, 139, 140, n. 41
Siegburg, Church of St. Servatius, portable altar of St. Gregorius, 67, *75*
Sigebert, bishop of Minden, 28, *23*
Sion (Sitten), Cathedral, Treasury, Altheus Reliquary, 14, *8*
Spain, 37, 141
Speyer, Cathedral, 14
Stavelot, Abbey, 65, 78
Stockholm, Nationalmuseum, lion aquamanile, 114, *143*
Syria, 139

Theophanu, abbess of Essen, 20, 44, 47, 54, *47*

Theophanu, empress, 20, 28, 43, 44, 101, *11, 43*

Theophilus of Helmarshausen, 21, 33, 103, n. 34. *See also* Roger of Helmarshausen

Tongeren, Church of Our Lady, ivory Crucifixion, 26, 28, *22*

Trier, 14, 20, 25, 39:
—Cathedral, Treasury, 8, n. 80; compendium from Abingdhof (ms. 62), n. 77; gospels: ms. 137, n. 77; ms. 138, n. 77; ms. 139, 103-104, 109, nn. 34, 77, *130, 137*; ms. 142, 109-114, nn. 76, 77, 81, *136, 138-140, 142* (*see also* Cleveland, The Cleveland Museum of Art); of St. Godehard (ms. 141), 78, 79, *91*; of Tegernsee (ms. 140), 75, 79, *88*; reliquary of St. Andrew's sandal, 16, 37, 43, 47, *13*
—Stadtbibliothek: Codex Egberti, 21, *16*; Registrum Gregorii, 26, *21*
—workshops of, 21, 26, 28, 43, 45, 47

Troyes, Cathedral, casket with Virtues and Vices, 87

Tübingen, Staatsbibliothek, ivory of Bishop Sigebert, 28, *23*

Udalric, bishop of Halberstadt, 62

Uppsala, Universitätsbibliothek, gospels of Lund Cathedral, 106, n. 77, *132*

Velletri, Cathedral of S. Clemente, altar cross, 54, *60*

Venice, San Marco, Treasury: icon of St. Michael, 56, *62*; perfume burner, 96, *121*

Vienna, Kunsthistorisches Museum, chalice and paten from Wilten Abbey, 84, 85, n. 60, *108*

Weingarten, 49

Weland, 81, nn. 46, 56, *94*

Welfenschatz. *See* Guelph Treasure

Werden, Abbey, 45, 47

Weserraum, 14, 139, n. 4

Whereabouts unknown: beechwood casket, 141 no. 60; chalice-shaped reliquary, 142 no. 78; mazer reliquary, 142 no. 84; oval flask, 139 no. 11; tower-shaped reliquary, 127, 141 no. 55, *160*

Wibald, abbot of Stavelot, 65

Wilhelm II, emperor, 132

Wilhelm of Winchester, 115, 116

Wolfenbüttel:
—Herzog August-Bibliothek: Gospels of Henry the Lion, 33, 55, 81, 101, 106, 109-110, 111, 112, 114, 130-131, 137, 140 no. 26, nn. 77, 93, *33, 126, 141*; Helmstedt Gospels, 103, 106, 110, 113, nn. 77, 78, *133*
—Niedersächsisches Staatsarchiv: inventories of Cathedral of St. Blaise, 7-8, 86, 128, nn. 1, 11, 20, 22, 41, 87; marriage contract of Theophanu, 101

Library of Congress Cataloging in Publication Data

De Winter, Patrick M., 1939-
 The sacral treasure of the Guelphs.

 Bibliography: p.
 Includes index.
 1. Christian art and symbolism—Medieval, 500-1500—Germany (West)—Braunschweig. 2. Guelf, House of—Art patronage. 3. Dom St. Blasii (Braunschweig, Germany) 4. Braunschweig (Germany)—Churches. I. Cleveland Museum of Art. II. Title.
 N7950.B73D4 1985 704.9'482'0943 85-3820
 ISBN 0-910386-81-1